CAMBRIDGE LIBRARY COLLECTION

Books of enduring scholarly value

Literary Studies

This series provides a high-quality selection of early printings of literary works, textual editions, anthologies and literary criticism which are of lasting scholarly interest. Ranging from Old English to Shakespeare to early twentieth-century work from around the world, these books offer a valuable resource for scholars in reception history, textual editing, and literary studies.

The Works of Walter Pater

Walter Pater (1839–94) was the foremost Victorian writer on art and on aesthetic experience. He brought his extensive knowledge of the history of art to bear on the new problem of how to explain the very personal affective response to beauty, and raised this into a central concern of aesthetic and philosophical thought. His ideas still shape modern assumptions about how art plays on our feelings and intellectual responses. This edition of Pater's complete works was published in 1900–1 in a limited edition of 775 copies. It comprises eight volumes of his major works with an additional volume of critical essays first published in *The Guardian*. The collection of Pater's articles on ancient Greek thought, poetry, sculpture and architecture presented in this volume had previously been published in 1895 under the editorship of Pater's friend and literary executor C. L. Shadwell.

Cambridge University Press has long been a pioneer in the reissuing of out-of-print titles from its own backlist, producing digital reprints of books that are still sought after by scholars and students but could not be reprinted economically using traditional technology. The Cambridge Library Collection extends this activity to a wider range of books which are still of importance to researchers and professionals, either for the source material they contain, or as landmarks in the history of their academic discipline.

Drawing from the world-renowned collections in the Cambridge University Library, and guided by the advice of experts in each subject area, Cambridge University Press is using state-of-the-art scanning machines in its own Printing House to capture the content of each book selected for inclusion. The files are processed to give a consistently clear, crisp image, and the books finished to the high quality standard for which the Press is recognised around the world. The latest print-on-demand technology ensures that the books will remain available indefinitely, and that orders for single or multiple copies can quickly be supplied.

The Cambridge Library Collection will bring back to life books of enduring scholarly value (including out-of-copyright works originally issued by other publishers) across a wide range of disciplines in the humanities and social sciences and in science and technology.

The Works
of Walter Pater

VOLUME 7: GREEK STUDIES :
A SERIES OF ESSAYS

WALTER PATER

CAMBRIDGE
UNIVERSITY PRESS

CAMBRIDGE UNIVERSITY PRESS

Cambridge, New York, Melbourne, Madrid, Cape Town,
Singapore, São Paolo, Delhi, Tokyo, Mexico City

Published in the United States of America by Cambridge University Press, New York

www.cambridge.org
Information on this title: www.cambridge.org/9781108034296

© in this compilation Cambridge University Press 2011

This edition first published 1901
This digitally printed version 2011

ISBN 978-1-108-03429-6 Paperback

The Works

OF

Walter Pater

IN EIGHT VOLUMES

VII

GREEK STUDIES

Greek Studies

A Series of Essays

BY

WALTER PATER

FELLOW OF BRASENOSE COLLEGE

LONDON
MACMILLAN AND CO., Limited
NEW YORK: THE MACMILLAN COMPANY
1901

PREFACE

THE present volume consists of a collection of
essays by the late Mr. Pater, all of which have
already been given to the public in various
Magazines; and it is owing to the kindness of
the several proprietors of those Magazines that
they can now be brought together in a collected
shape. It will, it is believed, be felt, that their
value is considerably enhanced by their appear-
ance in a single volume, where they can throw
light upon one another, and exhibit by their
connexion a more complete view of the scope
and purpose of Mr. Pater in dealing with the
art and literature of the ancient world.

The essays fall into two distinct groups, one
dealing with the subjects of Greek mythology
and Greek poetry, the other with the history of
Greek sculpture and Greek architecture. But
these two groups are not wholly distinct; they
mutually illustrate one another, and serve to
enforce Mr. Pater's conception of the essential

unity, in all its many-sidedness, of the Greek character. The god understood as the "spiritual form" of the things of nature is not only the key-note of the "Study of Dionysus"[1] and "The Myth of Demeter and Persephone,"[2] but reappears as contributing to the interpretation of the growth of Greek sculpture.[3] Thus, though in the bibliography of his writings, the two groups are separated by a considerable interval, there is no change of view; he had already reached the centre of the problem, and, the secret once gained, his mode of treatment of the different aspects of Greek life and thought is permanent and consistent.

The essay on "The Myth of Demeter and Persephone" was originally prepared as two lectures, for delivery, in 1875, at the Birmingham and Midland Institute. These lectures were published in the *Fortnightly Review*, in Jan. and Feb. 1876. The "Study of Dionysus" appeared in the same *Review* in Dec. 1876. "The Bacchanals of Euripides" must have been written about the same time, as a sequel to the "Study of Dionysus"; for, in 1878, Mr. Pater revised the four essays, with the intention, apparently, of publishing them collectively in a volume, an intention afterwards abandoned.

[1] See p. 34. [2] See p. 100. [3] See pp. 220, 254.

PREFACE

The text now printed has, except that of "The Bacchanals," been taken from proofs then set up, further corrected in manuscript. "The Bacchanals," written long before, was not published until 1889, when it appeared in *Macmillan's Magazine* for May. It was reprinted, without alteration, prefixed to Dr. Tyrrell's edition of the *Bacchae*. "Hippolytus Veiled" first appeared in August 1889, in *Macmillan's Magazine*. It was afterwards rewritten, but with only a few substantial alterations, in Mr. Pater's own hand, with a view, probably, of republishing it with other essays. This last revise has been followed in the text now printed.

The papers on Greek sculpture [1] are all that remain of a series which, if Mr. Pater had lived, would, probably, have grown into a still more important work. Such a work would have included one or more essays on Phidias and the Parthenon, of which only a fragment, though an important fragment, can be found amongst his papers ; and it was to have been prefaced by an Introduction to Greek Studies, only a page or two of which was ever written.

[1] "The Beginnings of Greek Sculpture" was published in the *Fortnightly Review*, Feb. and March 1880 ; "The Marbles of Ægina" in the same *Review* in April. "The Age of Athletic Prizemen" was published in the *Contemporary Review* in February of the present year.

This is not the place to speak of Mr. Pater's private virtues, the personal charm of his character, the brightness of his talk, the warmth of his friendship, the devotion of his family life. But a few words may be permitted on the value of the work by which he will be known to those who never saw him.

Persons only superficially acquainted, or by hearsay, with his writings, are apt to sum up his merits as a writer by saying that he was a master, or a consummate master of style; but those who have really studied what he wrote do not need to be told that his distinction does not lie in his literary grace alone, his fastidious choice of language, his power of word-painting, but in the depth and seriousness of his studies. That the amount he has produced, in a literary life of thirty years, is not greater, is one proof among many of the spirit in which he worked. His genius was "an infinite capacity for taking pains." That delicacy of insight, that gift of penetrating into the heart of things, that subtleness of interpretation, which with him seems an instinct, is the outcome of hard, patient, conscientious study. If he had chosen, he might, without difficulty, have produced a far greater body of work of less value ; and from a worldly point of view, he would have been wise. Such was not his under-

PREFACE

standing of the use of his talents. *Cui multum
datum est, multum quaeretur ab eo.* Those who
wish to understand the spirit in which he worked,
will find it in this volume.

C. L. S.

Oct. 1894.

CONTENTS

A STUDY OF DIONYSUS

THE SPIRITUAL FORM OF FIRE AND DEW

WRITERS on mythology speak habitually of the *religion* of the Greeks. In thus speaking, they are really using a misleading expression, and should speak rather of *religions;* each race and class of Greeks—the Dorians, the people of the coast, the fishers—having had a religion of its own, conceived of the objects that came nearest to it and were most in its thoughts, and the resulting usages and ideas never having come to have a precisely harmonised system, after the analogy of some other religions. The religion of Dionysus is the religion of people who pass their lives among the vines. As the religion of Demeter carries us back to the cornfields and farmsteads of Greece, and places us, in fancy, among a primitive race, in the furrow and beside the granary ; so the religion of Dionysus carries us back to its vineyards, and is a monument of the ways and thoughts of people whose days go by beside the winepress, and

9

under the green and purple shadows, and whose material happiness depends on the crop of grapes. For them the thought of Dionysus and his circle, a little Olympus outside the greater, covered the whole of life, and was a complete religion, a sacred representation or interpretation of the whole human experience, modified by the special limitations, the special privileges of insight or suggestion, incident to their peculiar mode of existence.

Now, if the reader wishes to understand what the scope of the religion of Dionysus was to the Greeks who lived in it, all it represented to them by way of one clearly conceived yet complex symbol, let him reflect what the loss would be if all the effect and expression drawn from the imagery of the vine and the cup fell out of the whole body of existing poetry ; how many fascinating trains of reflexion, what colour and substance would therewith have been deducted from it, filled as it is, apart from the more aweful associations of the Christian ritual, apart from Galahad's cup, with all the various symbolism of the fruit of the vine. That supposed loss is but an imperfect measure of all that the name of Dionysus recalled to the Greek mind, under a single imaginable form, an outward body of flesh presented to the senses, and comprehending, as its animating soul, a whole world of thoughts, surmises, greater and less experiences.

A STUDY OF DIONYSUS

The student of the comparative science of religions finds in the religion of Dionysus one of many modes of that primitive tree-worship which, growing out of some universal instinctive belief that trees and flowers are indeed habitations of living spirits, is found almost everywhere in the earlier stages of civilisation, enshrined in legend or custom, often graceful enough, as if the delicate beauty of the object of worship had effectually taken hold on the fancy of the worshipper. Shelley's *Sensitive Plant* shows in what mists of poetical reverie such feeling may still float about a mind full of modern lights, the feeling we too have of a life in the green world, always ready to assert its claim over our sympathetic fancies. Who has not at moments felt the scruple, which is with us always regarding animal life, following the signs of animation further still, till one almost hesitates to pluck out the little soul of flower or leaf?

And in so graceful a faith the Greeks had their share; what was crude and inane in it becoming, in the atmosphere of their energetic, imaginative intelligence, refined and humanised. The oak-grove of Dodona, the seat of their most venerable oracle, did but perpetuate the fancy that the sounds of the wind in the trees may be, for certain prepared and chosen ears, intelligible voices; they could believe in the transmigration of souls into mulberry and laurel, mint and hyacinth; and the dainty *Metamorphoses* of Ovid

are but a fossilised form of one morsel here and
there, from a whole world of transformation,
with which their nimble fancy was perpetually
playing. "Together with them," says the
Homeric hymn to Aphrodite, of the Hama-
dryads, the nymphs which animate the forest
trees, "with them, at the moment of their birth,
grew up out of the soil, oak-tree or pine, fair,
flourishing among the mountains. And when at
last the appointed hour of their death has come,
first of all, those fair trees are dried up ; the
bark perishes from around them, and the branches
fall away ; and therewith the soul of them
deserts the light of the sun."

These then are the nurses of the vine, bracing
it with interchange of sun and shade. They
bathe, they dance, they sing songs of enchant-
ment, so that those who seem oddly in love with
nature, and strange among their fellows, are still
said to be *nympholepti;* above all, they are
weavers or spinsters, spinning or weaving with
airiest fingers, and subtlest, many - coloured
threads, the foliage of the trees, the petals of
flowers, the skins of the fruit, the long thin
stalks on which the poplar leaves are set so lightly
that Homer compares to them, in their constant
motion, the maids who sit spinning in the house
of Alcinous. The nymphs of Naxos, where the
grape-skin is darkest, weave for him a purple
robe. Only, the ivy is never transformed, is
visible as natural ivy to the last, pressing the

dark outline of its leaves close upon the firm, white, quite human flesh of the god's forehead.

In its earliest form, then, the religion of Dionysus presents us with the most graceful phase of this graceful worship, occupying a place between the ruder fancies of half-civilised people concerning life in flower or tree, and the dreamy after-fancies of the poet of the *Sensitive Plant*. He is the soul of the individual vine, first; the young vine at the house-door of the newly married, for instance, as the vine-grower stoops over it, coaxing and nursing it, like a pet animal or a little child; afterwards, the soul of the whole species, the spirit of fire and dew, alive and leaping in a thousand vines, as the higher intelligence, brooding more deeply over things, pursues, in thought, the generation of sweetness and strength in the veins of the tree, the transformation of water into wine, little by little; noting all the influences upon it of the heaven above and the earth beneath; and shadowing forth, in each pause of the process, an intervening person—what is to us but the secret chemistry of nature being to them the mediation of living spirits. So they passed on to think of Dionysus (naming him at last from the brightness of the sky and the moisture of the earth) not merely as the soul of the vine, but of all that life in flowing things of which the vine is the symbol, because its most emphatic example. At Delos he bears a son, from whom

in turn spring the three mysterious sisters Œno, Spermo, and Elais, who, dwelling in the island, exercise respectively the gifts of turning all things at will into oil, and corn, and wine. In the *Bacchæ* of Euripides, he gives his followers, by miracle, honey and milk, and the water gushes for them from the smitten rock. He comes at last to have a scope equal to that of Demeter, a realm as wide and mysterious as hers ; the whole productive power of the earth is in him, and the explanation of its annual change. As some embody their intuitions of that power in corn, so others in wine. He is the dispenser of the earth's hidden wealth, giver of riches through the vine, as Demeter through the grain. And as Demeter sends the airy, dainty-wheeled and dainty-winged spirit of Triptolemus to bear her gifts abroad on all winds, so Dionysus goes on his eastern journey, with its many intricate adventures, on which he carries his gifts to every people.

A little Olympus outside the greater, I said, of Dionysus and his companions ; he is the centre of a cycle, the hierarchy of the creatures of water and sunlight in many degrees ; and that fantastic system of tree-worship places round him, not the fondly whispering spirits of the more graceful inhabitants of woodland only, the nymphs of the poplar and the pine, but the whole satyr circle, intervening between the headship of the vine and the mere earth, the grosser, less human

spirits, incorporate and made visible, of the more coarse and sluggish sorts of vegetable strength, the fig, the reed, the ineradicable weed-things which will attach themselves, climbing about the vine-poles, or seeking the sun between the hot stones. For as Dionysus, the *spiritual form* of the vine, is of the highest human type, so the fig-tree and the reed have animal souls, mistake-able in the thoughts of a later, imperfectly re-membering age, for mere abstractions of animal nature ; Snubnose, and Sweetwine, and Silenus, the oldest of them all, so old that he has come to have the gift of prophecy.

Quite different from them in origin and intent, but confused with them in form, are those other companions of Dionysus, Pan and his children. Home-spun dream of simple people, and like them in the uneventful tenour of his existence, he has almost no story ; he is but a presence ; the *spiritual form* of Arcadia, and the ways of human life there ; the reflexion, in sacred image or ideal, of its flocks, and orchards, and wild honey ; the dangers of its hunters ; its weariness in noonday heat ; its children, agile as the goats they tend, who run, in their picturesque rags, across the solitary wanderer's path, to startle him, in the unfamiliar upper places ; its one adornment and solace being the dance to the homely shepherd's pipe, cut by Pan first from the sedges of the brook Molpeia.

Breathing of remote nature, the sense of which

15

is so profound in the Homeric hymn to Pan, the pines, the foldings of the hills, the leaping streams, the strange echoings and dying of sound on the heights, "the bird, which among the petals of many-flowered spring, pouring out a dirge, sends forth her honey-voiced song," "the crocus and the hyacinth disorderly mixed in the deep grass"—things which the religion of Dionysus loves—Pan joins the company of the Satyrs. Amongst them, they give their names to insolence and mockery, and the finer sorts of malice, to unmeaning and ridiculous fear. But the best spirits have found in them also a certain human pathos, as in displaced beings, coming even nearer to most men, in their very roughness, than the noble and delicate person of the vine ; dubious creatures, half-way between the animal and human kinds, speculating wistfully on their being, because not wholly understanding themselves and their place in nature ; as the animals seem always to have this expression to some noticeable degree in the presence of man. In the later school of Attic sculpture they are treated with more and more of refinement, till in some happy moment Praxiteles conceived a model, often repeated, which concentrates this sentiment of true humour concerning them ; a model of dainty natural ease in posture, but with the legs slightly crossed, as only lowly-bred gods are used to carry them, and with some puzzled trouble of youth, you might wish for a moment

to smoothe away, puckering the forehead a little, between the pointed ears, on which the goodly hair of his animal strength grows low. Little by little, the signs of brute nature are subordinated, or disappear ; and at last, Robetta, a humble Italian engraver of the fifteenth century, entering into the Greek fancy because it belongs to all ages, has expressed it in its most exquisite form, in a design of Ceres and her children, of whom their mother is no longer afraid, as in the Homeric hymn to Pan. The puck-noses have grown delicate, so that, with Plato's infatuated lover, you may call them winsome, if you please ; and no one would wish those hairy little shanks away, with which one of the small Pans walks at her side, grasping her skirt stoutly ; while the other, the sick or weary one, rides in the arms of Ceres herself, who in graceful Italian dress, and decked airily with fruit and corn, steps across a country of cut sheaves, pressing it closely to her, with a child's peevish trouble in its face, and its small goat-legs and tiny hoofs folded over together, precisely after the manner of a little child.

There is one element in the conception of Dionysus, which his connexion with the satyrs, Marsyas being one of them, and with Pan, from whom the flute passed to all the shepherds of Theocritus, alike illustrates, his interest, namely, in one of the great species of music. One form of that wilder vegetation, of which the Satyr race is the soul made visible, is the reed, which

the creature plucks and trims into musical pipes. And as Apollo inspires and rules over all the music of strings, so Dionysus inspires and rules over all the music of the reed, the water-plant, in which the ideas of water and of vegetable life are brought close together, natural property, therefore, of the spirit of life in the green sap. I said that the religion of Dionysus was, for those who lived in it, a complete religion, a complete sacred representation and interpretation of the whole of life ; and as, in his relation to the vine, he fills for them the place of Demeter, is the life of the earth through the grape as she through the grain, so, in this other phase of his being, in his relation to the reed, he fills for them the place of Apollo ; he is the inherent cause of music and poetry ; he inspires ; he explains the phenomena of enthusiasm, as distinguished by Plato in the *Phædrus*, the secrets of possession by a higher and more energetic spirit than one's own, the gift of self-revelation, of passing out of oneself through words, tones, gestures. A winged Dionysus, venerated at Amyclæ, was perhaps meant to represent him thus, as the god of enthusiasm, of the rising up on those spiritual wings, of which also we hear something in the *Phædrus* of Plato.

The artists of the Renaissance occupied themselves much with the person and the story of Dionysus ; and Michelangelo, in a work still remaining in Florence, in which he essayed

with success to produce a thing which should pass with the critics for a piece of ancient sculpture, has represented him in the fulness, as it seems, of this enthusiasm, an image of delighted, entire surrender to transporting dreams. And this is no subtle after-thought of a later age, but true to certain finer movements of old Greek sentiment, though it may seem to have waited for the hand of Michelangelo before it attained complete realisation. The head of Ion leans, as they recline at the banquet, on the shoulder of Charmides; he mutters in his sleep of things seen therein, but awakes as the flute-players enter, whom Charmides has hired for his birthday supper. The soul of Callias, who sits on the other side of Charmides, flashes out; he counterfeits, with life-like gesture, the personal tricks of friend or foe; or the things he could never utter before, he finds words for now; the secrets of life are on his lips. It is in this loosening of the lips and heart, strictly, that Dionysus is the Deliverer, *Eleutherios;* and of such enthusiasm, or ecstasy, is, in a certain sense, an older patron than Apollo himself. Even at Delphi, the centre of Greek inspiration and of the religion of Apollo, his claim always maintained itself; and signs are not wanting that Apollo was but a later comer there. There, under his later reign, hard by the golden image of Apollo himself, near the sacred tripod on which the Pythia sat to prophesy, was to be seen a strange object—a sort

of coffin or cinerary urn with the inscription, "Here lieth the body of Dionysus, the son of Semele." The pediment of the great temple was divided between them—Apollo with the nine Muses on that side, Dionysus, with perhaps three times three Graces, on this. A third of the whole year was held sacred to him ; the four winter months were the months of Dionysus ; and in the shrine of Apollo itself he was worshipped with almost equal devotion.

The religion of Dionysus takes us back, then, into that old Greek life of the vineyards, as we see it on many painted vases, with much there as we should find it now, as we see it in Bennozzo Gozzoli's mediæval fresco of the *Invention of Wine* in the Campo Santo at Pisa—the family of Noah presented among all the circumstances of a Tuscan vineyard, around the press from which the first wine is flowing, a painted idyll, with its vintage colours still opulent in decay, and not without its solemn touch of biblical symbolism. For differences, we detect in that primitive life, and under that Greek sky, a nimbler play of fancy, lightly and unsuspiciously investing all things with personal aspect and incident, and a certain mystical apprehension, now almost departed, of unseen powers beyond the material veil of things, corresponding to the exceptional vigour and variety of the Greek organisation. This peasant life lies, in unhistoric time, behind the definite forms with which poetry and a refined

priesthood afterwards clothed the religion of
Dionysus ; and the mere scenery and circum-
stances of the vineyard have determined many
things in its development. The noise of the
vineyard still sounds in some of his epithets,
perhaps in his best-known name — *Iacchus,
Bacchus.* The masks suspended on base or
cornice, so familiar an ornament in later Greek
architecture, are the little faces hanging from the
vines, and moving in the wind, to scare the birds.
That garland of ivy, the æsthetic value of which
is so great in the later imagery of Dionysus and
his descendants, the leaves of which, floating
from his hair, become so noble in the hands of
Titian and Tintoret, was actually worn on the
head for coolness ; his earliest and most sacred
images were wrought in the wood of the vine.
The people of the vineyard had their feast, the
little or *country Dionysia*, which still lived on, side
by side with the greater ceremonies of a later
time, celebrated in December, the time of the
storing of the new wine. It was then that the
potters' fair came, *calpis* and *amphora*, together
with lamps against the winter, laid out in order
for the choice of buyers ; for Keramus, the
Greek Vase, is a son of Dionysus, of wine and of
Athene, who teaches men all serviceable and
decorative art. Then the goat was killed, and its
blood poured out at the root of the vines ; and
Dionysus literally drank the blood of goats ; and,
being Greeks, with quick and mobile sympathies,

δεισιδαίμονες, "superstitious," or rather "susceptible of religious impressions," some among them, remembering those departed since last year, add yet a little more, and a little wine and water for the dead also ; brooding how the sense of these things might pass below the roots, to spirits hungry and thirsty, perhaps, in their shadowy homes. But the gaiety, that gaiety which Aristophanes in the *Acharnians* has depicted with so many vivid touches, as a thing of which civil war had deprived the villages of Attica, preponderates over the grave. The travelling country show comes round with its puppets ; even the slaves have their holiday ;[1] the mirth becomes excessive ; they hide their faces under grotesque masks of bark, or stain them with wine-lees, or potters' crimson even, like the old rude idols painted red ; and carry in midnight procession such rough symbols of the productive force of nature as the women and children had best not look upon ; which will be frowned upon, and refine themselves, or disappear, in the feasts of cultivated Athens.

Of the whole story of Dionysus, it was the episode of his marriage with Ariadne about which ancient art concerned itself oftenest, and with most effect. Here, although the antiquarian

[1] There were some who suspected Dionysus of a secret democratic interest ; though indeed he was *liberator* only of men's hearts, and ἐλευθερεύς only because he never forgot Eleutheræ, the little place which, in Attica, first received him.

may still detect circumstances which link the persons and incidents of the legend with the mystical life of the earth, as symbols of its annual change, yet the merely human interest of the story has prevailed over its earlier significance; the *spiritual form* of fire and dew has become a romantic lover. And as a story of romantic love, fullest perhaps of all the motives of classic legend of the pride of life, it survived with undiminished interest to a later world, two of the greatest masters of Italian painting having poured their whole power into it ; Titian with greater space of ingathered shore and mountain, and solemn foliage, and fiery animal life ; Tintoret with profounder luxury of delight in the nearness to each other, and imminent embrace, of glorious bodily presences ; and both alike with consummate beauty of physical form. Hardly less humanised is the Theban legend of Dionysus, the legend of his birth from Semele, which, out of the entire body of tradition concerning him, was accepted as central by the Athenian imagination. For the people of Attica, he comes from Bœotia, a country of northern marsh and mist, but from whose sombre, black marble towns came also the vine, the musical reed cut from its sedges, and the worship of the Graces, always so closely connected with the religion of Dionysus. "At Thebes alone," says Sophocles, "mortal women bear immortal gods." His mother is the daughter of Cadmus, himself marked out by

many curious circumstances as the close kinsman
of the earth, to which he all but returns at last,
as the serpent, in his old age, attesting some
closer sense lingering there of the affinity of man
with the dust from whence he came. Semele, an
old Greek word, as it seems, for the surface of the
earth, the daughter of Cadmus, beloved by Zeus,
desires to see her lover in the glory with which
he is seen by the immortal Hera. He appears
to her in lightning. But the mortal may not
behold him and live. Semele gives premature
birth to the child Dionysus ; whom, to preserve
it from the jealousy of Hera, Zeus hides in a part
of his thigh, the child returning into the loins of
its father, whence in due time it is born again.
Yet in this fantastic story, hardly less than in the
legend of Ariadne, the story of Dionysus has
become a story of human persons, with human
fortunes, and even more intimately human appeal
to sympathy ; so that Euripides, pre-eminent as
a poet of pathos, finds in it a subject altogether
to his mind. All the interest now turns on the
development of its points of moral or sentimental
significance ; the love of the immortal for the
mortal, the presumption of the daughter of man
who desires to see the divine form as it is ; on the
fact that not without loss of sight, or life itself,
can man look upon it. The travail of nature has
been transformed into the pangs of the human
mother ; and the poet dwells much on the
pathetic incident of death in childbirth, making

A STUDY OF DIONYSUS

Dionysus, as Callimachus calls him, a seven months' child, cast out among its enemies, motherless. And as a consequence of this human interest, the legend attaches itself, as in an actual history, to definite sacred objects and places, the venerable relic of the wooden image which fell into the chamber of Semele with the lightning-flash, and which the piety of a later age covered with plates of brass ; the *Ivy-Fountain* near Thebes, the water of which was so wonderfully bright and sweet to drink, where the nymphs bathed the new-born child ; the grave of Semele, in a sacred enclosure grown with ancient vines, where some volcanic heat or flame was perhaps actually traceable, near the lightning-struck ruins of her supposed abode.

Yet, though the mystical body of the earth is forgotten in the human anguish of the mother of Dionysus, the sense of his essence of fire and dew still lingers in his most sacred name, as the son of Semele, *Dithyrambus*. We speak of a certain wild music in words or rhythm as *dithyrambic*, like the dithyrambus, that is, the wild choral-singing of the worshippers of Dionysus. But Dithyrambus seems to have been, in the first instance, the name, not of the hymn, but of the god to whom the hymn is sung ; and, through a tangle of curious etymological speculations as to the precise derivation of this name, one thing seems clearly visible, that it commemorates, namely, the double birth of the vine-god ; that

25

he is born once and again ; his birth, first of fire,
and afterwards of dew ; the two dangers that
beset him ; his victory over two enemies, the
capricious, excessive heats and colds of spring.

He is πυριγενής, then, fire-born, the son of
lightning ; lightning being to light, as regards
concentration, what wine is to the other strengths
of the earth. And who that has rested a hand
on the glittering silex of a vineyard slope in
August, where the pale globes of sweetness are
lying, does not feel this? It is out of the bitter
salts of a smitten, volcanic soil that it comes up
with the most curious virtues. The mother
faints and is parched up by the heat which
brings the child to the birth ; and it pierces
through, a wonder of freshness, drawing its
everlasting green and typical coolness out of
the midst of the ashes ; its own stem becoming
at last like a tangled mass of tortured metal. In
thinking of Dionysus, then, as fire-born, the
Greeks apprehend and embody the sentiment,
the poetry, of all tender things which grow out
of a hard soil, or in any sense blossom before the
leaf, like the little mezereon-plant of English
gardens, with its pale-purple, wine-scented flowers
upon the leafless twigs in February, or like the
almond-trees of Tuscany, or Aaron's rod that
budded, or the staff in the hand of the Pope
when Tannhäuser's repentance is accepted.

And his second birth is of the dew. The
fire of which he was born would destroy him in

his turn, as it withered up his mother ; a second
danger comes ; from this the plant is protected
by the influence of the cooling cloud, the lower
part of his father the sky, in which it is wrapped
and hidden, and of which it is born again, its
second mother being, in some versions of the
legend, Hyé—the Dew. The nursery, where
Zeus places it to be brought up, is a cave in
Mount Nysa, sought by a misdirected ingenuity
in many lands, but really, like the place of the
carrying away of Persephone, a place of fantasy,
the oozy place of springs in the hollow of the
hillside, nowhere and everywhere, where the
vine was " invented." The nymphs of the trees
overshadow it from above ; the nymphs of the
springs sustain it from below—the *Hyades*, those
first leaping mænads, who, as the springs become
rain-clouds, go up to heaven among the stars,
and descend again, as dew or shower, upon it ;
so that the religion of Dionysus connects itself,
not with tree-worship only, but also with ancient
water-worship, the worship of the *spiritual forms*
of springs and streams. To escape from his
enemies Dionysus leaps into the sea, the original
of all rain and springs, whence, in early summer,
the women of Elis and Argos were wont to call
him, with the singing of a hymn. And again,
in thus commemorating Dionysus as born of the
dew, the Greeks apprehend and embody the
sentiment, the poetry, of water. For not the
heat only, but its solace—the *freshness* of the

27

cup—this too was felt by those people of the vineyard, whom the prophet Melampus had taught to mix always their wine with water, and with whom the watering of the vines became a religious ceremony ; the very dead, as they thought, drinking of and refreshed by the stream. And who that has ever felt the heat of a southern country does not know this poetry, the motive of the loveliest of all the works attributed to Giorgione, the *Fête Champêtre* in the Louvre ; the intense sensations, the subtle and far-reaching symbolisms, which, in these places, cling about the touch and sound and sight of it ? Think of the darkness of the well in the breathless court, with the delicate ring of ferns kept alive just within the opening ; of the sound of the fresh water flowing through the wooden pipes into the houses of Venice, on summer mornings ; of the cry *Acqua frésca !* at Padua or Verona, when the people run to buy what they prize, in its rare purity, more than wine, bringing pleasures so full of exquisite appeal to the imagination, that, in these streets, the very beggars, one thinks, might exhaust all the philosophy of the epicurean.

Out of all these fancies comes the vine-growers' god, the *spiritual form* of fire and dew. Beyond the famous representations of Dionysus in later art and poetry—the *Bacchanals* of Euripides, the statuary of the school of Praxiteles —a multitude of literary allusions and local

customs carry us back to this world of vision unchecked by positive knowledge, in which the myth is begotten among a primitive people, as they wondered over the life of the thing their hands helped forward, till it became for them a kind of spirit, and their culture of it a kind of worship. Dionysus, as we see him in art and poetry, is the projected expression of the ways and dreams of this primitive people, brooded over and harmonised by the energetic Greek imagination; the religious imagination of the Greeks being, precisely, a unifying or identifying power, bringing together things naturally asunder, making, as it were, for the human body a soul of waters, for the human soul a body of flowers; welding into something like the identity of a human personality the whole range of man's experiences of a given object, or series of objects—all their outward qualities, and the visible facts regarding them—all the hidden ordinances by which those facts and qualities hold of unseen forces, and have their roots in purely visionary places.

Dionysus came later than the other gods to the centres of Greek life; and, as a consequence of this, he is presented to us in an earlier stage of development than they; that element of natural fact which is the original essence of all mythology being more unmistakeably impressed upon us here than in other myths. Not the least interesting point in the study of him is, that he illustrates very clearly, not only the

earlier, but also a certain later influence of this element of natural fact, in the development of the gods of Greece. For the physical sense, latent in it, is the clue, not merely to the original signification of the incidents of the divine story, but also to the source of the peculiar imaginative expression which its persons subsequently retain, in the forms of the higher Greek sculpture. And this leads me to some general thoughts on the relation of Greek sculpture to mythology, which may help to explain what the function of the imagination in Greek sculpture really was, in its handling of divine persons.

That Zeus is, in earliest, original, primitive intention, the open sky, across which the thunder sometimes sounds, and from which the rain descends—is a fact which not only explains the various stories related concerning him, but determines also the expression which he retained in the work of Pheidias, so far as it is possible to recall it, long after the growth of those later stories had obscured, for the minds of his worshippers, his primary signification. If men felt, as Arrian tells us, that it was a calamity to die without having seen the Zeus of Olympia ; that was because they experienced the impress there of that which the eye and the whole being of man love to find above him ; and the genius of Pheidias had availed to shed, upon the gold and ivory of the physical form, the blandness, the breadth, the smile of the open sky ; the mild

heat of it still coming and going, in the face of
the father of all the children of sunshine and
shower ; as if one of the great white clouds had
composed itself into it, and looked down upon
them thus, out of the midsummer noonday ; so
that those things might be felt as warm, and
fresh, and blue, by the young and the old, the
weak and the strong, who came to sun them-
selves in the god's presence, as procession and
hymn rolled on, in the fragrant and tranquil
courts of the great Olympian temple ; while all
the time those people consciously apprehended
in the carved image of Zeus none but the
personal, and really human, characteristics.

Or think, again, of the Zeus of Dodona.
The oracle of Dodona, with its dim grove of
oaks, and sounding instruments of brass to
husband the faintest whisper in the leaves, was
but a great consecration of that sense of a
mysterious will, of which people still feel, or
seem to feel, the expression, in the motions of
the wind, as it comes and goes, and which
makes it, indeed, seem almost more than a mere
symbol of the spirit within us. For Zeus was,
indeed, the god of the winds also ; Æolus, their
so-called god, being only his mortal minister, as
having come, by long study of them, through
signs in the fire and the like, to have a certain
communicable skill regarding them, in relation
to practical uses. Now, suppose a Greek
sculptor to have proposed to himself to present

to his worshippers the image of this Zeus of
Dodona, who is in the trees and on the currents
of the air. Then, if he had been a really
imaginative sculptor, working as Pheidias worked,
the very soul of those moving, sonorous creatures
would have passed through his hand, into the
eyes and hair of the image ; as they can actually
pass into the visible expression of those who have
drunk deeply of them ; as we may notice, some-
times, in our walks on mountain or shore.

Victory again—*Niké*—associated so often with
Zeus—on the top of his staff, on the foot of his
throne, on the palm of his extended hand—
meant originally, mythologic science tells us,
only the great victory of the sky, the triumph
of morning over darkness. But that physical
morning of her origin has its ministry to the
later æsthetic sense also. For if *Niké*, when she
appears in company with the mortal, and wholly
fleshly hero, in whose chariot she stands to guide
the horses, or whom she crowns with her garland
of parsley or bay, or whose names she writes on a
shield, is imaginatively conceived, it is because the
old skyey influences are still not quite suppressed
in her clear-set eyes, and the dew of the morning
still clings to her wings and her floating hair.

The office of the imagination, then, in Greek
sculpture, in its handling of divine persons, is
thus to condense the impressions of natural
things into human form ; to retain that early
mystical sense of water, or wind, or light, in the

moulding of eye and brow ; to arrest it, or rather, perhaps, to set it free, there, as human expression. The body of man, indeed, was for the Greeks, still the genuine work of Prometheus ; its connexion with earth and air asserted in many a legend, not shaded down, as with us, through innumerable stages of descent, but direct and immediate ; in precise contrast to our physical theory of our life, which never seems to fade, dream over it as we will, out of the light of common day. The oracles with their messages to human intelligence from birds and springs of water, or vapours of the earth, were a witness to that connexion. Their story went back, as they believed, with unbroken continuity, and in the very places where their later life was lived, to a past, stretching beyond, yet continuous with, actual memory, in which heaven and earth mingled ; to those who were sons and daughters of stars, and streams, and dew ; to an ancestry of grander men and women, actually clothed in, or incorporate with, the qualities and influences of those objects ; and we can hardly over-estimate the influence on the Greek imagination of this mythical connexion with the natural world, at not so remote a date, and of the solemnising power exercised thereby over their thoughts. In this intensely poetical situation, the historical Greeks, the Athenians of the age of Pericles, found themselves ; it was as if the actual roads on which men daily walk, went up and on, into a visible wonderland.

With such habitual impressions concerning the body, the physical nature of man, the Greek sculptor, in his later day, still free in imagination, through the lingering influence of those early dreams, may have more easily infused into human form the sense of sun, or lightning, or cloud, to which it was so closely akin, the spiritual flesh allying itself happily to mystical meanings, and readily expressing seemingly unspeakable qualities. But the human form is a limiting influence also ; and in proportion as art impressed human form, in sculpture or in the drama, on the vaguer conceptions of the Greek mind, there was danger of an escape from them of the free spirit of air, and light, and sky. Hence, all through the history of Greek art, there is a struggle, a *Streben*, as the Germans say, between the palpable and limited human form, and the floating essence it is to contain. On the one hand, was the teeming, still fluid world, of old beliefs, as we see it reflected in the somewhat formless *theogony* of Hesiod ; a world, the Titanic vastness of which is congruous with a certain sublimity of speech, when he has to speak, for instance, of motion or space ; as the Greek language itself has a primitive copiousness and energy of words, for wind, fire, water, cold, sound—attesting a deep susceptibility to the impressions of those things—yet with edges, most often, melting into each other. On the other hand, there was that limiting, controlling tendency,

identified with the Dorian influence in the history
of the Greek mind, the spirit of a severe and
wholly self-conscious intelligence; bent on
impressing everywhere, in the products of the
imagination, the definite, perfectly conceivable
human form, as the only worthy subject of art;
less in sympathy with the mystical genealogies
of Hesiod, than with the heroes of Homer, end-
ing in the entirely humanised religion of Apollo,
the clearly understood humanity of the old Greek
warriors in the marbles of Ægina. The represent-
ation of man, as he is or might be, became the
aim of sculpture, and the achievement of this
the subject of its whole history; one early carver
had opened the eyes, another the lips, a third
had given motion to the feet; in various ways,
in spite of the retention of archaic idols, the
genuine human expression had come, with the
truthfulness of life itself.

These two tendencies, then, met and struggled
and were harmonised in the supreme imagina-
tion, of Pheidias, in sculpture—of Æschylus, in
the drama. Hence, a series of wondrous person-
alities, of which the Greek imagination became
the dwelling-place; beautiful, perfectly under-
stood human outlines, embodying a strange,
delightful, lingering sense of clouds and water
and sun. Such a world, the world of really
imaginative Greek sculpture, we still see, re-
flected in many a humble vase or battered
coin, in Bacchante, and Centaur, and Amazon;

evolved out of that "vasty deep"; with most command, in the consummate fragments of the Parthenon; not, indeed, so that he who runs may read, the gifts of Greek sculpture being always delicate, and asking much of the receiver; but yet visible, and a pledge to us, of creative power, as, to the worshipper, of the presence, which, without that material pledge, had but vaguely haunted the fields and groves.

This, then, was what the Greek imagination did for men's sense and experience of natural forces, in Athene, in Zeus, in Poseidon; for men's sense and experience of their own bodily qualities—swiftness, energy, power of concentrating sight and hand and foot on a momentary physical act—in the close hair, the chastened muscle, the perfectly poised attention of the *quoit-player;* for men's sense, again, of ethical qualities—restless idealism, inward vision, power of presence through that vision in scenes behind the experience of ordinary men—in the idealised Alexander.

To illustrate this function of the imagination, as especially developed in Greek art, we may reflect on what happens with us in the use of certain names, as expressing summarily, this name for you and that for me—Helen, Gretchen, Mary—a hundred associations, trains of sound, forms, impressions, remembered in all sorts of degrees, which, through a very wide and full experience, they have the power of bringing with

them ; in which respect, such names are but revealing instances of the whole significance, power, and use of language in general. Well,— the mythical conception, projected at last, in drama or sculpture, is the *name*, the instrument of the identification, of the given matter,—of its unity in variety, its outline or definition in mystery ; its *spiritual form*, to use again the expression I have borrowed from William Blake —form, with hands, and lips, and opened eyelids —spiritual, as conveying to us, in that, the soul of rain, or of a Greek river, or of swiftness, or purity.

To illustrate this, think what the effect would be, if you could associate, by some trick of memory, a certain group of natural objects, in all their varied perspective, their changes of colour and tone in varying light and shade, with the being and image of an actual person. You travelled through a country of clear rivers and wide meadows, or of high windy places, or of lowly grass and willows, or of the *Lady of the Lake ;* and all the complex impressions of these objects wound themselves, as a second animated body, new and more subtle, around the person of some one left there, so that they no longer come to recollection apart from each other. Now try to conceive the image of an actual person, in whom, somehow, all those impressions of the vine and its fruit, as the highest type of the life of the green sap, had become incorporate ;—all the scents and colours of its flower and fruit, and

something of its curling foliage ; the chances of its growth ; the enthusiasm, the easy flow of more choice expression, as its juices mount within one ; for the image is eloquent, too, in word, gesture, and glancing of the eyes, which seem to be informed by some soul of the vine within it : as Wordsworth says,

> Beauty born of murmuring sound
> Shall pass into her face—

so conceive an image into which the beauty, "born" of the vine, has passed ; and you have the idea of Dionysus, as he appears, entirely fashioned at last by central Greek poetry and art, and is consecrated in the Οἰνοφόρια and the Ἀνθεστήρια, the great festivals of the *Winepress* and the *Flowers*.

The word *wine*, and with it the germ of the myth of Dionysus, is older than the separation of the Indo-Germanic race. Yet, with the people of Athens, Dionysus counted as the youngest of the gods ; he was also the son of a mortal, dead in childbirth, and seems always to have exercised the charm of the latest born, in a sort of allowable fondness. Through the fine-spun speculations of modern ethnologists and grammarians, noting the changes in the letters of his name, and catching at the slightest historical records of his worship, we may trace his coming from Phrygia, the birthplace of the more mystical elements of

A STUDY OF DIONYSUS

Greek religion, over the mountains of Thrace. On the heights of Pangæus he leaves an oracle, with a perpetually burning fire, famous down to the time of Augustus, who reverently visited it. Southwards still, over the hills of Parnassus, which remained for the inspired women of Bœotia the centre of his presence, he comes to Thebes, and the family of Cadmus. From Bœotia he passes to Attica; to the villages first; at last to Athens; at an assignable date, under Peisistratus; out of the country, into the town.

To this stage of his town-life, that Dionysus of "enthusiasm" already belonged; it was to the Athenians of the town, to urbane young men, sitting together at the banquet, that those expressions of a sudden eloquence came, of the loosened utterance and finer speech, its colour and imagery. Dionysus, then, has entered Athens, to become urbane like them; to walk along the marble streets in frequent procession, in the persons of noble youths, like those who at the *Oschophoria* bore the branches of the vine from his temple, to the temple of *Athene of the Parasol*, or of beautiful slaves; to contribute through the arts to the adornment of life, yet perhaps also in part to weaken it, relaxing ancient austerity. Gradually, his rough country feasts will be outdone by the feasts of the town; and as comedy arose out of those, so these will give rise to tragedy. For his entrance upon this new stage of his career, his coming into the town, is from the

first tinged with melancholy, as if in entering the town he had put off his country peace. The other Olympians are above sorrow. Dionysus, like a strenuous mortal hero, like Hercules or Perseus, has his alternations of joy and sorrow, of struggle and hard-won triumph. It is out of the sorrows of Dionysus, then,—of Dionysus in winter—that all Greek tragedy grows ; out of the song of the sorrows of Dionysus, sung at his winter feast by the chorus of satyrs, singers clad in goat-skins, in memory of his rural life, one and another of whom, from time to time, steps out of the company to emphasise and develope this or that circumstance of the story ; and so the song becomes dramatic. He will soon forget that early country life, or remember it but as the dreamy background of his later existence. He will become, as always in later art and poetry, of dazzling whiteness ; no longer dark with the air and sun, but like one ἐσκιατροφηκώς—brought up under the shade of Eastern porticoes or pavilions, or in the light that has only reached him softened through the texture of green leaves ; honey-pale, like the delicate people of the city, like the flesh of women, as those old vase-painters conceive of it, who leave their hands and faces untouched with the pencil on the white clay. The ruddy god of the vineyard, stained with wine-lees, or coarser colour, will hardly recognise his double, in the white, graceful, mournful figure, weeping, chastened, lifting up his arms in yearn-

ing affection towards his late-found mother, as we
see him on a famous Etruscan mirror. Only, in
thinking of this early tragedy, of these town-
feasts, and of the entrance of Dionysus into
Athens, you must suppose, not the later Athens
which is oftenest in our thoughts, the Athens of
Pericles and Pheidias; but that little earlier
Athens of Peisistratus, which the Persians
destroyed, which some of us perhaps would
rather have seen, in its early simplicity, than the
greater one ; when the old image of the god,
carved probably out of the stock of an enormous
vine, had just come from the village of Eleutheræ
to his first temple in the *Lenæum*—the quarter
of the winepresses, near the *Limnæ*—the marshy
place, which in Athens represents the cave of
Nysa ; its little buildings on the hill-top, still
with steep rocky ways, crowding round the
ancient temple of Erechtheus and the grave of
Cecrops, with the old miraculous olive-tree still
growing there, and the old snake of Athene
Polias still alive somewhere in the temple court.

The artists of the Italian Renaissance have
treated Dionysus many times, and with great
effect, but always in his joy, as an embodiment of
that glory of nature to which the Renaissance
was a return. But in an early engraving of
Mocetto there is for once a Dionysus treated
differently. The cold light of the background
displays a barren hill, the bridge and towers of

an Italian town, and quiet water. In the fore-
ground, at the root of a vine, Dionysus is sitting,
in a posture of statuesque weariness ; the leaves
of the vine are grandly drawn, and wreathing
heavily round the head of the god, suggest the
notion of his incorporation into it. The right
hand, holding a great vessel languidly and in-
differently, lets the stream of wine flow along
the earth ; while the left supports the forehead,
shadowing heavily a face, comely, but full of an
expression of painful brooding. One knows not
how far one may really be from the mind of the
old Italian engraver, in gathering from his
design this impression of a melancholy and
sorrowing Dionysus. But modern motives are
clearer ; and in a *Bacchus* by a young Hebrew
painter, in the exhibition of the Royal Academy
of 1868, there was a complete and very fascinat-
ing realisation of such a motive ; the god of the
bitterness of wine, " of things too sweet " ; the
sea-water of the Lesbian grape become some-
what brackish in the cup. Touched by the
sentiment of this subtler, melancholy Dionysus,
we may ask whether anything similar in feeling is
to be actually found in the range of Greek ideas ;
—had some antitype of this fascinating figure
any place in Greek religion ? Yes ; in a certain
darker side of the double god of nature, obscured
behind the brighter episodes of Thebes and
Naxos, but never quite forgotten, something
corresponding to this deeper, more refined idea,

really existed — the conception of Dionysus
Zagreus ; an image, which has left, indeed, but
little effect in Greek art and poetry, which
criticism has to put patiently together, out o
late, scattered hints in various writers ; but
which is yet discernible, clearly enough to show
that it really visited certain Greek minds here
and there ; and discernible, not as a late after-
thought, but as a tradition really primitive, and
harmonious with the original motive of the idea
of Dionysus. In its potential, though unrealised
scope, it is perhaps the subtlest dream in Greek
religious poetry, and is, at least, part of the
complete physiognomy of Dionysus, as it actually
reveals itself to the modern student, after a
complete survey.

The whole compass of the idea of Dionysus,
a dual god of both summer and winter, became
ultimately, as we saw, almost identical with that
of Demeter. The Phrygians believed that the
god slept in winter and awoke in summer, and
celebrated his waking and sleeping ; or that he
was bound and imprisoned in winter, and un-
bound in spring. We saw how, in Elis and at
Argos, the women called him out of the sea,
with the singing of hymns, in early spring ; and
a beautiful ceremony in the temple at Delphi,
which, as we know, he shares with Apollo,
described by Plutarch, represents his mystical
resurrection. Yearly, about the time of the
shortest day, just as the light begins to increase,

and while hope is still tremulously strung, the priestesses of Dionysus were wont to assemble with many lights at his shrine, and there, with songs and dances, awoke the new-born child after his wintry sleep, waving in a sacred cradle, like the great basket used for winnowing corn, a symbolical image, or perhaps a real infant. He is twofold then—a *Döppelganger*; like Persephone, he belongs to two worlds, and has much in common with her, and a full share of those dark possibilities which, even apart from the story of the rape, belong to her. He is a *Chthonian* god, and, like all the children of the earth, has an element of sadness; like Hades himself, he is hollow and devouring, an eater of man's flesh—*sarcophagus*—the grave which consumed unaware the ivory-white shoulder of Pelops.

And you have no sooner caught a glimpse of this image, than a certain perceptible shadow comes creeping over the whole story; for, in effect, we have seen glimpses of the sorrowing Dionysus, all along. Part of the interest of the Theban legend of his birth is that he comes of the marriage of a god with a mortal woman; and from the first, like merely mortal heroes, he falls within the sphere of human chances. At first, indeed, the melancholy settles round the person of his mother, dead in childbirth, and ignorant of the glory of her son; in shame, according to Euripides; punished, as her own sisters allege, for impiety. The death of Semele

is a sort of ideal or type of this peculiar claim on human pity, as the descent of Persephone into Hades, of all human pity over the early death of women. Accordingly, his triumph being now consummated, he descends into Hades, through the unfathomable Alcyonian lake, according to the most central version of the legend, to bring her up from thence ; and that Hermes, the shadowy conductor of souls, is constantly associated with Dionysus, in the story of his early life, is not without significance in this connexion. As in Delphi the winter months were sacred to him, so in Athens his feasts all fall within the four months on this and the other side of the shortest day ; as Persephone spends those four months—a third part of the year—in Hades. Son or brother of Persephone he actually becomes at last, in confused, half-developed tradition ; and even has his place, with his dark sister, in the Eleusinian mysteries, as Iacchus ; where, on the sixth day of the feast, in the great procession from Athens to Eleusis, we may still realise his image, moving up and down above the heads of the vast multitude, as he goes, beside " *the two*," to the temple of Demeter, amid the light of torches at noonday.

But it was among the mountains of Thrace that this gloomier element in the being of Dionysus had taken the strongest hold. As in the sunny villages of Attica the cheerful elements of his religion had been developed, so, in those

wilder northern regions, people continued to brood over its darker side, and hence a current of gloomy legend descended into Greece. The subject of the *Bacchanals* of Euripides is the infatuated opposition of Pentheus, king of Thebes, to Dionysus and his religion ; his cruelty to the god, whom he shuts up in prison, and who appears on the stage with his delicate limbs cruelly bound, but who is finally triumphant ; Pentheus, the man of grief, being torn to pieces by his own mother, in the judicial madness sent upon her by the god. In this play, Euripides has only taken one of many versions of the same story, in all of which Dionysus is victorious, his enemy being torn to pieces by the sacred women, or by wild horses, or dogs, or the fangs of cold ; or the mænad Ambrosia, whom he is supposed to pursue for purposes of lust, suddenly becomes a vine, and binds him down to the earth inextricably, in her serpentine coils.

In all these instances, then, Dionysus punishes his enemies by repaying them in kind. But a deeper vein of poetry pauses at the sorrow, and in the conflict does not too soon anticipate the final triumph. It is Dionysus himself who exhausts these sufferings. Hence, in many forms —reflexes of all the various phases of his wintry existence—the image of Dionysus Zagreus, *the Hunter*—of Dionysus in winter—storming wildly on the dark Thracian hills, from which, like Ares and Boreas, he originally descends into

Greece ; the thought of the hunter concentrat-
ing into itself all men's forebodings over the
departure of the year at its richest, and the death
of all sweet things in the long-continued cold,
when the sick and the old and little children,
gazing out morning after morning on the dun
sky, can hardly believe in the return any more
of a bright day. Or he is connected with the
fears, the dangers and hardships of the hunter
himself, lost or slain sometimes, far from home,
in the dense woods of the mountains, as he seeks
his meat so ardently ; becoming, in his chase,
almost akin to the wild beasts—to the wolf, who
comes before us in the name of Lycurgus, one of
his bitterest enemies—and a phase, therefore, of
his own personality, in the true intention of the
myth. This transformation, this image of the
beautiful soft creature become an enemy of
human kind, putting off himself in his madness,
wronged by his own fierce hunger and thirst,
and haunting, with terrible sounds, the high
Thracian farms, is the most tragic note of the
whole picture, and links him on to one of the
gloomiest creations of later romance, the were-
wolf, the belief in which still lingers in Greece,
as in France, where it seems to become in-
corporate in the darkest of all romantic histories,
that of Gilles de Retz.

And now we see why the tradition of human
sacrifice lingered on in Greece, in connexion
with Dionysus, as a thing of actual detail, and

not remote, so that Dionysius of Halicarnassus
counts it among the horrors of Greek religion.
That the sacred women of Dionysus ate, in
mystical ceremony, raw flesh, and drank blood,
is a fact often mentioned, and commemorates, as
it seems, the actual sacrifice of a fair boy deliber-
ately torn to pieces, fading at last into a symbolical
offering. At Delphi, the wolf was preserved for
him, on the principle by which Venus loves the
dove, and Hera peacocks ; and there were places
in which, after the sacrifice of a kid to him, a
curious mimic pursuit of the priest who had
offered it represented the still surviving horror
of one who had thrown a child to the wolves.
The three daughters of Minyas devote themselves
to his worship ; they cast lots, and one of them
offers her own tender infant to be torn by the
three, like a roe ; then the other women pursue
them, and they are turned into bats, or moths,
or other creatures of the night. And fable is
endorsed by history ; Plutarch telling us how,
before the battle of Salamis, with the assent of
Themistocles, three Persian captive youths were
offered to Dionysus *the Devourer*.

As, then, some embodied their fears of winter
in Persephone, others embodied them in Dionysus,
a devouring god, whose sinister side (as the best
wine itself has its treacheries) is illustrated in the
dark and shameful secret society described by
Livy, in which his worship ended at Rome,
afterwards abolished by solemn act of the senate.

A STUDY OF DIONYSUS

He becomes a new Aidoneus, a hunter of men's souls; like him, to be appeased only by costly sacrifices.

And then, Dionysus recovering from his mid-winter madness, how intensely these people conceive the spring! It is that triumphant Dionysus, cured of his great malady, and sane in the clear light of the longer days, whom Euripides in the *Bacchanals* sets before us, as still, essentially, the Hunter, Zagreus; though he keeps the red streams and torn flesh away from the delicate body of the god, in his long vesture of white and gold, and fragrant with Eastern odours. Of this I hope to speak in another paper; let me conclude this by one phase more of religious custom.

If Dionysus, like Persephone, has his gloomy side, like her he has also a peculiar message for a certain number of refined minds, seeking, in the later days of Greek religion, such modifications of the old legend as may minister to ethical culture, to the perfecting of the moral nature. A type of second birth, from first to last, he opens, in his series of annual changes, for minds on the look-out for it, the hope of a possible analogy, between the resurrection of nature, and something else, as yet unrealised, reserved for human souls; and the beautiful, weeping creature, vexed by the wind, suffering, torn to pieces, and rejuvenescent again at last, like a tender shoot of living green out of the hardness and stony dark-

ness of the earth, becomes an emblem or ideal of chastening and purification, and of final victory through suffering. It is the finer, mystical sentiment of the few, detached from the coarser and more material religion of the many, and accompanying it, through the course of its history, as its ethereal, less palpable, life-giving soul, and, as always happens, seeking the quiet, and not too anxious to make itself felt by others. With some unfixed, though real, place in the general scheme of Greek religion, this phase of the worship of Dionysus had its special development in the Orphic literature and mysteries. Obscure as are those followers of the mystical Orpheus, we yet certainly see them, moving, and playing their part, in the later ages of Greek religion. Old friends with new faces, though they had, as Plato witnesses, their less worthy aspect, in certain appeals to vulgar, superstitious fears, they seem to have been not without the charm of a real and inward religious beauty, with their neologies, their new readings of old legends, their sense of mystical second meanings, as they refined upon themes grown too familiar, and linked, in a sophisticated age, the new to the old. In this respect, we may perhaps liken them to the mendicant orders in the Middle Ages, with their florid, romantic theology, beyond the bounds of orthodox tradition, giving so much new matter to art and poetry. They are a picturesque addition, also, to the exterior of Greek life, with

their white dresses, their dirges, their fastings and ecstasies, their outward asceticism and material purifications. And the central object of their worship comes before us as a tortured, persecuted, slain god — the suffering Dionysus — of whose legend they have their own special and esoteric version. That version, embodied in a supposed Orphic poem, *The Occultation of Dionysus*, is represented only by the details that have passed from it into the almost endless *Dionysiaca* of Nonnus, a writer of the fourth century; and the imagery has to be put back into the shrine, bit by bit, and finally incomplete. Its central point is the picture of the rending to pieces of a divine child, of whom a tradition, scanty indeed, but harmonious in its variations, had long maintained itself. It was in memory of it, that those who were initiated into the Orphic mysteries tasted of the raw flesh of the sacrifice, and thereafter ate flesh no more; and it connected itself with that strange object in the Delphic shrine, the grave of Dionysus.

Son, first, of Zeus, and of Persephone whom Zeus woos, in the form of a serpent — the white, golden-haired child, the best-beloved of his father, and destined by him to be the ruler of the world, grows up in secret. But one day, Zeus, departing on a journey, in his great fondness for the child, delivered to him his crown and staff, and so left him — shut in a strong tower. Then it came to pass that the jealous Here sent

out the Titans against him. They approached the crowned child, and with many sorts of play-things enticed him away, to have him in their power, and then miserably slew him—hacking his body to pieces, as the wind tears the vine, with the axe *Pelekus*, which, like the swords of Roland and Arthur, has its proper name. The fragments of the body they boiled in a great cauldron, and made an impious banquet upon them, afterwards carrying the bones to Apollo, whose rival the young child should have been, thinking to do him service. But Apollo, in great pity for this his youngest brother, laid the bones in a grave, within his own holy place. Meanwhile, Here, full of her vengeance, brings to Zeus the heart of the child, which she had snatched, still beating, from the hands of the Titans. But Zeus delivered the heart to Semele; and the soul of the child remaining awhile in Hades, where Demeter made for it new flesh, was thereafter born of Semele—a second Zagreus —the younger, or Theban Dionysus.

THE BACCHANALS OF EURIPIDES

So far, I have endeavoured to present, with something of the concrete character of a picture, Dionysus, the old Greek god, as we may discern him through a multitude of stray hints in art and poetry and religious custom, through modern speculation on the tendencies of early thought, through traits and touches in our own actual states of mind, which may seem sympathetic with those tendencies. In such a picture there must necessarily be a certain artificiality ; things near and far, matter of varying degrees of certainty, fact and surmise, being reflected and concentrated, for its production, as if on the surface of a mirror. Such concrete character, however, Greek poet or sculptor, from time to time, impressed on the vague world of popular belief and usage around him ; and in the *Bacchanals* of Euripides we have an example of the figurative or imaginative power of poetry, selecting and combining, at will, from that mixed and floating mass, weaving the many-coloured threads together, blending the various phases of legend—all the light and shade of the

subject—into a shape, substantial and firmly set, through which a mere fluctuating tradition might retain a permanent place in men's imaginations. Here, in what Euripides really says, in what we actually see on the stage, as we read his play, we are dealing with a single real object, not with uncertain effects of many half-fancied objects. Let me leave you for a time almost wholly in his hands, while you look very closely at his work, so as to discriminate its outlines clearly.

This tragedy of the *Bacchanals*—a sort of masque or morality, as we say—a monument as central for the legend of Dionysus as the Homeric hymn for that of Demeter, is unique in Greek literature, and has also a singular interest in the life of Euripides himself. He is writing in old age (the piece was not played till after his death) not at Athens, nor for a polished Attic audience, but for a wilder and less temperately cultivated sort of people, at the court of Archelaus, in Macedonia. Writing in old age, he is in that subdued mood, a mood not necessarily sordid, in which (the shudder at the nearer approach of the unknown world coming over him more frequently than of old) accustomed ideas, conformable to a sort of common sense regarding the unseen, oftentimes regain what they may have lost, in a man's allegiance. It is a sort of madness, he begins to think, to differ from the received opinions thereon. Not that he is insincere or ironical, but that he tends, in the

sum of probabilities, to dwell on their more peaceful side ; to sit quiet, for the short remaining time, in the reflexion of the more cheerfully lighted side of things ; and what is accustomed —what holds of familiar usage—comes to seem the whole essence of wisdom, on all subjects ; and the well-known delineation of the vague country, in Homer or Hesiod, one's best attainable mental outfit, for the journey thither. With this sort of quiet wisdom the whole play is penetrated. Euripides has said, or seemed to say, many things concerning Greek religion, at variance with received opinion ; and now, in the end of life, he desires to make his peace—what shall at any rate be peace with men. He is in the mood for acquiescence, or even for a palinode ; and this takes the direction, partly of mere submission to, partly of a refining upon, the authorised religious tradition : he calmly sophisticates this or that element of it which had seemed grotesque ; and has, like any modern writer, a theory how myths were made, and how in lapse of time their first signification gets to be obscured among mortals ; and what he submits to, that he will also adorn fondly, by his genius for words.

And that very neighbourhood afforded him his opportunity. It was in the neighbourhood of Pella, the Macedonian capital, that the worship of Dionysus, the newest of the gods, prevailed in its most extravagant form—the

Thiasus, or wild, nocturnal procession of Bacchic women, retired to the woods and hills for that purpose, with its accompaniments of music, and lights, and dancing. Rational and moderate Athenians, as we may gather from some admissions of Euripides himself, somewhat despised all that ; while those who were more fanatical forsook the home celebrations, and went on pilgrimage from Attica to Cithæron or Delphi. But at Pella persons of high birth took part in the exercise, and at a later period we read in Plutarch how Olympias, the mother of Alexander the Great, was devoted to this enthusiastic worship. Although in one of Botticelli's pictures the angels dance very sweetly, and may represent many circumstances actually recorded in the Hebrew scriptures, yet we hardly understand the dance as a religious ceremony ; the bare mention of it sets us thinking on some fundamental differences between the pagan religions and our own. It is to such ecstasies, however, that all nature-worship seems to tend ; that giddy, intoxicating sense of spring—that tingling in the veins, sympathetic with the yearning life of the earth, having, apparently, in all times and places, prompted some mode of wild dancing. Coleridge, in one of his fantastic speculations, refining on the German word for enthusiasm—*Schwärmerei*, swarming, as he says, " like the swarming of bees together "—has explained how the sympathies of mere numbers, as such, the random catching on

fire of one here and another there, when people are collected together, generates as if by mere contact, some new and rapturous spirit, not traceable in the individual units of a multitude. Such *swarming* was the essence of that strange dance of the Bacchic women : literally like winged things, they follow, with motives, we may suppose, never quite made clear even to themselves, their new, strange, romantic god. Himself a woman-like god,—it was on women and feminine souls that his power mainly fell. At Elis, it was the women who had their own little song with which at spring-time they professed to call him from the sea : at Brasiæ they had their own temple where none but women might enter ; and so the *Thiasus*, also, is almost exclusively formed of women—of those who experience most directly the influence of things which touch thought through the senses—the presence of night, the expectation of morning, the nearness of wild, unsophisticated, natural things—the echoes, the coolness, the noise of frightened creatures as they climbed through the darkness, the sunrise seen from the hill-tops, the disillusion, the bitterness of satiety, the deep slumber which comes with the morning. Athenians visiting the Macedonian capital would hear, and from time to time actually see, something of a religious custom, in which the habit of an earlier world might seem to survive. As they saw the lights flitting over the mountains,

and heard the wild, sharp cries of the women, there was presented, as a singular fact in the more prosaic actual life of a later time, an enthusiasm otherwise relegated to the wonderland of a distant past, in which a supposed primitive harmony and understanding between man and nature renewed itself. Later sisters of Centaur and Amazon, the Mænads, as they beat the earth in strange sympathy with its waking up from sleep, or as, in the description of the Messenger, in the play of Euripides, they lie sleeping in the glen, revealed among the morning mists, were themselves indeed as remnants—flecks left here and there and not yet quite evaporated under the hard light of a later and commoner day—of a certain cloud-world which had once covered all things with a veil of mystery. Whether or not, in what was often probably coarse as well as extravagant, there may have lurked some finer vein of ethical symbolism, such as Euripides hints at—the soberer influence, in the *Thiasus*, of keen air and animal expansion, certainly, for art, and a poetry delighting in colour and form, it was a custom rich in suggestion. The imitative arts would draw from it altogether new motives of freedom and energy, of freshness in old forms. It is from this fantastic scene that the beautiful wind-touched draperies, the rhythm, the heads suddenly thrown back, of many a Pompeian wall-painting and sarcophagus-frieze are originally derived ; and that melting languor, that perfectly

composed lassitude of the fallen Mænad, became
a fixed type in the school of grace, the school of
Praxiteles.

The circumstances of the place thus combining
with his peculiar motive, Euripides writes the
Bacchanals. It is this extravagant phase of
religion, and the latest-born of the gods, which
as an *amende honorable* to the once slighted tradi-
tions of Greek belief, he undertakes to interpret
to an audience composed of people who, like
Scyles, the Hellenising king of Scythia, feel the
attraction of Greek religion and Greek usage,
but on their quainter side, and partly relish that
extravagance. Subject and audience alike stimu-
late the romantic temper, and the tragedy of the
Bacchanals, with its innovations in metre and
diction, expressly noted as foreign or barbarous—
all the charm and grace of the clear-pitched
singing of the chorus, notwithstanding—with
its subtleties and sophistications, its grotesques,
mingled with and heightening a real shudder at
the horror of the theme, and a peculiarly fine
and human pathos, is almost wholly without the
reassuring calm, generally characteristic of the
endings of Greek tragedy : is itself excited,
troubled, disturbing—a spotted or dappled thing,
like the oddly dappled fawn-skins of its own
masquerade, so aptly expressive of the shifty,
twofold, rapidly-doubling genius of the divine,
wild creature himself. Let us listen and watch
the strange masks coming and going, for a while,

as far as may be as we should do with a modern
play. What are its charms ? What is still alive,
impressive, and really poetical for us, in the dim
old Greek play ?

The scene is laid at Thebes, where the
memory of Semele, the mother of Dionysus, is
still under a cloud. Her own sisters, sinning
against natural affection, pitiless over her pathetic
death and finding in it only a judgment upon the
impiety with which, having shamed herself with
some mortal lover, she had thrown the blame of
her sin upon Zeus, have, so far, triumphed over
her. The true and glorious version of her story
lives only in the subdued memory of the two
aged men, Teiresias the prophet, and her father
Cadmus, apt now to let things go loosely by,
who has delegated his royal power to Pentheus,
the son of one of those sisters—a hot-headed
and impious youth. So things had passed at
Thebes ; and now a strange circumstance has
happened. An odd sickness has fallen upon the
women : Dionysus has sent the sting of his
enthusiasm upon them, and has pushed it to a
sort of madness, a madness which imitates the
true *Thiasus*. Forced to have the form without
the profit of his worship, the whole female
population, leaving distaff and spindle, and headed
by the three princesses, have deserted the town,
and are lying encamped on the bare rocks, or
under the pines, among the solitudes of Cithæron.
And it is just at this point that the divine child,

supposed to have perished at his mother's side in the flames, returns to his birthplace, grown to manhood.

Dionysus himself speaks the prologue. He is on a journey through the world to found a new religion ; and the first motive of this new religion is the vindication of the memory of his mother. In explaining this design, Euripides, who seeks always for pathetic effect, tells in few words, touching because simple, the story of Semele—here, and again still more intensely in the chorus which follows—the merely human sentiment of maternity being not forgotten, even amid the thought of the divine embraces of her fiery bed-fellow. It is out of tenderness for her that the son's divinity is to be revealed. A yearning affection, the affection with which we see him lifting up his arms about her, satisfied at last, on an old Etruscan metal mirror, has led him from place to place : everywhere he has had his dances and established his worship ; and everywhere his presence has been her justification. First of all the towns in Greece he comes to Thebes, the scene of her sorrows : he is standing beside the sacred waters of Dirce and Ismenus : the holy place is in sight : he hears the Greek speech, and sees at last the ruins of the place of her lying-in, at once his own birth-chamber and his mother's tomb. His image, as it detaches itself little by little from the episodes of the play, and is further characterised by the

songs of the chorus, has a singular completeness
of symbolical effect. The incidents of a fully
developed human personality are superinduced
on the mystical and abstract essence of that
fiery spirit in the flowing veins of the earth—
the aroma of the green world is retained in the
fair human body, set forth in all sorts of finer
ethical lights and shades—with a wonderful kind
of subtlety. In the course of his long progress
from land to land, the gold, the flowers, the
incense of the East, have attached themselves
deeply to him : their effect and expression rest
now upon his flesh like the gleaming of that old
ambrosial ointment of which Homer speaks as
resting ever on the persons of the gods, and
cling to his clothing—the mitre binding his
perfumed yellow hair—the long tunic down to
the white feet, somewhat womanly, and the
fawn-skin, with its rich spots, wrapped about
the shoulders. As the door opens to admit
him, the scented air of the vineyards (for the
vine-blossom has an exquisite perfume) blows
through ; while the convolvulus on his mystic
rod represents all wreathing flowery things what-
ever, with or without fruit, as in America all
such plants are still called *vines*. "Sweet upon
the mountains," the excitement of which he loves
so deeply and to which he constantly invites his
followers—"sweet upon the mountains," and
profoundly amorous, his presence embodies all
the voluptuous abundance of Asia, its beating

sun, its " fair-towered cities, full of inhabitants,"
which the chorus describe in their luscious
vocabulary, with the rich Eastern names—Lydia,
Persia, Arabia Felix : he is a sorcerer or an en-
chanter, the tyrant Pentheus thinks : the springs
of water, the flowing of honey and milk and
wine, are his miracles, wrought in person.

We shall see presently how, writing for that
northern audience, Euripides crosses the Theban
with the gloomier Thracian legend, and lets the
darker stain show through. Yet, from the first,
amid all this floweriness, a touch or trace of that
gloom is discernible. The fawn-skin, composed
now so daintily over the shoulders, may be worn
with the whole coat of the animal made up, the
hoofs gilded and tied together over the right
shoulder, to leave the right arm disengaged to
strike, its head clothing the human head within,
as Alexander, on some of his coins, looks out
from the elephant's scalp, and Hercules out of
the jaws of a lion, on the coins of Camarina.
Those diminutive golden horns attached to the
forehead, represent not fecundity merely, nor
merely the crisp tossing of the waves of streams,
but horns of offence. And our fingers must be-
ware of the *thyrsus*, tossed about so wantonly by
himself and his chorus. The pine-cone at its top
does but cover a spear-point ; and the thing is a
weapon—the sharp spear of the hunter Zagreus
—though hidden now by the fresh leaves, and
that button of pine-cone (useful also to dip in

63

wine, to check the sweetness) which he has plucked down, coming through the forest, at peace for a while this spring morning.

And the chorus emphasise this character, their songs weaving for the whole piece, in words more effective than any painted scenery, a certain congruous background which heightens all ; the intimate sense of mountains and mountain things being in this way maintained throughout, and concentrated on the central figure. "He is sweet among the mountains," they say, "when he drops down upon the plain, out of his mystic musings"—and we may think we see the green festoons of the vine dropping quickly, from foot-place to foot-place, down the broken hill-side in spring, when like the Bacchanals, all who can, wander out of the town to enjoy the earliest heats. "Let us go out into the fields," we say ; a strange madness seems to lurk among the flowers, ready to lay hold on us also ; αὐτίκα γᾶ πᾶσα χορεύσει—soon the whole earth will dance and sing.

Dionysus is especially a woman's deity, and he comes from the east conducted by a chorus of gracious Lydian women, his true sisters— Bassarids, clad like himself in the long tunic, or *bassara*. They move and speak to the music of clangorous metallic instruments, cymbals and tambourines, relieved by the clearer notes of the pipe ; and there is a strange variety of almost imitative sounds for such music, in their very

words. The Homeric hymn to Demeter pre-
cedes the art of sculpture, but is rich in sugges-
tions for it ; here, on the contrary, in the first
chorus of the *Bacchanals*, as elsewhere in the
play, we feel that the poetry of Euripides is
probably borrowing something from art ; that
in these choruses, with their repetitions and
refrains, he is reproducing perhaps the spirit of
some sculptured relief which, like Luca della
Robbia's celebrated work for the organ-loft of
the cathedral of Florence, worked by various
subtleties of line, not in the lips and eyes only,
but in the drapery and hands also, to a strange
reality of impression of musical effect on visible
things.

They beat their drums before the palace ;
and then a humourous little scene, a reflex of
the old Dionysiac comedy — of that laughter
which was an essential element of the earliest
worship of Dionysus—follows the first chorus.
The old blind prophet Teiresias, and the aged
king Cadmus, always secretly true to him, have
agreed to celebrate the *Thiasus*, and accept his
divinity openly. The youthful god has no-
where said decisively that he will have none
but young men in his sacred dance. But for
that purpose they must put on the long tunic,
and that spotted skin which only rustics wear,
and assume the *thyrsus* and ivy-crown. Teiresias
arrives and is seen knocking at the doors. And
then, just as in the medieval mystery, comes the

inevitable grotesque, not unwelcome to our poet, who is wont in his plays, perhaps not altogether consciously, to intensify by its relief both the pity and the terror of his conceptions. At the summons of Teiresias, Cadmus appears, already arrayed like him in the appointed ornaments, in all their odd contrast with the infirmity and staidness of old age. Even in old men's veins the spring leaps again, and they are more than ready to begin dancing. But they are shy of the untried dress, and one of them is blind—ποῖ δεῖ χορεύειν; ποῖ καθιστάναι πόδα; καὶ κρᾶτα σεῖσαι πολιόν; and then the difficulty of the way! the long, steep journey to the glens! may pilgrims boil their peas? might they proceed to the place in carriages? At last, while the audience laugh more or less delicately at their aged fumblings, in some co-operative manner, the eyes of the one combining with the hands of the other, the pair are about to set forth.

Here Pentheus is seen approaching the palace in extreme haste. He has been absent from home, and returning, has just heard of the state of things at Thebes—the strange malady of the women, the dancings, the arrival of the mysterious stranger : he finds all the women departed from the town, and sees Cadmus and Teiresias in masque. Like the exaggerated diabolical figures in some of the religious plays and imageries of the Middle Age, he is an impersonation of stupid impiety, one of those whom the gods willing to

destroy first infatuate. Alternating between glib
unwisdom and coarse mockery, between violence
and a pretence of moral austerity, he understands
only the sorriest motives ; thinks the whole thing
feigned, and fancies the stranger, so effeminate, so
attractive of women with whom he remains day
and night, but a poor sensual creature, and the
real motive of the Bacchic women the indulg-
ence of their lust ; his ridiculous old grandfather
he is ready to renounce, and accuses Teiresias of
having in view only some fresh source of pro-
fessional profit to himself in connexion with some
new-fangled oracle ; his petty spite avenges itself
on the prophet by an order to root up the sacred
chair, where he sits to watch the birds for
divination, and disturb the order of his sacred
place ; and even from the moment of his en-
trance the mark of his doom seems already set
upon him, in an impotent trembling which
others notice in him. Those of the women
who still loitered, he has already caused to be
shut up in the common prison ; the others, with
Ino, Autonoe, and his own mother, Agave, he
will hunt out of the glens ; while the stranger
is threatened with various cruel forms of death.
But Teiresias and Cadmus stay to reason with
him, and induce him to abide wisely with them ;
the prophet fittingly becomes the interpreter of
Dionysus, and explains the true nature of the
visitor ; his divinity, the completion or counter-
part of that of Demeter ; his gift of prophecy ;

all the soothing influences he brings with him ; above all, his gift of the medicine of sleep to weary mortals. But the reason of Pentheus is already sickening, and the judicial madness gathering over it. Teiresias and Cadmus can but "go pray." So again, not without the laughter of the audience, supporting each other a little grotesquely against a fall, they get away at last.

And then, again, as in those quaintly carved and coloured imageries of the Middle Age—the martyrdom of the youthful Saint Firmin, for instance, round the choir at Amiens—comes the full contrast, with a quite medieval simplicity and directness, between the insolence of the tyrant, now at last in sight of his prey, and the outraged beauty of the youthful god, meek, surrounded by his enemies, like some fair wild creature in the snare of the hunter. Dionysus has been taken prisoner ; he is led on to the stage, with his hands bound, but still holding the *thyrsus*. Unresisting he had submitted himself to his captors ; his colour had not changed ; with a smile he had bidden them do their will, so that even they are touched with awe, and are almost ready to admit his divinity. Marvellously white and red, he stands there ; and now, unwilling to be revealed to the unworthy, and requiring a fitness in the receiver, he represents himself, in answer to the inquiries of Pentheus, not as Dionysus, but simply as the god's prophet,

in full trust in whom he desires to hear his
sentence. Then the long hair falls to the ground
under the shears ; the mystic wand is torn from
his hand, and he is led away to be tied up, like
some dangerous wild animal, in a dark place
near the king's stables.

Up to this point in the play, there has been
a noticeable ambiguity as to the person of
Dionysus, the main figure of the piece ; he is in
part Dionysus, indeed ; but in part, only his
messenger, or minister preparing his way ; a
certain harshness of effect in the actual appear-
ance of a god upon the stage being in this way
relieved, or made easy, as by a gradual revelation
in two steps. To Pentheus, in his invincible
ignorance, his essence remains to the last un-
revealed, and even the women of the chorus
seem to understand in him, so far, only the
forerunner of their real leader. As he goes away
bound, therefore, they too, threatened also in
their turn with slavery, invoke his greater
original to appear and deliver them. In pathetic
cries they reproach Thebes for rejecting them—
τί μ' ἀναίνει, τί με φεύγεις; yet they foretell his
future greatness ; a new Orpheus, he will more
than renew that old miraculous reign over
animals and plants. Their song is full of
suggestions of wood and river. It is as if, for a
moment, Dionysus became the suffering vine
again ; and the rustle of the leaves and water
come through their words to refresh it. The

fountain of Dirce still haunted by the virgins of
Thebes, where the infant god was cooled and
washed from the flecks of his fiery birth, becomes
typical of the coolness of all springs, and is made,
by a really poetic licence, the daughter of the
distant Achelous—the earliest born, the father in
myth, of all Greek rivers.

A giddy sonorous scene of portents and
surprises follows—a distant, exaggerated, dramatic
reflex of that old thundering tumult of the festival
in the vineyard—in which Dionysus reappears,
miraculously set free from his bonds. First, in
answer to the deep-toned invocation of the chorus,
a great voice is heard from within, proclaiming
him to be the son of Semele and Zeus. Then,
amid the short, broken, rapturous cries of the
women of the chorus, proclaiming him master,
the noise of an earthquake passes slowly; the
pillars of the palace are seen waving to and fro;
while the strange, memorial fire from the tomb
of Semele blazes up and envelopes the whole
building. The terrified women fling themselves
on the ground; and then, at last, as the place is
shaken open, Dionysus is seen stepping out from
among the tottering masses of the mimic palace,
bidding them arise and fear not. But just here
comes a long pause in the action of the play, in
which we must listen to a messenger newly
arrived from the glens, to tell us what he has
seen there, among the Mænads. The singular,
somewhat sinister beauty of this speech, and a

similar one subsequent—a fair description of morning on the mountain-tops, with the Bacchic women sleeping, which turns suddenly to a hard, coarse picture of animals cruelly rent—is one of the special curiosities which distinguish this play ; and, as it is wholly narrative, I shall give it in English prose, abbreviating, here and there, some details which seem to have but a metrical value :—

" I was driving my herd of cattle to the summit of the scaur to feed, what time the sun sent forth his earliest beams to warm the earth. And lo ! three companies of women, and at the head of one of them Autonoe, thy mother Agave at the head of the second, and Ino at the head of the third. And they all slept, with limbs relaxed, leaned against the low boughs of the pines, or with head thrown heedlessly among the oak-leaves strewn upon the ground—all in the sleep of temperance, not, as thou saidst, pursuing Cypris through the solitudes of the forest, drunken with wine, amid the low rustling of the lotus-pipe.

" And thy mother, when she heard the lowing of the kine, stood up in the midst of them, and cried to them to shake off sleep. And they, casting slumber from their eyes, started upright, a marvel of beauty and order, young and old and maidens yet unmarried. And first, they let fall their hair upon their shoulders ; and those

whose cinctures were unbound re-composed the spotted fawn-skins, knotting them about with snakes, which rose and licked them on the chin. Some, lately mothers, who with breasts still swelling had left their babes behind, nursed in their arms antelopes, or wild whelps of wolves, and yielded them their milk to drink ; and upon their heads they placed crowns of ivy or of oak, or of flowering convolvulus. Then one, taking a thyrsus-wand, struck with it upon a rock, and thereupon leapt out a fine rain of water ; another let down a reed upon the earth, and a fount of wine was sent forth there ; and those whose thirst was for a white stream, skimming the surface with their finger-tips, gathered from it abundance of milk ; and from the ivy of the mystic wands streams of honey distilled. Verily ! hadst thou seen these things, thou wouldst have worshipped whom now thou revilest.

"And we shepherds and herdsmen came together to question with each other over this matter—what strange and terrible things they do. And a certain wayfarer from the city, subtle in speech, spake to us—'O ! dwellers upon these solemn ledges of the hills, will ye that we hunt down, and take, amid her revelries, Agave, the mother of Pentheus, according to the king's pleasure ?' And he seemed to us to speak wisely ; and we lay in wait among the bushes ; and they, at the time appointed, began moving their wands for the Bacchic dance,

calling with one voice upon Bromius !—Iacchus !
—the son of Zeus ! and the whole mountain
was moved with ecstasy together, and the wild
creatures ; nothing but was moved in their
running. And it chanced that Agave, in her
leaping, lighted near me, and I sprang from my
hiding-place, willing to lay hold on her ; and
she groaned out, 'O ! dogs of hunting, these
fellows are upon our traces ; but follow me !
follow ! with the mystic wands for weapons in
your hands.' And we, by flight, hardly escaped
tearing to pieces at their hands, who thereupon
advanced with knifeless fingers upon the young
of the kine, as they nipped the green ; and then
hadst thou seen one holding a bleating calf in
her hands, with udder distent, straining it
asunder ; others tore the heifers to shreds
amongst them ; tossed up and down the morsels
lay in sight—flank or hoof—or hung from the
fir-trees, dropping churned blood. The fierce,
horned bulls stumbled forward, their breasts
upon the ground, dragged on by myriad hands
of young women, and in a moment the inner
parts were rent to morsels. So, like a flock of
birds aloft in flight, they retreat upon the level
lands outstretched below, which by the waters of
Asopus put forth the fair-flowering crop of
Theban people—Hysiæ and Erythræ—below the
precipice of Cithæron."—

A grotesque scene follows, in which the

humour we noted, on seeing those two old men diffidently set forth in chaplet and fawn-skin, deepens into a profound tragic irony. Pentheus is determined to go out in arms against the Bacchanals and put them to death, when a sudden desire seizes him to witness them in their encampment upon the mountains. Dionysus, whom he still supposes to be but a prophet or messenger of the god, engages to conduct him thither ; and, for greater security among the dangerous women, proposes that he shall disguise himself in female attire. As Pentheus goes within for that purpose, he lingers for a moment behind him, and in prophetic speech declares the approaching end ;—the victim has fallen into the net ; and he goes in to assist at the toilet, to array him in the ornaments which he will carry to Hades, destroyed by his own mother's hands. It is characteristic of Euripides —part of his fine tact and subtlety—to relieve and justify what seems tedious, or constrained, or merely terrible and grotesque, by a suddenly suggested trait of homely pathos, or a glimpse of natural beauty, or a morsel of form or colour seemingly taken directly from picture or sculpture. So here, in this fantastic scene our thoughts are changed in a moment by the singing of the chorus, and divert for a while to the dark-haired tresses of the wood ; the breath of the river-side is upon us ; beside it, a fawn escaped from the hunter's net is flying swiftly in

its joy ; like it, the Mænad rushes along ; and we see the little head thrown back upon the neck, in deep aspiration, to drink in the dew.

Meantime, Pentheus has assumed his disguise, and comes forth tricked up with false hair and the dress of a Bacchanal ; but still with some misgivings at the thought of going thus attired through the streets of Thebes, and with many laughable readjustments of the unwonted articles of clothing. And with the woman's dress, his madness is closing faster round him ; just before, in the palace, terrified at the noise of the earth-quake, he had drawn sword upon a mere fantastic appearance, and pierced only the empty air. Now he begins to see the sun double, and Thebes with all its towers repeated, while his conductor seems to him transformed into a wild beast ; and now and then, we come upon some touches of a curious psychology, so that we might almost seem to be reading a modern poet. As if Euripides had been aware of a not unknown symptom of incipient madness (it is said) in which the patient, losing the sense of resistance, while lifting small objects imagines himself to be raising enormous weights, Pentheus, as he lifts the *thyrsus*, fancies he could lift Cithæron with all the Bacchanals upon it. At all this the laughter of course will pass round the theatre ; while those who really pierce into the purpose of the poet, shudder, as they see the victim thus grotesquely clad going to his doom,

already foreseen in the ominous chant of the chorus—and as it were his grave-clothes, in the dress which makes him ridiculous.

Presently a messenger arrives to announce that Pentheus is dead, and then another curious narrative sets forth the manner of his death. Full of wild, coarse, revolting details, of course not without pathetic touches, and with the loveliness of the serving Mænads, and of their mountain solitudes—their trees and water—never quite forgotten, it describes how, venturing as a spy too near the sacred circle, Pentheus was fallen upon, like a wild beast, by the mystic huntresses and torn to pieces, his mother being the first to begin " the sacred rites of slaughter."

And at last Agave herself comes upon the stage, holding aloft the head of her son, fixed upon the sharp end of the *thyrsus*, calling upon the women of the chorus to welcome the revel of the Evian god ; who, accordingly, admit her into the company, professing themselves her fellow-revellers, the Bacchanals being thus absorbed into the chorus for the rest of the play. For, indeed, all through it, the true, though partly suppressed relation of the chorus to the Bacchanals is this, that the women of the chorus, staid and temperate for the moment, following Dionysus in his alternations, are but the paler sisters of his more wild and gloomy votaries— the true followers of the mystical Dionysus— the real chorus of Zagreus ; the idea that their

violent proceedings are the result of madness only, sent on them as a punishment for their original rejection of the god, being, as I said, when seen from the deeper motives of the myth, only a " sophism " of Euripides—a piece of rationalism of which he avails himself for the purpose of softening down the tradition of which he has undertaken to be the poet. Agave comes on the stage, then, blood-stained, exulting in her " victory of tears," still quite visibly mad indeed, and with the outward signs of madness, and as her mind wanders, musing still on the fancy that the dead head in her hands is that of a lion she has slain among the mountains—a young lion, she avers, as she notices the down on the young man's chin, and his abundant hair—a fancy in which the chorus humour her, willing to deal gently with the poor distraught creature. Supported by them, she rejoices " exceedingly, exceedingly," declaring herself " fortunate " in such goodly spoil ; priding herself that the victim has been slain, not with iron weapons, but with her own white fingers, she summons all Thebes to come and behold. She calls for her aged father to draw near and see ; and for Pentheus himself, at last, that he may mount and rivet her trophy, appropriately decorative there, between the triglyphs of the cornice below the roof, visible to all.

And now, from this point onwards, Dionysus himself becomes more and more clearly discern-

ible as the hunter, a wily hunter, and man the
prey he hunts for; "Our king is a hunter,"
cry the chorus, as they unite in Agave's triumph
and give their sanction to her deed. And as the
Bacchanals supplement the chorus, and must be
added to it to make the conception of it complete;
so in the conception of Dionysus also a certain
transference, or substitution, must be made—
much of the horror and sorrow of Agave, of
Pentheus, of the whole tragic situation, must be
transferred to him, if we wish to realise in the
older, profounder, and more complete sense of
his nature, that mystical being of Greek tradition
to whom all these experiences—his madness, the
chase, his imprisonment and death, his peace
again—really belong; and to discern which,
through Euripides' peculiar treatment of his
subject, is part of the curious interest of this
play.

Through the *sophism* of Euripides! For that,
again, is the really descriptive word, with which
Euripides, a lover of sophisms, as Aristophanes
knows, himself supplies us. Well;—this softened
version of the Bacchic madness is a sophism of
Euripides; and Dionysus *Omophagus*—the eater
of raw flesh, must be added to the golden image
of Dionysus *Meilichius*—the honey-sweet, if the
old tradition in its completeness is to be, in spite
of that sophism, our closing impression; if we
are to catch, in its fulness, that deep under-
current of horror which runs below, all through

this masque of spring, and realise the spectacle
of that wild chase, in which Dionysus is ulti-
mately both the hunter and the spoil.

But meantime another person appears on the
stage ; Cadmus enters, followed by attendants
bearing on a bier the torn limbs of Pentheus,
which lying wildly scattered through the tangled
wood, have been with difficulty collected and
now decently put together and covered over.
In the little that still remains before the end of
the play, destiny now hurrying things rapidly
forward, and strong emotions, hopes and fore-
bodings being now closely packed, Euripides has
before him an artistic problem of enormous
difficulty. Perhaps this very haste and close-
packing of the matter, which keeps the mind
from dwelling overmuch on detail, relieves its
real extravagance, and those who read it care-
fully will think that the pathos of Euripides has
been equal to the occasion. In a few profoundly
designed touches he depicts the perplexity of
Cadmus, in whose house a god had become an
inmate, only to destroy it—the regret of the old
man for the one male child to whom that house
had looked up as the pillar whereby aged people
might feel secure; the piteous craziness of Agave;
the unconscious irony with which she caresses
the florid, youthful head of her son ; the delicate
breaking of the thing to her reviving intelligence,
as Cadmus, though he can but wish that she
might live on for ever in her visionary enjoy-

ment, prepares the way, by playing on that other horrible legend of the Theban house, the tearing of Actæon to death—he too destroyed by a god. He gives us the sense of Agave's gradual return to reason through many glimmering doubts, till she wakes up at last to find the real face turned up towards the mother and murderess ; the quite naturally spontaneous sorrow of the mother, ending with her confession, down to her last sigh, and the final breaking up of the house of Cadmus ; with a result so genuine, heartfelt, and dignified withal in its expression of a strange ineffable woe, that a fragment of it, the lamentation of Agave over her son, in which the long-pent agony at last finds vent, were, it is supposed, adopted into his paler work by an early Christian poet, and have figured since, as touches of real fire, in the *Christus Patiens* of Gregory Nazianzen.

THE MYTH OF

DEMETER AND PERSEPHONE

I

No chapter in the history of human imagination
is more curious that the myth of Demeter, and
Kore or Persephone. Alien in some respects
from the genuine traditions of Greek mythology,
a relic of the *earlier* inhabitants of Greece, and
having but a subordinate place in the religion
of Homer, it yet asserted its interest, little by
little, and took a complex hold on the minds
of the Greeks, becoming finally the central and
most popular subject of their national worship.
Following its changes, we come across various
phases of Greek culture, which are not without
their likenesses in the modern mind. We trace
it in the dim first period of instinctive popular
conception ; we see it connecting itself with
many impressive elements of art, and poetry, and
religious custom, with the picturesque supersti-
tions of the many, and with the finer intuitions
of the few ; and besides this, it is in itself full of

interest and suggestion, to all for whom the ideas of the Greek religion have any real meaning in the modern world. And the fortune of the myth has not deserted it in later times. In the year 1780, the long-lost text of the Homeric Hymn to Demeter was discovered among the manuscripts of the imperial library at Moscow ; and, in our own generation, the tact of an eminent student of Greek art, Sir Charles Newton, has restored to the world the buried treasures of the little temple and precinct of Demeter, at Cnidus, which have many claims to rank in the central order of Greek sculpture. The present essay is an attempt to select and weave together, for those who are now approaching the deeper study of Greek thought, whatever details in the development of this myth, arranged with a view rather to a total impression than to the debate of particular points, may seem likely to increase their stock of poetical impressions, and to add to this some criticisms on the expression which it has left of itself in extant art and poetry.

The central expression, then, of the story of Demeter and Persephone is the Homeric hymn, to which Grote has assigned a date at least as early as six hundred years before Christ. The one survivor of a whole family of hymns on this subject, it was written, perhaps, for one of those contests which took place on the seventh day of the Eleusinian festival, and in which a bunch of

ears of corn was the prize; perhaps, for actual use in the mysteries themselves, by the *Hierophantes*, or Interpreter, who showed to the worshippers at Eleusis those sacred places to which the poem contains so many references. About the composition itself there are many difficult questions, with various surmises as to why it has remained only in this unique manuscript of the end of the fourteenth century. Portions of the text are missing, and there are probably some additions by later hands; yet most scholars have admitted that it possesses some of the true characteristics of the Homeric style, some genuine echoes of the age immediately succeeding that which produced the Iliad and the Odyssey. Listen now to a somewhat abbreviated version of it.

"I begin the song of Demeter"—says the prize-poet, or the Interpreter, the Sacristan of the holy places—"the song of Demeter and her daughter Persephone, whom Aidoneus carried away by the consent of Zeus, as she played, apart from her mother, with the deep-bosomed daughters of the Ocean, gathering flowers in a meadow of soft grass—roses and the crocus and fair violets and flags, and hyacinths, and, above all, the strange flower of the narcissus, which the Earth, favouring the desire of Aidoneus, brought forth for the first time, to snare the footsteps of the flower-like girl. A hundred

heads of blossom grew up from the roots of it, and the sky and the earth and the salt wave of the sea were glad at the scent thereof. She stretched forth her hands to take the flower; thereupon the earth opened, and the king of the great nation of the dead sprang out with his immortal horses. He seized the unwilling girl, and bore her away weeping, on his golden chariot. She uttered a shrill cry, calling upon her father Zeus; but neither man nor god heard her voice, nor even the nymphs of the meadow where she played; except Hecate only, the daughter of Persæus, sitting, as ever, in her cave, half veiled with a shining veil, thinking delicate thoughts; she, and the Sun also, heard her.

"So long as she could still see the earth, and the sky, and the sea with the great waves moving, and the beams of the sun, and still thought to see again her mother, and the race of the ever-living gods, so long hope soothed her, in the midst of her grief. The peaks of the hills and the depths of the sea echoed her cry. And the mother heard it. A sharp pain seized her at the heart; she plucked the veil from her hair, and cast down the blue hood from her shoulders, and fled forth like a bird, seeking Persephone over dry land and sea. But neither man nor god would tell her the truth; nor did any bird come to her as a sure messenger.

"Nine days she wandered up and down upon the earth, having blazing torches in her hands;

and, in her great sorrow, she refused to taste of ambrosia, or of the cup of the sweet nectar, nor washed her face. But when the tenth morning came, Hecate met her, having a light in her hands. But Hecate had heard the voice only, and had seen no one, and could not tell Demeter who had borne the girl away. And Demeter said not a word, but fled away swiftly with her, having the blazing torches in her hands, till they came to the Sun, the watchman both of gods and men ; and the goddess questioned him, and the Sun told her the whole story.

"Then a more terrible grief took possession of Demeter, and, in her anger against Zeus, she forsook the assembly of the gods and abode among men, for a long time veiling her beauty under a worn countenance, so that none who looked upon her knew her, until she came to the house of Celeus, who was then king of Eleusis. In her sorrow, she sat down at the wayside by the virgin's well, where the people of Eleusis come to draw water, under the shadow of an olive-tree. She seemed as an aged woman whose time of child-bearing is gone by, and from whom the gifts of Aphrodite have been withdrawn, like one of the hired servants, who nurse the children or keep house, in kings' palaces. And the daughters of Celeus, four of them, like goddesses, possessing the flower of their youth, Callidice, Cleisidice, Demo, and Callithoe the eldest of them, coming to draw water that they

might bear it in their brazen pitchers to their
father's house, saw Demeter and knew her not.
The gods are hard for men to recognise.

"They asked her kindly what she did there,
alone; and Demeter answered, dissemblingly,
that she was escaped from certain pirates, who
had carried her from her home and meant to
sell her as a slave. Then they prayed her to
abide there while they returned to the palace,
to ask their mother's permission to bring her
home.

"Demeter bowed her head in assent; and
they, having filled their shining vessels with
water, bore them away, rejoicing in their beauty.
They came quickly to their father's house, and
told their mother what they had seen and heard.
Their mother bade them return, and hire the
woman for a great price; and they, like the
hinds or young heifers leaping in the fields in
spring, fulfilled with the pasture, holding up the
folds of their raiment, sped along the hollow
road-way, their hair, in colour like the crocus,
floating about their shoulders as they went.
They found the glorious goddess still sitting by
the wayside, unmoved. Then they led her to
their father's house; and she, veiled from head
to foot, in her deep grief, followed them on the
way, and her blue robe gathered itself as she
walked, in many folds about her feet. They
came to the house, and passed through the
sunny porch, where their mother, Metaneira, was

sitting against one of the pillars of the roof,
having a young child in her bosom. They ran
up to her; but Demeter crossed the threshold,
and, as she passed through, her head rose and
touched the roof, and her presence filled the
doorway with a divine brightness.

"Still they did not wholly recognise her.
After a time she was made to smile. She refused
to drink wine, but tasted of a cup mingled of
water and barley, flavoured with mint. It
happened that Metaneira had lately borne a
child. It had come beyond hope, long after its
elder brethren, and was the object of a pecu-
liar tenderness and of many prayers with all.
Demeter consented to remain, and become the
nurse of this child. She took the child in her
immortal hands, and placed it in her fragrant
bosom; and the heart of the mother rejoiced.
Thus Demeter nursed Demophoon. And the
child grew like a god, neither sucking the breast,
nor eating bread; but Demeter daily anointed
it with ambrosia, as if it had indeed been the
child of a god, breathing sweetly over it and
holding it in her bosom; and at nights, when
she lay alone with the child, she would hide it
secretly in the red strength of the fire, like a
brand; for her heart yearned towards it, and she
would fain have given to it immortal youth.

"But the foolishness of his mother prevented
it. For a suspicion growing up within her, she
awaited her time, and one night peeped in upon

them, and thereupon cried out in terror at what she saw. And the goddess heard her; and a sudden anger seizing her, she plucked the child from the fire and cast it on the ground,—the child she would fain have made immortal, but who must now share the common destiny of all men, though some inscrutable grace should still be his, because he had lain for awhile on the knees and in the bosom of the goddess.

"Then Demeter manifested herself openly. She put away the mask of old age, and changed her form, and the spirit of beauty breathed about her. A fragrant odour fell from her raiment, and her flesh shone from afar; the long yellow hair descended waving over her shoulders, and the great house was filled as with the brightness of lightning. She passed out through the halls; and Metaneira fell to the earth, and was speechless for a long time, and remembered not to lift the child from the ground. But the sisters, hearing its piteous cries, leapt from their beds and ran to it. Then one of them lifted the child from the earth, and wrapped it in her bosom, and another hastened to her mother's chamber to awake her : they came round the child, and washed away the flecks of the fire from its panting body, and kissed it tenderly all about : but the anguish of the child ceased not; the arms of other and different nurses were about to enfold it.

"So, all night, trembling with fear, they

sought to propitiate the glorious goddess ; and in the morning they told all to their father, Celeus. And he, according to the commands of the goddess, built a fair temple ; and all the people assisted ; and when it was finished every man departed to his own home. Then Demeter returned, and sat down within the temple-walls, and remained still apart from the company of the gods, alone in her wasting regret for her daughter Persephone.

" And, in her anger, she sent upon the earth a year of grievous famine. The dry seed remained hidden in the soil ; in vain the oxen drew the ploughshare through the furrows ; much white seed-corn fell fruitless on the earth, and the whole human race had like to have perished, and the gods had no more service of men, unless Zeus had interfered. First he sent Iris, afterwards all the gods, one by one, to turn Demeter from her anger ; but none was able to persuade her ; she heard their words with a hard countenance, and vowed by no means to return to Olympus, nor to yield the fruit of the earth, until her eyes had seen her lost daughter again. Then, last of all, Zeus sent Hermes into the kingdom of the dead, to persuade Aidoneus to suffer his bride to return to the light of day. And Hermes found the king at home in his palace, sitting on a couch, beside the shrinking Persephone, consumed within herself by desire for her mother. A doubtful smile passed over

the face of Aidoneus ; yet he obeyed the message, and bade Persephone return ; yet praying her a little to have gentle thoughts of him, nor judge him too hardly, who was also an immortal god. And Persephone arose up quickly in great joy ; only, ere she departed, he caused her to eat a morsel of sweet pomegranate, designing secretly thereby, that she should not remain always upon earth, but might some time return to him. And Aidoneus yoked the horses to his chariot ; and Persephone ascended into it ; and Hermes took the reins in his hands and drove out through the infernal halls ; and the horses ran willingly ; and they two quickly passed over the ways of that long journey, neither the waters of the sea, nor of the rivers, nor the deep ravines of the hills, nor the cliffs of the shore, resisting them ; till at last Hermes placed Persephone before the door of the temple where her mother was ; who, seeing her, ran out quickly to meet her, like a Mænad coming down a mountain-side, dusky with woods.

" So they spent all that day together in intimate communion, having many things to hear and tell. Then Zeus sent to them Rhea, his venerable mother, the oldest of divine persons, to bring them back reconciled, to the company of the gods ; and he ordained that Persephone should remain two parts of the year with her mother, and one third part only with her husband, in the kingdom of the dead. So Demeter suffered

the earth to yield its fruits once more, and the land was suddenly laden with leaves and flowers and waving corn. Also she visited Triptolemus and the other princes of Eleusis, and instructed them in the performance of her sacred rites,— those mysteries of which no tongue may speak. Only, blessed is he whose eyes have seen them ; his lot after death is not as the lot of other men ! "

In the story of Demeter, as in all Greek myths, we may trace the action of three different influences, which have moulded it with varying effects, in three successive phases of its development. There is first its half-conscious, instinctive, or mystical, phase, in which, under the form of an unwritten legend, living from mouth to mouth, and with details changing as it passes from place to place, there lie certain primitive impressions of the phenomena of the natural world. We may trace it next in its conscious, poetical or literary, phase, in which the poets become the depositaries of the vague instinctive product of the popular imagination, and handle it with a purely literary interest, fixing its outlines, and simplifying or developing its situations. Thirdly, the myth passes into the ethical phase, in which the persons and the incidents of the poetical narrative are realised as abstract symbols, because intensely characteristic examples, of moral or spiritual conditions.

Behind the adventures of the stealing of Persephone and the wanderings of Demeter in search of her, as we find them in the Homeric hymn, we may discern the confused conception, under which that early age, in which the myths were first created, represented to itself those changes in physical things, that order of summer and winter, of which it had no scientific, or systematic explanation, but in which, nevertheless, it divined a multitude of living agencies, corresponding to those ascertained forces, of which our colder modern science tells the number and the names. Demeter—Demeter and Persephone, at first, in a sort of confused union—is the earth, in the fixed order of its annual changes, but also in all the accident and detail of the growth and decay of its children. Of this conception, floating loosely in the air, the poets of a later age take possession; they create Demeter and Persephone as we know them in art and poetry. From the vague and fluctuating union, in which together they had represented the earth and its changes, the mother and the daughter define themselves with special functions, and with fixed, well-understood relationships, the incidents and emotions of which soon weave themselves into a pathetic story. Lastly, in proportion as the literary or æsthetic activity completes the picture or the poem, the ethical interest makes itself felt. These strange persons —Demeter and Persephone—these marvellous incidents—the translation into Hades, the seeking

of Demeter, the return of Persephone to her,—lend themselves to the elevation and correction of the sentiments of sorrow and awe, by the presentment to the senses and the imagination of an ideal expression of them. Demeter cannot but seem the type of divine grief. Persephone is the goddess of death, yet with a promise of life to come. Those three phases, then, which are more or less discernible in all mythical development, and constitute a natural order in it, based on the necessary conditions of human apprehension, are fixed more plainly, perhaps, than in any other passage of Greek mythology in the story of Demeter. And as the Homeric hymn is the central expression of its literary or poetical phase, so the marble remains, of which I shall have to speak by and bye, are the central extant illustration of what I have called its ethical phase.

Homer, in the Iliad, knows Demeter, but only as the goddess of the fields, the originator and patroness of the labours of the countryman, in their yearly order. She stands, with her hair yellow like the ripe corn, at the threshing-floor, and takes her share in the toil, the heap of grain whitening, as the flails, moving in the wind, disperse the chaff. Out in the fresh fields, she yields to the embraces of Iasion, to the extreme jealousy of Zeus, who slays her mortal lover with lightning. The flowery town of Pyrasus—the *wheat-town*,—an ancient place in Thessaly, is her sacred precinct. But when

Homer gives a list of the orthodox gods, her
name is not mentioned.

Homer, in the Odyssey, knows Persephone
also, but not as Kore ; only as the queen of the
dead—ἐπαινὴ Περσεφόνη—dreadful Persephone, the
goddess of destruction and death, according to
the apparent import of her name. She accom-
plishes men's evil prayers ; she is the mistress
and manager of men's shades, to which she can
dispense a little more or less of life, dwelling in
her mouldering palace on the steep shore of the
Oceanus, with its groves of barren willows and
tall poplars. But that Homer knew her as the
daughter of Demeter there are no signs ; and of
his knowledge of the rape of Persephone there
is only the faintest sign,—he names Hades by
the golden reins of his chariot, and his beautiful
horses.

The main theme, then, the most characteristic
peculiarities, of the story, as subsequently de-
veloped, are not to be found, expressly, in the
true Homer. We have in him, on the one hand,
Demeter, as the perfectly fresh and blithe goddess
of the fields, whose children, if she has them,
must be as the perfectly discreet and peaceful,
unravished Kore ; on the other hand, we have
Persephone, as the wholly terrible goddess of
death, who brings to Ulysses the querulous
shadows of the dead, and has the head of the
gorgon Medusa in her keeping. And it is only
when these two contrasted images have been

brought into intimate relationship, only when Kore and Persephone have been identified, that the deeper mythology of Demeter begins.

This combination has taken place in Hesiod ; and in three lines of the *Theogony* we find the stealing of Persephone by Aidoneus,[1]—one of those things in Hesiod, perhaps, which are really older than Homer. Hesiod has been called the poet of helots, and is thought to have preserved some of the traditions of those earlier inhabitants of Greece who had become a kind of serfs ; and in a certain shadowiness in his conceptions of the gods, contrasting with the concrete and heroic forms of the gods of Homer, we may perhaps trace something of the quiet unspoken brooding of a subdued people—of that silently dreaming temper to which the story of Persephone properly belongs. However this may be, it is in Hesiod that the two images, unassociated in Homer— the goddess of summer and the goddess of death, Kore and Persephone—are identified with much significance ; and that strange, dual being makes her first appearance, whose latent capabilities the poets afterwards developed ; among the rest, a peculiar blending of those two contrasted aspects, full of purpose for the duly chastened intelligence ; death, resurrection, rejuvenescence.—*Awake, and sing, ye that dwell in the dust !*

[1] *Theogony*, 912-914 :

Αὐτὰρ ὁ Δήμητρος πολυφόρβης ἐς λέχος ἦλθεν,
ἣ τέκε Περσεφόνην λευκώλενον, ἣν Ἀϊδωνεὺς
ἥρπασεν ἧς παρὰ μητρός· ἔδωκε δὲ μητίετα Ζεύς.

GREEK STUDIES

Modern science explains the changes of the
natural world by the hypothesis of certain un-
conscious forces ; and the sum of these forces,
in their combined action, constitutes the scientific
conception of nature. But, side by side with
the growth of this more mechanical conception,
an older and more spiritual, Platonic, philosophy
has always maintained itself, a philosophy more
of instinct than of the understanding, the mental
starting-point of which is not an observed
sequence of outward phenomena, but some
such feeling as most of us have on the first
warmer days in spring, when we seem to feel
the genial processes of nature actually at work ;
as if just below the mould, and in the hard wood
of the trees, there were really circulating some
spirit of life, akin to that which makes its
energies felt within ourselves. Starting with a
hundred instincts such as this, that older un-
mechanical, spiritual, or Platonic, philosophy
envisages nature rather as the unity of a living
spirit or person, revealing itself in various degrees
to the kindred spirit of the observer, than as a
system of mechanical forces. Such a philosophy
is a systematised form of that sort of poetry (we
may study it, for instance, either in Shelley or
in Wordsworth), which also has its fancies of a
spirit of the earth, or of the sky,—a personal
intelligence abiding in them, the existence of
which is assumed in every suggestion such poetry
makes to us of a sympathy between the ways

and aspects of outward nature and the moods of
men. And what stood to the primitive intel-
ligence in place of such metaphysical conceptions
were those cosmical stories or myths, such as
this of Demeter and Persephone, which spring-
ing up spontaneously in many minds, came at
last to represent to them, in a certain number of
sensibly realised images, all they knew, felt, or
fancied, of the natural world about them. The
sky in its unity and its variety,—the sea in its
unity and its variety, — mirrored themselves
respectively in these simple, but profoundly im-
pressible spirits, as Zeus, as Glaucus or Poseidon.
And a large part of their experience—all, that
is, that related to the earth in its changes, the
growth and decay of all things born of it—was
covered by the story of Demeter, the myth of
the earth as a mother. They thought of
Demeter as the old Germans thought of Hertha,
or the later Greeks of Pan, as the Egyptians
thought of Isis, the land of the Nile, made green
by the streams of Osiris, for whose coming Isis
longs, as Demeter for Persephone ; thus naming
together in her all their fluctuating thoughts,
impressions, suspicions, of the earth and its
appearances, their whole complex divination of
a mysterious life, a perpetual working, a con-
tinous act of conception there. Or they thought
of the many-coloured earth as the garment of
Demeter, as the great modern pantheist poet
speaks of it as the " garment of God." Its

brooding fertility ; the spring flowers breaking
from its surface, the thinly disguised unhealth-
fulness of their heavy perfume, and of their
chosen places of growth ; the delicate, feminine,
Prosperina-like motion of all growing things ;
its fruit, full of drowsy and poisonous, or fresh,
reviving juices ; its sinister caprices also, its
droughts and sudden volcanic heats ; the long
delays of spring ; its dumb sleep, so suddenly
flung away ; the sadness which insinuates itself
into its languid luxuriance ; all this grouped
itself round the persons of Demeter and her
circle. They could turn always to her, from
the actual earth itself, in aweful yet hopeful
prayer, and a devout personal gratitude, and
explain it through her, in its sorrow and its
promise, its darkness and its helpfulness to man.

The personification of abstract ideas by
modern painters or sculptors, of wealth, of
commerce, of health, for instance, shocks, in
most cases, the æsthetic sense, as something con-
ventional or rhetorical, as a mere transparent
allegory, or figure of speech, which could please
almost no one. On the other hand, such sym-
bolical representations, under the form of human
persons, as Giotto's *Virtues* and *Vices* at Padua,
or his *Saint Poverty* at Assisi, or the series of the
planets in certain early Italian engravings, are
profoundly poetical and impressive. They seem
to be something more than mere symbolism,

and to be connected with some peculiarly sympathetic penetration, on the part of the artist, into the subjects he intended to depict. Symbolism intense as this, is the creation of a special temper, in which a certain simplicity, taking all things literally, *au pied de la lettre*, is united to a vivid pre-occupation with the æsthetic beauty of the image itself, the *figured* side of figurative expression, the *form* of the metaphor. When it is said, "Out of his mouth goeth a sharp sword," that temper is ready to deal directly and boldly with that difficult image, like that old designer of the fourteenth century, who has depicted this, and other images of the Apocalypse, in a coloured window at Bourges. Such symbolism cares a great deal for the hair of *Temperance*, discreetly bound, for some subtler likeness to the colour of the sky in the girdle of *Hope*, for the inwoven flames in the red garment of *Charity*. And what was specially peculiar to the temper of the old Florentine painter, Giotto, to the temper of his age in general, doubtless, more than to that of ours, was the persistent and universal mood of the age in which the story of Demeter and Persephone was first created. If some painter of our own time has conceived the image of *The Day* so intensely, that we hardly think of distinguishing between the image, with its girdle of dissolving morning mist, and the meaning of the image ; if William Blake, to our so great delight, makes the morning stars

literally "sing together"—these fruits of individual genius are in part also a "survival" from
a different age, with the whole mood of which
this mode of expression was more congruous
than it is with ours. But there are traces of the
old temper in the man of to-day also ; and
through these we can understand that earlier
time—a very poetical time, with the more highly
gifted peoples—in which every impression men
received of the action of powers without or
within them suggested to them the presence of
a soul or will, like their own—a person, with
a living spirit, and senses, and hands, and feet ;
which, when it talked of the return of Kore to
Demeter, or the marriage of Zeus and Here, was
not using rhetorical language, but yielding to a
real illusion ; to which the voice of man "was
really a stream, beauty an effluence, death a mist."

The gods of Greek mythology overlap each
other ; they are confused or connected with each
other, lightly or deeply, as the case may be, and
sometimes have their doubles, at first sight as in
a troubled dream, yet never, when we examine
each detail more closely, without a certain truth
to human reason. It is only in a limited sense
that it is possible to lift, and examine by itself,
one thread of the network of story and imagery,
which, in a certain age of civilisation, wove itself
over every detail of life and thought, over every
name in the past, and almost every place in

DEMETER AND PERSEPHONE

Greece. The story of Demeter, then, was the work of no single author or place or time ; the poet of its first phase was no single person, but the whole consciousness of an age, though an age doubtless with its differences of more or less imaginative individual minds—with one, here or there, eminent, though but by a little, above a merely receptive majority, the spokesman of a universal, though faintly-felt prepossession, attaching the errant fancies of the people around him to definite names and images. The myth grew up gradually, and at many distant places, in many minds, independent of each other, but dealing in a common temper with certain elements and aspects of the natural world, as one here, and another there, seemed to catch in that incident or detail which flashed more incisively than others on the inward eye, some influence, or feature, or characteristic of the great mother. The various epithets of Demeter, the local variations of her story, its incompatible incidents, bear witness to the manner of its generation. They illustrate that indefiniteness which is characteristic of Greek mythology, a theology with no central authority, no link on historic time, liable from the first to an unobserved transformation. They indicate the various, far-distant spots from which the visible body of the goddess slowly collected its constituents, and came at last to have a well-defined existence in the popular mind. In this sense, Demeter appears to one in

her anger, sullenly withholding the fruits of the earth, to another in her pride of Persephone, to another in her grateful gift of the arts of agriculture to man ; at last only, is there a general recognition of a clearly-arrested outline, a tangible embodiment, which has solidified itself in the imagination of the people, they know not how.

The worship of Demeter belongs to that older religion, nearer to the earth, which some have thought they could discern, behind the more definitely national mythology of Homer. She is the goddess of dark caves, and is not wholly free from monstrous form. She gave men the first fig in one place, the first poppy in another ; in another, she first taught the old Titans to mow. She is the mother of the vine also ; and the assumed name by which she called herself in her wanderings, is Dôs—a gift ; the crane, as the harbinger of rain, is her messenger among the birds. She knows the magic powers of certain plants, cut from her bosom, to bane or bless ; and, under one of her epithets, herself presides over the springs, as also coming from the secret places of the earth. She is the goddess, then, at first, of the fertility of the earth in its wildness ; and so far, her attributes are to some degree confused with those of the Thessalian Gaia and the Phrygian Cybele. Afterwards, and it is now that her most characteristic attributes begin to concentrate themselves,

she separates herself from these confused rela-
tionships, as specially the goddess of agriculture,
of the fertility of the earth when furthered by
human skill. She is the preserver of the seed
sown in hope, under many epithets derived from
the incidents of vegetation, as the simple country-
man names her, out of a mind full of the various
experiences of his little garden or farm. She
is the most definite embodiment of all those
fluctuating mystical instincts, of which Gaia,[1]
the mother of the earth's gloomier offspring, is
a vaguer and mistier one. There is nothing of
the confused outline, the mere shadowiness of
mystical dreaming, in this most concrete human
figure. No nation, less æsthetically gifted than
the Greeks, could have thus lightly thrown its
mystical surmise and divination into images so
clear and idyllic as those of the solemn goddess
of the country, in whom the characteristics of
the mother are expressed with so much tender-
ness, and the "beauteous head" of Kore, then
so fresh and peaceful.

In this phase, then, the story of Demeter
appears as the peculiar creation of country-people
of a high impressibility, dreaming over their
work in spring or autumn, half consciously
touched by a sense of its sacredness, and a sort of

[1] In the Homeric hymn, pre-eminently, of the flower which
grew up for the first time, to snare the footsteps of Kore, the
fair but deadly Narcissus, the flower of νάρκη, the numbness of
death.

mystery about it. For there is much in the life
of the farm everywhere which gives to persons
of any seriousness of disposition, special oppor-
tunity for grave and gentle thoughts. The
temper of people engaged in the occupations of
country life, so permanent, so "near to nature,"
is at all times alike ; and the habitual solemnity
of thought and expression which Wordsworth
found in the peasants of Cumberland, and the
painter François Millet in the peasants of Brittany,
may well have had its prototype in early Greece.
And so, even before the development, by the
poets, of their aweful and passionate story,
Demeter and Persephone seem to have been
pre-eminently the *venerable*, or *aweful*, goddesses.
Demeter haunts the fields in spring, when the
young lambs are dropped ; she visits the barns
in autumn ; she takes part in mowing and bind-
ing up the corn, and is the goddess of sheaves.
She presides over all the pleasant, significant
details of the farm, the threshing-floor and the
full granary, and stands beside the woman baking
bread at the oven. With these fancies are
connected certain simple rites ; the half-under-
stood local observance, and the half-believed
local legend, reacting capriciously on each other.
They leave her a fragment of bread and a morsel
of meat, at the cross-roads, to take on her journey ;
and perhaps some real Demeter carries them
away, as she wanders through the country.
The incidents of their yearly labour become to

them acts of worship; they seek her blessing
through many expressive names, and almost
catch sight of her, at dawn or evening, in the
nooks of the fragrant fields. She lays a finger
on the grass at the road-side, and some new
flower comes up. All the picturesque imple-
ments of country life are hers; the poppy also,
emblem of an inexhaustible fertility, and full
of mysterious juices for the alleviation of pain.
The countrywoman who puts her child to sleep
in the great, cradle-like, basket, for winnowing
the corn, remembers Demeter *Courotrophos*, the
mother of corn and children alike, and makes it
a little coat out of the dress worn by its father
at his initiation into her mysteries. Yet she is
an angry goddess too, sometimes — Demeter
Erinnys, the goblin of the neighbourhood, haunt-
ing its shadowy places. She lies on the ground
out of doors on summer nights, and becomes wet
with the dew. She grows young again every
spring, yet is of great age, the wrinkled woman
of the Homeric hymn, who becomes the nurse
of Demophoon. Other lighter, errant stories
nest themselves, as time goes on, within the
greater. The water-newt, which repels the lips
of the traveller who stoops to drink, is a certain
urchin, Abas, who spoiled by his mockery the
pleasure of the thirsting goddess, as she drank
once of a wayside spring in her wanderings.
The night-owl is the transformed Ascalabus,
who alone had seen Persephone eat that morsel

of pomegranate, in the garden of Aidoneus. The
bitter wild mint was once a girl, who for a
moment had made her jealous, in Hades.

The episode of Triptolemus, to whom
Demeter imparts the mysteries of the plough,
like the details of some sacred rite, that he may
bear them abroad to all people, embodies, in
connexion with her, another group of the circum-
stances of country life. As with all the other
episodes of the story, there are here also local
variations, traditions of various favourites of the
goddess at different places, of whom grammarians
can tell us, finally obscured behind the greater
fame of Triptolemus of Eleusis. One might
fancy, at first, that Triptolemus was a quite
Bœotian divinity, of the ploughshare. Yet we
know that the thoughts of the Greeks concern-
ing the culture of the earth from which they
came, were most often noble ones; and if we
examine carefully the works of ancient art which
represent him, the second thought will suggest
itself, that there was nothing clumsy or coarse
about this patron of the plough—something,
rather, of the movement of delicate wind or fire,
about him and his chariot. And this finer
character is explained, if, as we are justified in
doing, we bring him into closest connexion with
that episode, so full of a strange mysticism, of
the *Nursing of Demophoon*, in the Homeric hymn.
For, according to some traditions, none other

than Triptolemus himself was the subject of that mysterious experiment, in which Demeter laid the child nightly, in the red heat of the fire ; and he lives afterwards, not immortal indeed, not wholly divine, yet, as Shakspere says, a "nimble spirit," feeling little of the weight of the material world about him—the element of winged fire in the clay. The delicate, fresh, farm-lad we may still actually see sometimes, like a graceful field-flower among the corn, becomes, in the sacred legend of agriculture, a king's son ; and then, the fire having searched out from him the grosser elements on that famous night, all compact now of spirit, a priest also, administering the gifts of Demeter to all the earth. Certainly, the extant works of art which represent him, gems or vase-paintings, conform truly enough to this ideal of a "nimble spirit," though he wears the broad country hat, which Hermes also wears, going swiftly, half on the airy, mercurial wheels of his farm instrument, harrow or plough—half on wings of serpents—the worm, symbolical of the soil, but winged, as sending up the dust committed to it, after subtle firing, in colours and odours of fruit and flowers. It is an altogether sacred character, again, that he assumes in another precious work, of the severer period of Greek art, lately discovered at Eleusis, and now preserved in the museum of Athens, a singularly refined bas-relief, in which he stands, a firm and serious youth, between Demeter and

Persephone, who places her hand as with some sacred influence, and consecrating gesture, upon him.

But the house of the prudent countryman will be, of course, a place of honest manners; and Demeter *Thesmophoros* is the guardian of married life, the deity of the discretion of wives. She is therefore the founder of civilised order. The peaceful homes of men, scattered about the land, in their security—Demeter represents these fruits of the earth also, not without a suggestion of the white cities, which shine upon the hills above the waving fields of corn, seats of justice and of true kingship. She is also in a certain sense the patron of travellers, having, in her long wanderings after Persephone, recorded and handed down those omens, caught from little things—the birds which crossed her path, the persons who met her on the way, the words they said, the things they carried in their hands, εἰνόδια σύμβολα—by noting which, men bring their journeys to a successful end; so that the simple countryman may pass securely on his way; and is led by signs from the goddess herself, when he travels far to visit her, at Hermione or Eleusis.

So far the attributes of Demeter and Kore are similar. In the mythical conception, as in the religious acts connected with it, the mother and the daughter are almost interchangeable;

they are the *two* goddesses, the twin-named.
Gradually, the office of Persephone is developed,
defines itself; functions distinct from those of
Demeter are attributed to her. Hitherto, always
at the side of Demeter and sharing her worship,
she now appears detached from her, going and
coming, on her mysterious business. A third
part of the year she abides in darkness; she
comes up in the spring; and every autumn,
when the countryman sows his seed in the
earth, she descends thither again, and the world
of the dead lies open, spring and autumn, to
let her in and out. Persephone, then, is the
summer-time, and, in this sense, a daughter of
the earth; but the summer as bringing winter;
the flowery splendour and consummated glory of
the year, as thereafter immediately beginning to
draw near to its end, as the first yellow leaf
crosses it, in the first severer wind. She is the
last day of spring, or the first day of autumn, in
the threefold division of the Greek year. Her
story is, indeed, but the story, in an intenser
form, of Adonis, of Hyacinth, of Adrastus—the
king's blooming son, fated, in the story of
Herodotus, to be wounded to death with an
iron spear—of Linus, a fair child who is torn
to pieces by hounds every spring-time—of the
English Sleeping Beauty. From being the
goddess of summer and the flowers, she becomes
the goddess of night and sleep and death, con-
fuseable with Hecate, the goddess of midnight

terrors,—Κόρη ἄρρητος, the mother of the Erinnyes, who appeared to Pindar, to warn him of his approaching death, upbraiding him because he had made no hymn in her praise, which swan's song he thereupon began, but finished with her. She is a twofold goddess, therefore, according as one or the other of these two contrasted aspects of her nature is seized, respectively. A duality, an inherent opposition in the very conception of Persephone, runs all through her story, and is part of her ghostly power. There is ever something in her of a divided or ambiguous identity : hence the many euphemisms of later language concerning her.

The "worship of sorrow," as Goethe called it, is sometimes supposed to have had almost no place in the religion of the Greeks. Their religion has been represented as a religion of mere cheerfulness, the worship by an untroubled, unreflecting humanity, conscious of no deeper needs, of the embodiments of its own joyous activity. It helped to hide out of their sight those traces of decay and weariness, of which the Greeks were constitutionally shy, to keep them from peeping too curiously into certain shadowy places, appropriate enough to the gloomy imagination of the middle age ; and it hardly proposed to itself to give consolation to people who, in truth, were never " sick or sorry." But this familiar view of Greek religion is based on a consideration of a part only of what is known

concerning it, and really involves a misconception, akin to that which underestimates the influence of the romantic spirit generally, in Greek poetry and art ; as if Greek art had dealt exclusively with human nature in its sanity, suppressing all motives of strangeness, all the beauty which is born of difficulty, permitting nothing but an Olympian, though perhaps somewhat wearisome calm. In effect, such a conception of Greek art and poetry leaves in the central expressions of Greek culture none but negative qualities ; and the legend of Demeter and Persephone, perhaps the most popular of all Greek legends, is sufficient to show that the " worship of sorrow " was not without its function in Greek religion ; their legend is a legend made by and for sorrowful, wistful, anxious people ; while the most important artistic monuments of that legend sufficiently prove that the Romantic spirit was really at work in the minds of Greek artists, extracting by a kind of subtle alchemy, a beauty, not without the elements of tranquillity, of dignity and order, out of a matter, at first sight painful and strange.

The student of *origins*, as French critics say, of the earliest stages of art and poetry, must be content to follow faint traces ; and in what has been here said, much may seem to have been made of little, with too much completion, by a general framework or setting, of what after

all are but doubtful or fragmentary indications. Yet there is a certain cynicism too, in that over-positive temper, which is so jealous of our catching any resemblance in the earlier world to the thoughts that really occupy our own minds, and which, in its estimate of the actual fragments of antiquity, is content to find no seal of human intelligence upon them. Slight indeed in themselves, these fragmentary indications become suggestive of much, when viewed in the light of such general evidence about the human imagination as is afforded by the theory of "comparative mythology," or what is called the theory of "animism." Only, in the application of these theories, the student of Greek religion must never forget that, after all, it is with poetry, not with systematic theological belief or dogma, that he has to do. As regards this story of Demeter and Persephone, what we actually possess is some actual fragments of poetry, some actual fragments of sculpture; and with a curiosity, justified by the direct æsthetic beauty of these fragments, we feel our way backwards to that engaging picture of the poet-people, with which the ingenuity of modern theory has filled the void in our knowledge. The abstract poet of that first period of mythology, creating in this wholly impersonal, intensely spiritual way,—the abstract spirit of poetry itself, rises before the mind; and, in speaking of this poetical age, we must take heed, before all things, in no sense to misconstrue the poets.

II

THE stories of the Greek mythology, like other things which belong to no man, and for which no one in particular is responsible, had their fortunes. In that world of floating fancies there was a struggle for life; there were myths which never emerged from that first stage of popular conception, or were absorbed by stronger competitors, because, as some true heroes have done, they lacked the sacred poet or prophet, and were never remodelled by literature; while, out of the myth of Demeter, under the careful conduct of poetry and art, came the little pictures, the idylls, of the Homeric hymn, and the gracious imagery of Praxiteles. The myth has now entered its second or poetical phase, then, in which more definite fancies are grouped about the primitive stock, in a conscious literary temper, and the whole interest settles round the images of the beautiful girl going down into the darkness, and the weary woman who seeks her lost daughter —divine persons, then sincerely believed in by the majority of the Greeks. The Homeric hymn

is the central monument of this second phase. In it, the changes of the natural year have become a personal history, a story of human affection and sorrow, yet with a far-reaching religious significance also, of which the mere earthly spring and autumn are but an analogy ; and in the development of this human element, the writer of the hymn sometimes displays a genuine power of pathetic expression. The whole episode of the fostering of Demophoon, in which over the body of the dying child human longing and regret are blent so subtly with the mysterious design of the goddess to make the child immortal, is an excellent example of the sentiment of pity in literature. Yet though it has reached the stage of conscious literary interpretation, much of its early mystical or cosmical character still lingers about the story, as it is here told. Later mythologists simply define the personal history ; but in this hymn we may, again and again, trace curious links of connexion with the original purpose of the myth. Its subject is the weary woman, indeed, our Lady of Sorrows, the *mater dolorosa* of the ancient world, but with a certain latent reference, all through, to the mystical person of the earth. Her robe of dark blue is the raiment of her mourning, but also the blue robe of the earth in shadow, as we see it in Titian's landscapes ; her great age is the age of the immemorial earth ; she becomes a nurse, therefore, holding Demophoon in her bosom ;

the folds of her garment are fragrant, not merely
with the incense of Eleusis, but with the natural
perfume of flowers and fruit. The sweet breath
with which she nourishes the child Demophoon,
is the warm west wind, feeding all germs of
vegetable life ; her bosom, where he lies, is the
bosom of the earth, with its strengthening heat,
reserved and shy, offended if human eyes scrutinise
too closely its secret chemistry ; it is with the
earth's natural surface of varied colour that she
has, " in time past, given pleasure to the sun " ;
the yellow hair which falls suddenly over her
shoulders, at her transformation in the house of
Celeus, is still partly the golden corn ;—in art
and poetry she is ever the blond goddess ; tarry-
ing in her temple, of which an actual hollow
in the earth is the prototype, among the spicy
odours of the Eleusinian ritual, she is the spirit
of the earth, lying hidden in its dark folds until
the return of spring, among the flower-seeds and
fragrant roots, like the seeds and aromatic woods
hidden in the wrappings of the dead. Through-
out the poem, we have a sense of a certain near-
ness to nature, surviving from an earlier world ;
the sea is understood as a person, yet is still the
real sea, with the waves moving. When it is
said that no bird gave Demeter tidings of Perse-
phone, we feel that to that earlier world, ways
of communication between all creatures may have
seemed open, which are closed to us. It is Iris
who brings to Demeter the message of Zeus ;

that is, the rainbow signifies to the earth the good-will of the rainy sky towards it. Persephone springing up with great joy from the couch of Aidoneus, to return to her mother, is the sudden outburst of the year. The heavy and narcotic aroma of spring flowers hangs about her, as about the actual spring. And this mingling of the primitive cosmical import of the myth with the later, personal interests of the story, is curiously illustrated by the place which the poem assigns to Hecate. This strange Titaness is, first, a nymph only ; afterwards, as if changed incurably by the passionate cry of Persephone, she becomes her constant attendant, and is even identified with her. But in the Homeric hymn her lunar character is clear ; she is really the moon only, who hears the cry of Persephone, as the sun saw her, when Aidoneus carried her away. One morning, as the mother wandered, the moon appeared, as it does in its last quarter, rising very bright, just before dawn ; that is, in the words of the Homeric hymn—"on the tenth morning Hecate met her, having a light in her hands." The fascinating, but enigmatical figure, "sitting ever in her cave, half-veiled with a shining veil, thinking delicate thoughts," in which we seem to see the subject of some picture of the Italian Renaissance, is but the lover of Endymion—like Persephone, withdrawn, in her season, from the eyes of men. The sun saw her ; the moon saw her not, but heard her cry, and is

ever after the half-veiled attendant of the queen of dreams and of the dead.

But the story of Demeter and Persephone lends itself naturally to description, and it is in descriptive beauties that the Homeric hymn excels; its episodes are finished designs, and directly stimulate the painter and the sculptor to a rivalry with them. Weaving the names of the flowers into his verse, names familiar to us in English, though their Greek originals are uncertain, the writer sets Persephone before us, herself like one of them—καλυκῶπις—like the budding calyx of a flower,—in a picture, which, in its mingling of a quaint freshness and simplicity with a certain earnestness, reads like a description of some early Florentine design, such as Sandro Botticelli's *Allegory of the Seasons*. By an exquisite chance also, a common metrical expression connects the perfume of the newly-created narcissus with the salt odour of the sea. Like one of those early designs also, but with a deeper infusion of religious earnestness, is the picture of Demeter sitting at the wayside, in shadow as always, with the well of water and the olive-tree. She has been journeying all night, and now it is morning, and the daughters of Celeus bring their vessels to draw water. That image of the seated Demeter, resting after her long flight "through the dark continent," or in the house of Celeus, when she refuses the red wine, or again, solitary, in her newly-finished

temple of Eleusis, enthroned in her grief, fixed itself deeply on the Greek imagination, and became a favourite subject of Greek artists. When the daughters of Celeus come to conduct her to Eleusis, they come as in a Greek frieze, full of energy and motion and waving lines, but with gold and colours upon it. Eleusis—*coming* —the *coming* of Demeter thither, as thus told in the Homeric hymn, is the central instance in Greek mythology of such divine appearances. "She leaves for a season the company of the gods and abides among men ; " and men's merit is to receive her in spite of appearances. Metaneira and others, in the Homeric hymn, partly detect her divine character ; they find χάρις—a certain gracious air—about her, which makes them think her, perhaps, a royal person in disguise. She becomes in her long wanderings almost wholly humanised, and in return, she and Persephone, alone of the Greek gods, seem to have been the objects of a sort of personal love and loyalty. Yet they are ever the solemn goddesses,—θεαὶ σεμναί, the word expressing religious awe, the Greek sense of the divine presence.

Plato, in laying down the rules by which the poets are to be guided in speaking about divine things to the citizens of the ideal republic, forbids all those episodes of mythology which represent the gods as assuming various forms, and visiting the earth in disguise. Below the

express reasons which he assigns for this rule, we may perhaps detect that instinctive antagonism to the old Heraclitean philosophy of perpetual change, which forces him, in his theory of morals and the state, of poetry and music, of dress and manners even, and of style in the very vessels and furniture of daily life, on an austere simplicity, the older Dorian or Egyptian type of a rigid, eternal immobility. The disintegrating, centrifugal influence, which had penetrated, as he thought, political and social existence, making men too myriad-minded, had laid hold on the life of the gods also, and, even in their calm sphere, one could hardly identify a single divine person as himself, and not another. There must, then, be no doubling, no disguises, no stories of transformation. The modern reader, however, will hardly acquiesce in this "improvement" of Greek mythology. He finds in these stories, like that, for instance, of the appearance of Athene to Telemachus, in the first book of the Odyssey, which has a quite biblical mysticity and solemnity,—stories in which, the hard material outline breaking up, the gods lay aside their visible form like a garment, yet remain essentially themselves,—not the least spiritual element of Greek religion, an evidence of the sense therein of unseen presences, which might at any moment cross a man's path, to be recognised, in half disguise, by the more delicately trained eye, here or there, by one and not by

another. Whatever religious elements they lacked, they had at least this sense of subtler and more remote ways of personal presence.

And as there are traces in the Homeric hymn of the primitive cosmical myth, relics of the first stage of the development of the story, so also many of its incidents are probably suggested by the circumstances and details of the Eleusinian ritual. There were religious usages before there were distinct religious conceptions, and these antecedent religious usages shape and determine, at many points, the ultimate religious conception, as the details of the myth interpret or explain the religious custom. The hymn relates the legend of certain holy places, to which various impressive religious rites had attached themselves—the holy well, the old fountain, the stone of sorrow, which it was the office of the " interpreter " of the holy places to show to the people. The sacred way which led from Athens to Eleusis was rich in such memorials. The nine days of the wanderings of Demeter in the Homeric hymn are the nine days of the duration of the greater or autumnal mysteries ; the jesting of the old woman Iambe, who endeavours to make Demeter smile, are the customary mockeries with which the worshippers, as they rested on the bridge, on the seventh day of the feast, assailed those who passed by. The torches in the hands of Demeter are borrowed from the same source ; and the shadow in which she is

constantly represented, and which is the peculiar sign of her grief, is partly ritual, and a relic of the caves of the old Chthonian worship, partly poetical—expressive, half of the dark earth to which she escapes from Olympus, half of her mourning. She appears consistently, in the hymn, as a teacher of rites, transforming daily life, and the processes of life, into a religious solemnity. With no misgiving as to the proprieties of a mere narration, the hymn-writer mingles these symbolical imitations with the outlines of the original story ; and, in his Demeter, the dramatic person of the mysteries mixes itself with the primitive mythical figure. And the worshipper, far from being offended by these interpolations, may have found a special impressiveness in them, as they linked continuously its inner sense with the outward imagery of the ritual.

And, as Demeter and her story embodied themselves gradually in the Greek imagination, so these mysteries in which her worship found its chief expression, grew up little by little, growing always in close connexion with the modifications of the story, sometimes prompting them, at other times suggested by them. That they had a single special author is improbable, and a mere invention of the Greeks, ignorant of their real history and the general analogy of such matters. Here again, as in the story itself, the idea of development, of degrees, of a slow

and natural growth, impeded here, diverted there, is the illuminating thought which earlier critics lacked. " No tongue may speak of them," says the Homeric hymn ; and the secret has certainly been kept. The antiquarian, dealing, letter by letter, with what is recorded of them, has left few certain *data* for the reflexion of the modern student of the Greek religion ; and of this, its central solemnity, only a fragmentary picture can be made. It is probable that these mysteries developed the symbolical significance of the story of the descent into Hades, the coming of Demeter to Eleusis, the *invention* of Persephone. They may or may not have been the vehicle of a secret doctrine, but were certainly an artistic spectacle, giving, like the mysteries of the middle age, a dramatic representation of the sacred story,—perhaps a detailed performance, perhaps only such a conventional representation, as was afforded for instance by the medieval ceremonies of Palm Sunday ; the whole, probably, centering in an image of Demeter—the work of Praxiteles or his school, in ivory and gold. There is no reason to suppose any specific difference between the observances of the Eleusinian festival and the accustomed usages of the Greek religion ; nocturns, libations, quaint purifications, processions—are common incidents of all Greek worship ; in all religious ceremonies there is an element of dramatic symbolism ; and what we really do see, through those scattered notices,

are things which have their parallels in a later age, the whole being not altogether unlike a modern pilgrimage. The exposition of the sacred places—the threshing-floor of Triptolemus, the rocky seat on which Demeter had rested in her sorrow, the well of Callichorus—is not so strange, as it would seem, had it no modern illustration. The libations, at once a watering of the vines and a drink-offering to the dead— still needing men's services, waiting for purification perhaps, or thirsting, like Dante's Adam of Brescia, in their close homes—must, to almost all minds, have had a certain natural impressiveness ; and a parallel has sometimes been drawn between this festival and All Souls' Day.

And who, everywhere, has not felt the mystical influence of that prolonged silence, the *mystic silence*, from which the very word " mystery " has its origin ? Something also there undoubtedly was, which coarser minds might misunderstand. On one day, the initiated went in procession to the sea-coast, where they underwent a purification by bathing in the sea. On the fifth night there was the torchlight procession ; and, by a touch of real life in him, we gather from the first page of Plato's *Republic* that such processions were popular spectacles, having a social interest, so that people made much of attending them. There was the procession of the sacred basket filled with poppy-seeds and pomegranates. There was the day of rest, after

the stress and excitement of the "great night."
On the sixth day, the image of Iacchus, son of
Demeter, crowned with myrtle and having a
torch in its hand, was carried in procession,
through thousands of spectators, along the sacred
way, amid joyous shouts and songs. We have
seen such processions ; we understand how many
different senses, and how lightly, various spectators
may put on them ; how little definite meaning
they may have even for those who officiate in
them. Here, at least, there was the image itself,
in that age, with its close connexion between
religion and art, presumably fair. Susceptibility
to the impressions of religious ceremonial must
always have varied with the peculiarities of in-
dividual temperament, as it varies in our own day ;
and Eleusis, with its incense and sweet singing,
may have been as little interesting to the out-
ward senses of some worshippers there, as the
stately and affecting ceremonies of the medieval
church to many of its own members. In a
simpler yet profounder sense than has sometimes
been supposed, these things were really addressed
to the initiated only.[1]

We have to travel a long way from the
Homeric hymn to the hymn of Callimachus, who
writes in the end of Greek literature, in the
third century before Christ, in celebration of the
procession of the sacred basket of Demeter, not

[1] The great Greek myths are, in truth, like abstract forces, which
ally themselves to various conditions.

at the Attic, but at the Alexandrian *Eleusinia*. He developes, in something of the prosaic spirit of a medieval writer of "mysteries," one of the burlesque incidents of the story, the insatiable hunger which seized on Erysichthon because he cut down a grove sacred to the goddess. Yet he finds his opportunities for skilful touches of poetry ;—"As the four white horses draw her sacred basket," he says, "so will the great goddess bring us a *white* spring, a *white* summer." He describes the grove itself, with its hedge of trees, so thick that an arrow could hardly pass through, its pines and fruit-trees and tall poplars within, and the water, like pale gold, running from the conduits. It is one of those famous poplars that receives the first stroke ; it sounds heavily to its companion trees, and Demeter perceives that her sacred grove is suffering. Then comes one of those transformations which Plato will not allow. Vainly anxious to save the lad from his ruin, she appears in the form of a priestess, but with the long hood of the goddess, and the poppy in her hand ; and there is something of a real shudder, some still surviving sense of a haunting presence in the groves, in the verses which describe her sudden revelation, when the workmen flee away, leaving their axes in the cleft trees.

Of the same age as the hymn of Callimachus, but with very different qualities, is the idyll of Theocritus on the *Shepherds' Journey*. Although it is possible to define an epoch in mythological

development in which literary and artificial
influences began to remodel the primitive, popular
legend, yet still, among children, and unchanging
childlike people, we may suppose that that primi-
tive stage always survived, and the old, instinctive
influences were still at work. As the subject of
popular religious celebrations also, the myth was
still the property of the people, and surrendered
to its capricious action. The shepherds in
Theocritus, on their way to celebrate one of the
more homely feasts of Demeter, about the time
of harvest, are examples of these childlike people ;
the age of the poets has long since come, but
they are of the older and simpler order, lingering
on in the midst of a more self-conscious world.
In an idyll, itself full of the delightful gifts of
Demeter, Theocritus sets them before us ;
through the blazing summer day's journey, the
smiling image of the goddess is always before
them ; and now they have reached the end of
their journey :—

"So I, and Eucritus, and the fair Amyntichus,
turned aside into the house of Phrasidamus, and
lay down with delight in beds of sweet tamarisk
and fresh cuttings from the vines, strewn on the
ground. Many poplars and elm - trees were
waving over our heads, and not far off the running
of the sacred water from the cave of the nymphs
warbled to us ; in the shimmering branches the
sun-burnt grasshoppers were busy with their talk,
and from afar the little owl cried softly, out of

the tangled thorns of the blackberry ; the larks were singing and the hedge-birds, and the turtle-dove moaned ; the bees flew round and round the fountains, murmuring softly ; the scent of late summer and of the fall of the year was every-where ; the pears fell from the trees at our feet, and apples in number rolled down at our sides, and the young plum-trees were bent to the earth with the weight of their fruit. The wax, four years old, was loosed from the heads of the wine-jars. O ! nymphs of Castalia, who dwell on the steeps of Parnassus, tell me, I pray you, was it a draught like this that the aged Chiron placed before Hercules, in the stony cave of Pholus ? Was it nectar like this that made the mighty shepherd on Anapus' shore, Polyphemus, who flung the rocks upon Ulysses' ships, dance among his sheepfolds ?—A cup like this ye poured out now upon the altar of Demeter, who presides over the threshing-floor. May it be mine, once more, to dig my big winnowing-fan through her heaps of corn ; and may I see her smile upon me, holding poppies and handfuls of corn in her two hands !"

Some of the modifications of the story of Demeter, as we find it in later poetry, have been supposed to be due, not to the genuine action of the Greek mind, but to the influence of that so-called Orphic literature, which, in the generation succeeding Hesiod, brought, from Thessaly and Phrygia, a tide of mystical ideas into the Greek

religion, sometimes, doubtless, confusing the clearness and naturalness of its original outlines, but also sometimes imparting to them a new and peculiar grace. Under the influence of this Orphic poetry, Demeter was blended, or identified, with Rhea Cybele, the mother of the gods, the wilder earth-goddess of Phrygia ; and the romantic figure of Dionysus Zagreus, Dionysus *the Hunter*, that most interesting, though somewhat melancholy variation on the better known Dionysus, was brought, as son or brother of Persephone, into her circle, the mystical vine, who, as Persephone descends and ascends from the earth, is rent to pieces by the Titans every year and remains long in Hades, but every springtime comes out of it again, renewing his youth. This identification of Demeter with Rhea Cybele is the motive which has inspired a beautiful chorus in the Helena—the *new* Helena—of Euripides, that great lover of all subtle refinements and modernisms, who, in this play, has worked on a strange version of the older story, which relates that Helen had never really gone to Troy at all, but sent her soul only there, apart from her sweet body, which abode all that time in Egypt, at the court of King Proteus, where she is found at last by her husband Menelaus, so that the Trojan war was about a phantom, after all. The chorus has even less than usual to do with the action of the play, being linked to it only by a sort of parallel, which may be under-

stood, between Menelaus seeking Helen, and Demeter seeking Persephone. Euripides, then, takes the matter of the Homeric hymn into the region of a higher and swifter poetry, and connects it with the more stimulating imagery of the Idæan mother. The Orphic mysticism or enthusiasm has been admitted into the story, which is now full of excitement, the motion of rivers, the sounds of the Bacchic cymbals heard over the mountains, as Demeter wanders among the woody valleys seeking her lost daughter, all directly expressed in the vivid Greek words. Demeter is no longer the subdued goddess of the quietly-ordered fields, but the mother of the gods, who has her abode in the heights of Mount Ida, who presides over the dews and waters of the white springs, whose flocks feed, not on grain, but on the curling tendrils of the vine, both of which she withholds in her anger, and whose chariot is drawn by wild beasts, fruit and emblem of the earth in its fiery strength. Not Hecate, but Pallas and Artemis, in full armour, swift-footed, vindicators of chastity, accompany her in her search for Persephone, who is already expressly, κόρη ἄρρητος—"the maiden whom none may name." When she rests from her long wanderings, it is into the stony thickets of Mount Ida, deep with snow, that she throws herself, in her profound grief. When Zeus desires to end her pain, the Muses and the "solemn" Graces are sent to dance and sing before her. It is then

that Cypris, the goddess of beauty, and the original cause, therefore, of her distress, takes into her hands the brazen tambourines of the Dionysiac worship with their Chthonian or deep-noted sound ; and it is she, not the old Iambe, who with this wild music, heard thus for the first time, makes Demeter smile at last. " Great," so the chorus ends with a picture, " great is the power of the stoles of spotted fawn-skins, and the green leaves of ivy twisted about the sacred wands, and the wheeling motion of the tambourine whirled round in the air, and the long hair floating unbound in honour of Bromius, and the nocturns of the goddess, when the moon looks full upon them."

The poem of Claudian on the *Rape of Proserpine*, the longest extant work connected with the story of Demeter, yet itself unfinished, closes the world of classical poetry. Writing in the fourth century of the Christian era, Claudian has his subject before him in the whole extent of its various development, and also profits by those many pictorial representations of it, which, from the famous picture of Polygnotus downwards, delighted the ancient world. His poem, then, besides having an intrinsic charm, is valuable for some reflexion in it of those lost works, being itself pre-eminently a work in colour, and excelling in a kind of painting in words, which brings its subject very pleasantly almost to the eye of the reader. The mind of this late votary

of the old gods, in a world rapidly changing, is
crowded with all the beautiful forms generated
by mythology, and now about to be forgotten.
In this after-glow of Latin literature, lighted up
long after their fortune had set, and just before
their long night began, they pass before us, in
his verses, with the utmost clearness, like the
figures in an actual procession. The nursing of
the infant Sun and Moon by Tethys; Proserpine
and her companions gathering flowers at early
dawn, when the violets are drinking in the dew,
still lying white upon the grass; the image of
Pallas winding the peaceful blossoms about the
steel crest of her helmet; the realm of Proserpine,
softened somewhat by her coming, and filled with
a quiet joy; the matrons of Elysium crowding
to her marriage toilet, with the bridal veil of
yellow in their hands; the Manes, crowned
with ghostly flowers yet warmed a little, at the
marriage feast; the ominous dreams of the
mother; the desolation of the home, like an
empty bird's-nest or an empty fold, when she
returns and finds Proserpine gone, and the spider
at work over her unfinished embroidery; the
strangely-figured raiment, the flowers in the
grass, which were once blooming youths, having
both their natural colour and the colour of their
poetry in them, and the clear little fountain there,
which was once the maiden Cyane;—all this is
shown in a series of descriptions, like the designs
in some unwinding tapestry, like Proserpine's own

embroidery, the description of which is the most
brilliant of these pictures, and, in its quaint con-
fusion of the images of philosophy with those of
mythology, anticipates something of the fancy of
the Italian Renaissance.

" Proserpina, filling the house soothingly with
her low song, was working a gift against the
return of her mother, with labour all to be in
vain.　In it, she marked out with her needle the
houses of the gods and the series of the elements,
showing by what law, nature, the parent of all,
settled the strife of ancient times, and the seeds
of things disparted into their places; the lighter
elements are borne aloft, the heavier fall to the
centre; the air grows bright with heat, a blazing
light whirls round the firmament; the sea flows;
the earth hangs suspended in its place.　And
there were divers colours in it; she illuminated
the stars with gold, infused a purple shade into
the water, and heightened the shore with gems
of flowers; and, under her skilful hand, the
threads, with their inwrought lustre, swell up,
in momentary counterfeit of the waves; you
might think that the sea-wind flapped against
the rocks, and that a hollow murmur came
creeping over the thirsty sands.　She puts in
the five zones, marking with a red ground the
midmost zone, possessed by burning heat; its
outline was parched and stiff; the threads seemed
thirsty with the constant sunshine; on either
side lay the two zones proper for human life,

where a gentle temperance reigns; and at the extremes she drew the twin zones of numbing cold, making her work dun and sad with the hues of perpetual frost. She paints in, too, the sacred places of Dis, her father's brother, and the Manes, so fatal to her; and an omen of her doom was not wanting; for, as she worked, as if with foreknowledge of the future, her face became wet with a sudden burst of tears. And now, in the utmost border of the tissue, she had begun to wind in the wavy line of the river Oceanus, with its glassy shallows; but the door sounds on its hinges, and she perceives the goddesses coming; the unfinished work drops from her hands, and a ruddy blush lights up in her clear and snow-white face."

I have reserved to the last what is perhaps the daintiest treatment of this subject in classical literature, the account of it which Ovid gives in the *Fasti*—a kind of Roman Calendar—for the seventh of April, the day of the games of Ceres. He tells over again the old story, with much of which, he says, the reader will be already familiar; but he has something also of his own to add to it, which the reader will hear for the first time; and, like one of those old painters who, in depicting a scene of Christian history, drew from their own fancy or experience its special setting and accessories, he translates the story into something very different from the Homeric hymn. The writer of the Homeric

hymn had made Celeus a king, and represented the scene at Eleusis in a fair palace, like the Venetian painters who depict the persons of the Holy Family with royal ornaments. Ovid, on the other hand, is more like certain painters of the early Florentine school, who represent the holy persons amid the more touching circumstances of humble life; and the special something of his own which he adds, is a pathos caught from homely things, not without a delightful, just perceptible, shade of humour even, so rare in such work. All the mysticism has disappeared; but, instead, we trace something of that "worship of sorrow," which has been sometimes supposed to have had no place in classical religious sentiment. In Ovid's well-finished elegiacs, Persephone's flower-gathering, the *Anthology*, reaches its utmost delicacy; but I give the following episode for the sake of its pathetic expression.

"After many wanderings Ceres was come to Attica. There, in the utmost dejection, for the first time, she sat down to rest on a bare stone, which the people of Attica still call the *stone of sorrow*. For many days she remained there motionless, under the open sky, heedless of the rain and of the frosty moonlight. Places have their fortunes; and what is now the illustrious town of Eleusis was then the field of an old man named Celeus. He was carrying home a load of acorns, and wild berries shaken down from the

brambles, and dry wood for burning on the
hearth ; his little daughter was leading two
goats home from the hills ; and at home there
was a little boy lying sick in his cradle.
'Mother,' said the little girl—and the goddess
was moved at the name of mother—'what do
you, all alone, in this solitary place ?' The old
man stopped too, in spite of his heavy burden,
and bade her take shelter in his cottage, though
it was but a little one. But at first she refused to
come ; she looked like an old woman, and an old
woman's coif confined her hair ; and as the man
still urged her, she said to him, 'Heaven bless
you ; and may children always be yours ! My
daughter has been stolen from me. Alas ! how
much happier is your lot than mine' ; and,
though weeping is impossible for the gods, as
she spoke, a bright drop, like a tear, fell into her
bosom. Soft-hearted, the little girl and the old
man weep together. And after that the good
man said, 'Arise ! despise not the shelter of my
little home ; so may the daughter whom you
seek be restored to you.' 'Lead me,' answered
the goddess ; 'you have found out the secret of
moving me ;' and she arose from the stone, and
followed the old man ; and as they went he told
her of the sick child at home—how he is restless
with pain, and cannot sleep. And she, before
entering the little cottage, gathered from the
untended earth the soothing and sleep-giving
poppy; and as she gathered it, it is said that she

forgot her vow, and tasted of the seeds, and broke
her long fast, unaware. As she came through the
door, she saw the house full of trouble, for now
there was no more hope of life for the sick
boy. She saluted the mother, whose name was
Metaneira, and humbly kissed the lips of the child,
with her own lips ; then the paleness left its face,
and suddenly the parents see the strength return-
ing to its body ; so great is the force that comes
from the divine mouth. And the whole family
was full of joy—the mother and the father and
the little girl ; they were the whole house-
hold." [1]

Three profound ethical conceptions, three im-
pressive sacred figures, have now defined them-
selves for the Greek imagination, condensed from
all the traditions which have now been traced,
from the hymns of the poets, from the instinctive
and unformulated mysticism of primitive minds.
Demeter is become the divine sorrowing mother.
Kore, the goddess of summer, is become Per-
sephone, the goddess of death, still associated
with the forms and odours of flowers and fruit,
yet as one risen from the dead also, presenting
one side of her ambiguous nature to men's
gloomier fancies. Thirdly, there is the image of
Demeter enthroned, chastened by sorrow, and
somewhat advanced in age, blessing the earth, in
her joy at the return of Kore. The myth has

[1] With this may be connected another passage of Ovid—
Metamorphoses, v. 391-408.

now entered on the third phase of its life, in which it becomes the property of those more elevated spirits, who, in the decline of the Greek religion, pick and choose and modify, with perfect freedom of mind, whatever in it may seem adapted to minister to their culture. In this way, the myths of the Greek religion become parts of an ideal, visible embodiments of the susceptibilities and intuitions of the nobler kind of souls ; and it is to this latest phase of mythological development that the highest Greek sculpture allies itself. Its function is to give visible æsthetic expression to the constituent parts of that ideal. As poetry dealt chiefly with the *incidents* of the story, so it is with the *personages* of the story—with Demeter and Kore themselves—that sculpture has to do.

For the myth of Demeter, like the Greek religion in general, had its unlovelier side, grotesque, unhellenic, unglorified by art, illustrated well enough by the description Pausanias gives us of his visit to the cave of the Black Demeter at Phigalia. In his time the image itself had vanished ; but he tells us enough about it to enable us to realise its general characteristics, monstrous as the special legend with which it was connected, the black draperies, the horse's head united to the woman's body, with the carved reptiles creeping about it. If, with the thought of this gloomy image of our mother the earth, in our minds, we take up one of those coins

which bear the image of Kore or Demeter,[1] we shall better understand what the function of sculpture really was, in elevating and refining the religious conceptions of the Greeks. Looking on the profile, for instance, on one of those coins of Messene, which almost certainly represent Demeter, and noting the crisp, chaste opening of the lips, the minutely wrought earrings, and the delicately touched ears of corn,—this trifling object being justly regarded as, in its æsthetic qualities, an epitome of art on a larger scale,—we shall see how far the imagination of the Greeks had travelled from what their Black Demeter shows us had once been possible for them, and in making the gods of their worship the objects of a worthy companionship in their thoughts. Certainly, the mind of the old workman who struck that coin was, if we may trust the testimony of his work, unclouded by impure or gloomy shadows. The thought of Demeter is impressed here, with all the purity and proportion, the purged and dainty intelligence of the human countenance. The mystery of it is indeed absent, perhaps could hardly have been looked for in so slight a thing, intended for no sacred purpose, and tossed lightly from hand to hand. But in his firm hold on the harmonies of the human face, the designer of this tranquil head of

[1] On these small objects the mother and daughter are hard to distinguish, the latter being recognisable only by a greater delicacy in the features and the more evident stamp of youth.

DEMETER AND PERSEPHONE

Demeter is on the one road to a command over the secrets of all imaginative pathos and mystery; though, in the perfect fairness and blitheness of his work, he might seem almost not to have known the incidents of her terrible story.

It is probable that, at a later period than in other equally important temples of Greece, the earlier archaic representation of Demeter in the sanctuary of Eleusis, was replaced by a more beautiful image in the new style, with face and hands of ivory, having therefore, in tone and texture, some subtler likeness to women's flesh, and the closely enveloping drapery being constructed in daintily beaten plates of gold. Praxiteles seems to have been the first to bring into the region of a freer artistic handling these shy deities of the earth, shrinking still within the narrow restraints of a hieratic, conventional treatment, long after the more genuine Olympians had broken out of them. The school of Praxiteles, as distinguished from that of Pheidias, is especially the school of grace, relaxing a little the severe ethical tension of the latter, in favour of a slightly Asiatic sinuosity and tenderness. Pausanias tells us that he carved the two goddesses for the temple of Demeter at Athens; and Pliny speaks of two groups of his in brass, the one representing the stealing of Persephone, the other her later, annual descent into Hades, conducted thither by the now pacified mother. All alike have perished; though perhaps some

more or less faint reflexion of the most important of these designs may still be traced on many painted vases which depict the stealing of Persephone,—a helpless, plucked flower in the arms of Aidoneus. And in this almost traditional form, the subject was often represented, in low relief, on tombs, some of which still remain ; in one or two instances, built up, oddly enough, in the walls of Christian churches. On the tombs of women who had died in early life, this was a favourite subject, some likeness of the actual lineaments of the deceased being sometimes transferred to the features of Persephone.

Yet so far, it might seem, when we consider the interest of this story in itself, and its importance in the Greek religion, that no adequate expression of it had remained to us in works of art. But in the year 1857, the discovery of the marbles, in the sacred precinct of Demeter at Cnidus, restored to us an illustration of the myth in its artistic phase, hardly less central than the Homeric hymn in its poetical phase. With the help of the descriptions and plans of Mr. Newton's book,[1] we can form, as one always wishes to do in such cases, a clear idea of the place where these marbles—three statues of the best style of Greek sculpture, now in the British Museum—were found. Occupying a ledge of rock, looking towards the sea, at the base of a

[1] *A History of Discoveries at Halicarnassus, Cnidus, and Branchidæ.*

cliff of upheaved limestone, of singular steepness and regularity of surface, the spot presents indications of volcanic disturbance, as if a chasm in the earth had opened here. It was this character, suggesting the belief in an actual connexion with the interior of the earth (local tradition claiming it as the scene of the stealing of Persephone), which probably gave rise, as in other cases where the landscape presented some peculiar feature in harmony with the story, to the dedication upon it of a house and an image of Demeter, with whom were associated Kore and "the gods with Demeter"—οἱ θεοὶ παρὰ Δαμάτρι—Aidoneus, and the mystical or Chthonian Dionysus. The house seems to have been a small chapel only, of simple construction, and designed for private use, the site itself having been private property, consecrated by a particular family, for their own religious uses, although other persons, servants or dependents of the founders, may also have frequented it. The architecture seems to have been insignificant, but the sculpture costly and exquisite, belonging, if contemporary with the erection of the building, to a great period of Greek art, of which also it is judged to possess intrinsic marks—about the year 350 before Christ, the probable date of the dedication of the little temple. The artists by whom these works were produced were, therefore, either the contemporaries of Praxiteles, whose Venus was for many centuries the glory of

Cnidus, or belonged to the generation immediately succeeding him. The temple itself was probably thrown down by a renewal of the volcanic disturbances; the statues however remaining, and the ministers and worshippers still continuing to make shift for their sacred business in the place, now doubly venerable, but with its temple unrestored, down to the second or third century of the Christian era, its frequenters being now perhaps mere chance comers, the family of the original donors having become extinct, or having deserted it. Into this later arrangement, clearly divined by Mr. Newton, through those faint indications which mean much for true experts, the extant remains, as they were found upon the spot, permit us to enter. It is one of the graves of that old religion, but with much still fresh in it. We see it with its provincial superstitions, and its curious magic rites, but also with its means of really solemn impressions, in the culminating forms of Greek art; the two faces of the Greek religion confronting each other here, and the whole having that rare peculiarity of a kind of personal stamp upon it, the place having been designed to meet the fancies of one particular soul, or at least of one family. It is always difficult to bring the every-day aspect of Greek religion home to us; but even the slighter details of this little sanctuary help us to do this; and knowing so little, as we do, of the greater mysteries of

DEMETER AND PERSEPHONE

Demeter, this glance into an actual religious place dedicated to her, and with the air of her worship still about it, is doubly interesting. The little votive figures of the goddesses, in baked earth, were still lying stored in the small treasury intended for such objects, or scattered about the feet of the images, together with lamps in great number, a lighted lamp being a favourite offering, in memory of the torches with which Demeter sought Persephone, or from some sense of inherent darkness in these gods of the earth; those torches in the hands of Demeter being indeed originally the artificial warmth and brightness of lamp and fire, on winter nights. The *diræ* or spells,—κατάδεσμοι—binding or devoting certain persons to the infernal gods, inscribed on thin rolls of lead, with holes, sometimes, for hanging them up about those quiet statues, still lay, just as they were left, anywhere within the sacred precinct, illustrating at once the gloomier side of the Greek religion in general, and of Demeter and Persephone especially, in their character of avenging deities, and as relics of ancient magic, reproduced so strangely at other times and places, reminding us of the permanence of certain odd ways of human thought. A woman binds with her spell the person who seduces her husband away from her and her children; another, the person who has accused her of preparing poison for her husband; another devotes one who has not restored a borrowed

garment, or has stolen a bracelet, or certain drinking-horns; and, from some instances, we might infer that this was a favourite place of worship for the poor and ignorant. In this living picture, we find still lingering on, at the foot of the beautiful Greek marbles, that phase of religious temper which a cynical mind might think a truer link of its unity and permanence than any higher æsthetic instincts—a phase of it, which the art of sculpture, humanising and refining man's conceptions of the unseen, tended constantly to do away. For the higher side of the Greek religion, thus humanised and refined by art, and elevated by it to the sense of beauty, is here also.

There were three ideal forms, as we saw, gradually shaping themselves in the development of the story of Demeter, waiting only for complete realisation at the hands of the sculptor; and now, with these forms in our minds, let us place ourselves in thought before the three images which once probably occupied the three niches or ambries in the face of that singular cliff at Cnidus, one of them being then wrought on a larger scale. Of the three figures, one probably represents Persephone, as the goddess of the dead; the second, Demeter enthroned; the third is probably a portrait-statue of a priestess of Demeter, but may perhaps, even so, represent Demeter herself, Demeter *Achæa*, Ceres *Deserta*, the *mater dolorosa* of the Greeks, a type not as yet

recognised in any other work of ancient art. Certainly, it seems hard not to believe that this work is in some way connected with the legend of the place to which it belonged, and the main subject of which it realises so completely ; and, at least, it shows how the higher Greek sculpture would have worked out this motive. If Demeter at all, it is Demeter the seeker,—Δηώ,—as she was called in the mysteries, in some pause of her restless wandering over the world in search of the lost child, and become at last an abstract type of the wanderer. The Homeric hymn, as we saw, had its sculptural motives, the great gestures of Demeter, who was ever the stately goddess, as she followed the daughters of Celeus, or sat by the well-side, or went out and in, through the halls of the palace, expressed in monumental words. With the sentiment of that monumental Homeric presence this statue is penetrated, uniting a certain solemnity of attitude and bearing, to a profound piteousness, an unrivalled pathos of expression. There is something of the pity of Michelangelo's *mater dolorosa*, in the wasted form and marred countenance, yet with the light breaking faintly over it from the eyes, which, contrary to the usual practice in ancient sculpture, are represented as looking upwards. It is the aged woman who has escaped from pirates, who has but just escaped being sold as a slave, calling on the young for pity. The sorrows of her long wanderings seem to have passed into the marble ;

and in this too, it meets the demands which the reader of the Homeric hymn, with its command over the resources of human pathos, makes upon the sculptor. The tall figure, in proportion above the ordinary height, is veiled, and clad to the feet in the longer tunic, its numerous folds hanging in heavy parallel lines, opposing the lines of the *peplus*, or cloak, which cross it diagonally over the breast, enwrapping the upper portion of the body somewhat closely. It is the very type of the wandering woman, going grandly, indeed, as Homer describes her, yet so human in her anguish, that we seem to recognise some far descended shadow of her, in the homely figure of the roughly clad French peasant woman, who, in one of Corot's pictures, is hasting along under a sad light, as the day goes out behind the little hill. We have watched the growth of the merely personal sentiment in the story ; and we may notice that, if this figure be indeed Demeter, then the conception of her has become wholly humanised ; no trace of the primitive cosmical import of the myth, no colour or scent of the mystical earth, remains about it.

The seated figure, much mutilated, and worn by long exposure, yet possessing, according to the best critics, marks of the school of Praxiteles, is almost undoubtedly the image of Demeter enthroned. Three times in the Homeric hymn she is represented as sitting, once by the fountain at the wayside, again in the house of Celeus, and

again in the newly finished temple of Eleusis ;
but always in sorrow ; seated on the πέτρα
ἀγέλαστος, which, as Ovid told us, the people of
Attica still called *the stone of sorrow.* Here she
is represented in her later state of reconciliation,
enthroned as the glorified mother of all things.
The delicate plaiting of the tunic about the
throat, the formal curling of the hair, and a
certain weight of over-thoughtfulness in the
brows, recall the manner of Leonardo da Vinci,
a master, one of whose characteristics is a very
sensitive expression of the sentiment of maternity.
It reminds one especially of a work by one of his
scholars, the *Virgin of the Balances*, in the Louvre,
a picture which has been thought to represent,
under a veil, the blessing of universal nature,
and in which the sleepy-looking heads, with
a peculiar grace and refinement of somewhat
advanced life in them, have just this half-weary
posture. We see here, then, the Here of the
world below, the Stygian Juno, the chief of
those Elysian matrons who come crowding, in
the poem of Claudian, to the marriage toilet of
Proserpine, the goddess of the fertility of the
earth and of all creatures, but still of fertility as
arisen out of death ;[1] and therefore she is not
without a certain pensiveness, having seen the
seed fall into the ground and die, many times.
Persephone is returned to her, and the hair

[1] Pallere ligustra,
Exspirare rosas, decrescere lilia vidi.

spreads, like a rich harvest, over her shoulders ;
but she is still veiled, and knows that the seed
must fall into the ground again, and Persephone
descend again from her.

The statues of the supposed priestess, and of
the enthroned Demeter, are of more than the
size of life ; the figure of Persephone is but
seventeen inches high, a daintily handled toy of
Parian marble, the miniature copy perhaps of a
much larger work, which might well be repro-
duced on a magnified scale. The conception
of Demeter is throughout chiefly human, and
even domestic, though never without a hieratic
interest, because she is not a goddess only, but
also a priestess. In contrast, Persephone is
wholly unearthly, the close companion, and even
the confused double, of Hecate, the goddess of
midnight terrors,—*Despœna*,—the final mistress
of all that lives ; and as sorrow is the character-
istic sentiment of Demeter, so awe of Persephone.
She is compact of sleep, and death, and flowers,
but of narcotic flowers especially,—a *revenant*,
who in the garden of Aidoneus has eaten of the
pomegranate, and bears always the secret of
decay in her, of return to the grave, in the
mystery of those swallowed seeds ; sometimes,
in later work, holding in her hand the key of
the great prison-house, but which unlocks all
secrets also ; (there, finally, or through oracles
revealed in dreams ;) sometimes, like Demeter,
the poppy, emblem of sleep and death by its

narcotic juices, of life and resurrection by its
innumerable seeds, of the dreams, therefore, that
may intervene between falling asleep and waking.
Treated as it is in the Homeric hymn, and still
more in this statue, the image of Persephone
may be regarded as the result of many efforts to
lift the old Chthonian gloom, still lingering on
in heavier souls, concerning the grave, to connect
it with impressions of dignity and beauty, and a
certain sweetness even ; it is meant to make
men in love, or at least at peace, with death.
The Persephone of Praxiteles' school, then,
is *Aphrodite-Persephone*, *Venus-Libitina*. Her
shadowy eyes have gazed upon the fainter
colouring of the under-world, and the tranquillity,
born of it, has " passed into her face " ; for the
Greek Hades is, after all, but a quiet, twilight
place, not very different from that *House of Fame*
where Dante places the great souls of the
classical world ; Aidoneus himself being con-
ceived, in the highest Greek sculpture, as but a
gentler Zeus, the great innkeeper ; so that when
a certain Greek sculptor had failed in his por-
traiture of Zeus, because it had too little hilarity,
too little, in the eyes and brow, of the open and
cheerful sky, he only changed its title, and the
thing passed excellently, with its heavy locks
and shadowy eyebrows, for the god of the dead.
The image of Persephone, then, as it is here
composed, with the tall, tower-like head-dress,
from which the veil depends—the corn-basket,

originally carried thus by the Greek women,
balanced on the head—giving the figure unusual
length, has the air of a body bound about with
grave-clothes ; while the archaic hands and feet,
and a certain stiffness in the folds of the drapery,
give it something of a hieratic character, and to
the modern observer may suggest a sort of kin-
ship with the more chastened kind of Gothic
work. But quite of the school of Praxiteles is
the general character of the composition ; the
graceful waving of the hair, the fine shadows of
the little face, of the eyes and lips especially,
like the shadows of a flower—a flower risen noise-
lessly from its dwelling in the dust—though still
with that fulness or heaviness in the brow, as of
sleepy people, which, in the delicate gradations
of Greek sculpture, distinguish the infernal deities
from their Olympian kindred. The object placed
in the hand may be, perhaps, a stiff, archaic flower,
but is probably the partly consumed pomegranate
—one morsel gone ; the most usual emblem of
Persephone being this mystical fruit, which,
because of the multitude of its seeds, was to the
Romans a symbol of fecundity, and was sold at
the doors of the temple of Ceres, that the women
might offer it there, and bear numerous children;
and so, to the middle age, became a symbol of
the fruitful earth itself ; and then of that other
seed sown in the dark under-world ; and at last
of that whole hidden region, so thickly sown,
which Dante visited, Michelino painting him,

in the *Duomo* of Florence, with this fruit in his hand, and Botticelli putting it into the childish hands of Him, who, if men " go down into hell, is there also."

There is an attractiveness in these goddesses of the earth, akin to the influence of cool places, quiet houses, subdued light, tranquillising voices. What is there in this phase of ancient religion for us, at the present day? The myth of Demeter and Persephone, then, illustrates the power of the Greek religion as a religion of pure ideas— of conceptions, which having no link on historical fact, yet, because they arose naturally out of the spirit of man, and embodied, in adequate symbols, his deepest thoughts concerning the conditions of his physical and spiritual life, maintained their hold through many changes, and are still not without a solemnising power even for the modern mind, which has once admitted them as recognised and habitual inhabitants ; and, abiding thus for the elevation and purifying of our sentiments, long after the earlier and simpler races of their worshippers have passed away, they may be a pledge to us of the place in our culture, at once legitimate and possible, of the associations, the conceptions, the imagery, of Greek religious poetry in general, of the poetry of all religions.

HIPPOLYTUS VEILED

CENTURIES of zealous archæology notwithstanding, many phases of the so varied Greek genius are recorded for the modern student in a kind of shorthand only, or not at all. Even for Pausanias, visiting Greece before its direct part in affairs was quite played out, much had perished or grown dim—of its art, of the truth of its outward history, above all of its religion as a credible or practicable thing. And yet Pausanias visits Greece under conditions as favourable for observation as those under which later travellers, Addison or Eustace, proceed to Italy. For him the impress of life in those old Greek cities is not less vivid and entire than that of medieval Italy to ourselves ; at Siena, for instance, with its ancient palaces still in occupation, its public edifices as serviceable as if the old republic had but just now vacated them, the tradition of their primitive worship still unbroken in its churches. Had the opportunities in which Pausanias was

fortunate been ours, how many haunts of the antique Greek life unnoticed by him we should have peeped into, minutely systematic in our painstaking ! how many a view would broaden out where he notes hardly anything at all on his map of Greece !

One of the most curious phases of Greek civilisation which has thus perished for us, and regarding which, as we may fancy, we should have made better use of that old traveller's facilities, is the early Attic deme-life—its picturesque, intensely localised variety, in the hollow or on the spur of mountain or sea-shore ; and with it many a relic of primitive religion, many an early growth of art parallel to what Vasari records of artistic beginnings in the smaller cities of Italy. Colonus and Acharnæ, surviving still so vividly by the magic of Sophocles, of Aristophanes, are but isolated examples of a widespread manner of life, in which, amid many provincial peculiarities, the first, yet perhaps the most costly and telling steps were made in all the various departments of Greek culture. Even in the days of Pausanias, Piræus was still traceable as a distinct township, once the possible rival of Athens, with its little old covered market by the seaside, and the symbolical picture of the place, its Genius, visible on the wall. And that is but the type of what there had been to know of threescore and more village communities, each having its own altars, its special worship and

place of civic assembly, its trade and crafts, its name drawn from physical peculiarity or famous incident, its body of heroic tradition. Lingering on while Athens, the great deme, gradually absorbed into itself more and more of their achievements, and passing away almost completely as political factors in the Peloponnesian war, they were still felt, we can hardly doubt, in the actual physiognomy of Greece. That variety in unity, which its singular geographical formation secured to Greece as a whole, was at its utmost in these minute reflexions of the national character, with all the relish of local difference—new art, new poetry, fresh ventures in political combination, in the conception of life, springing as if straight from the soil, like the thorn-blossom of early spring in magic lines over all that rocky land. On the other hand, it was just here that ancient habits clung most tenaciously—that old-fashioned, homely, delightful existence, to which the refugee, pent up in Athens in the years of the Peloponnesian war, looked back so fondly. If the impression of Greece generally is but enhanced by the littleness of the physical scene of events intellectually so great—such a system of grand lines, restrained within so narrow a compass, as in one of its fine coins—still more would this be true of those centres of country life. Here, certainly, was that assertion of seemingly small interests, which brings into free play, and gives his utmost value

to, the individual ; making his warfare, equally
with his more peaceful rivalries, deme against
deme, the mountain against the plain, the sea-
shore, (as in our own old Border life, but played
out here by wonderfully gifted people) tangible
as a personal history, to the doubling of its
fascination for those whose business is with the
survey of the dramatic side of life.

As with civil matters, so it was also, we may
fairly suppose, with religion ; the deme-life was
a manifestation of religious custom and sentiment,
in all their primitive local variety. As Athens,
gradually drawing into itself the various elements
of provincial culture, developed, with authority,
the central religious position, the demes-men
did but add the worship of Athene Polias, the
goddess of the capital, to their own pre-existent
ritual uses. Of local and central religion alike,
time and circumstance had obliterated much
when Pausanias came. A devout spirit, with
religion for his chief interest, eager for the trace
of a divine footstep, anxious even in the days of
Lucian to deal seriously with what had counted
for so much to serious men, he has, indeed, to
lament that " Pan is dead " :—" They come no
longer ! "—" These things happen no longer ! "
But the Greek—his very name also, *Hellen*, was
the title of a priesthood—had been religious
abundantly, sanctifying every detail of his actual
life with the religious idea ; and as Pausanias
goes on his way he finds many a remnant of that

earlier estate of religion, when, as he fancied, it had been nearer the gods, as it was certainly nearer the earth. It is marked, even in decay, with varieties of place ; and is not only continuous but *in situ.* At Phigaleia he makes his offerings to Demeter, agreeably to the paternal rites of the inhabitants, wax, fruit, undressed wool " still full of the *sordes* of the sheep." A dream from heaven cuts short his notice of the mysteries of Eleusis. He sees the stone, " big enough for a little man," on which Silenus was used to sit and rest ; at Athens, the tombs of the Amazons, of the purple-haired Nisus, of Deucalion ;—" it is a manifest token that he had dwelt there." The worshippers of Poseidon, even at his temple among the hills, might still feel the earth fluctuating beneath their feet. And in care for divine things, he tells us, the Athenians outdid all other Greeks. Even in the days of Nero it revealed itself oddly ; and it is natural to suppose that of this temper the demes, as the proper home of conservatism, were exceptionally express-ive. Scattered in those remote, romantic villages, among their olives or sea-weeds, lay the heroic graves, the relics, the sacred images, often rude enough amid the delicate tribute of later art ; this too oftentimes finding in such retirement its best inspirations, as in some Attic Fiesole. Like a network over the land of gracious poetic tradition, as also of undisturbed ceremonial usage surviving late for those who cared to seek it, the

local religions had been never wholly superseded
by the worship of the great national temples.
They were, in truth, the most characteristic
developments of a faith essentially earth-born or
indigenous.

And how often must the student of fine art,
again, wish he had the same sort of knowledge
about its earlier growth in Greece, that he
actually possesses in the case of Italian art!
Given any development at all in this matter,
there must have been phases of art, which, if
immature, were also veritable expressions of
power to come, intermediate discoveries of beauty,
such as are by no means a mere anticipation,
and of service only as explaining historically
larger subsequent achievements, but of permanent
attractiveness in themselves, being often, indeed,
the true maturity of certain amiable artistic
qualities. And in regard to Greek art at its
best—the Parthenon—no less than to the art
of the Renaissance at its best—the Sistine Chapel
—the more instructive light would be derived
rather from what precedes than what follows
such central success, from the determination to
apprehend the fulfilment of past effort rather
than the eve of decline, in the critical, central
moment which partakes of both. Of such early
promise, early achievement, we have in the case
of Greek art little to compare with what is
extant of the youth of the arts in Italy. Over-
beck's careful gleanings of its history form indeed

a sorry relic as contrasted with Vasari's intimations of the beginnings of the Renaissance. Fired by certain fragments of its earlier days, of a beauty, in truth, absolute, and vainly longing for more, the student of Greek sculpture indulges the thought of an ideal of youthful energy therein, yet withal of youthful self-restraint; and again, as with survivals of old religion, the privileged home, he fancies, of that ideal must have been in those venerable Attic townships, as to a large extent it passed away with them.

The budding of new art, the survival of old religion, at isolated centres of provincial life, where varieties of human character also were keen, abundant, asserted in correspondingly effective incident—this is what irresistible fancy superinduces on historic details, themselves meagre enough. The sentiment of antiquity is indeed a characteristic of all cultivated people, even in what may seem the freshest ages, and not exclusively a humour of our later world. In the earliest notices about them, as we know, the people of Attica appear already impressed by the immense antiquity of their occupation of its soil, of which they claim to be the very first flower. Some at least of those old demesmen we may well fancy sentimentally reluctant to change their habits, fearful of losing too much of themselves in the larger stream of life, clinging to what is antiquated as the work of centralisation goes on, needful as that work was,

with the great "Eastern difficulty" already ever in the distance. The fear of Asia, barbaric, splendid, hardly known, yet haunting the curious imagination of those who had borrowed thence the art in which they were rapidly excelling it, developing, as we now see, in the interest of Greek humanity, crafts begotten of tyrannic and illiberal luxury, was finally to suppress the rivalries of those primitive centres of activity, when the "invincible armada" of the common foe came into sight.

At a later period civil strife was to destroy their last traces. The old hoplite, from Rhamnus or Acharnæ, pent up in beleaguered Athens during that first summer of the Peloponnesian war, occupying with his household a turret of the wall, as Thucydides describes—one of many picturesque touches in that severe historian—could well remember the ancient provincial life which this conflict with Sparta was bringing to an end. He could recall his boyish, half-scared curiosity concerning those Persian ships, coming first as merchantmen, or with pirates on occasion, in the half-savage, wicked splendours of their decoration, the monstrous figure-heads, their glittering freightage. Men would hardly have trusted their women or children with that suspicious crew, hovering through the dusk. There were soothsayers, indeed, who had long foretold what happened soon after, giving shape to vague, supernatural terrors. And then he had crept

from his hiding-place with other lads to go view the enemies' slain at Marathon, beside those belated Spartans, this new war with whom seemed to be reviving the fierce local feuds of his younger days. *Paraloi* and *Diacrioi* had ever been rivals. Very distant it all seemed now, with all the stories he could tell; for in those crumbling little towns, as heroic life had lingered on into the actual, so, at an earlier date, the supernatural into the heroic. Like mist at dawn, the last traces of its divine visitors had then vanished from the land, where, however, they had already begotten "our best and oldest families."

It was Theseus, uncompromising young master of the situation, in fearless application of "the modern spirit" of his day to every phase of life where it was applicable, who, at the expense of Attica, had given Athens a people, reluctant enough, in truth, as Plutarch suggests, to desert "their homes and religious usages and many good and gracious kings of their own" for this elect youth, who thus figures, passably, as a kind of mythic shorthand for civilisation, making roads and the like, facilitating travel, suppressing various forms of violence, but many innocent things as well. So it must needs be in a world where, even hand in hand with a god-assisted hero, Justice goes blindfold. He slays the bull of Marathon and many another local tyrant, but also exterminates that delightful creature, the Centaur. The Amazon, whom Plato will

reinstate as the type of improved womanhood, has no better luck than Phæa, the sow-pig of Crommyon, foul old landed-proprietress. They exerted, however, the prerogative of poetic protest, and survive thereby. Centaur and Amazon, as we see them in the fine art of Greece, represent the regret of Athenians themselves for something that could never be brought to life again, and have their pathos. Those young heroes contending with Amazons on the frieze of the Mausoleum had best make haste with their bloody work, if young people's eyes can tell a true story. A type still of progress triumphant through injustice, set on improving things off the face of the earth, Theseus took occasion to attack the Amazons in their mountain home, not long after their ruinous conflict with Hercules, and hit them when they were down. That greater bully had laboured off on the world's highway, carrying with him the official girdle of Antiope, their queen, gift of Ares, and therewith, it would seem, the mystic secret of their strength. At sight of this new foe, at any rate, she came to a strange submission. The savage virgin had turned to very woman, and was presently a willing slave, returning on the gaily appointed ship in all haste to Athens, where in supposed wedlock she bore King Theseus a son.

With their annual visit—visit to the Gargareans !—for the purpose of maintaining their

species, parting with their boys early, these
husbandless women could hardly be supposed a
very happy, certainly not a very joyous people.
They figure rather as a sorry measure of the luck
of the female sex in taking a hard natural law into
their own hands, and by abnegation of all tender
companionship making shift with bare inde-
pendence, as a kind of second-best—the best
practicable by them in the imperfect actual con-
dition of things. But the heart-strings would
ache still where the breast had been cut away.
The sisters of Antiope had come, not immedi-
ately, but in careful array of battle, to bring back
the captive. All along the weary roads from
the Caucasus to Attica, their traces had remained
in the great graves of those who died by the way.
Against the little remnant, carrying on the fight
to the very midst of Athens, Antiope herself
had turned, all other thoughts transformed now
into wild idolatry of her hero. Superstitious, or
in real regret, the Athenians never forgot their
tombs. As for Antiope, the conscience of her
perfidy remained with her, adding the pang
of remorse to her own desertion, when King
Theseus, with his accustomed bad faith to women,
set her, too, aside in turn. Phædra, the true
wife, was there, peeping suspiciously at her
arrival ; and even as Antiope yielded to her
lord's embraces the thought had come that a
male child might be the instrument of her anger,
and one day judge her cause.

HIPPOLYTUS VEILED

In one of these doomed, decaying villages, then, King Theseus placed the woman and her babe, hidden, yet secure, within the Attic border, as men veil their mistakes or crimes. They might pass away, they and their story, together with the memory of other antiquated creatures of such places, who had had connubial dealings with the stars. The white, paved waggon-track, a by-path of the sacred way to Eleusis, zigzagged through sloping olive-yards, from the plain of silvered blue, with Athens building in the distance, and passed the door of the rude stone house, furnished scantily, which no one had ventured to inhabit of late years till they came there. On the ledges of the grey cliffs above, the laurel groves, stem and foliage of motionless bronze, had spread their tents. Travellers bound northwards were glad to repose themselves there, and take directions, or provision for their journey onwards, from the highland people, who came down hither to sell their honey, their cheese, and woollen stuff, in the tiny market-place. At dawn the great stars seemed to halt a while, burning as if for sacrifice to some pure deity, on those distant, obscurely named heights, like broken swords, the rim of the world. A little later you could just see the newly opened quarries, like streaks of snow on their russet-brown bosoms. Thither in spring-time all eyes turned from Athens devoutly, intent till the first shaft of lightning gave signal for the departure of the

163

sacred ship to Delos. Racing over those rocky surfaces, the virgin air descended hither with the secret of profound sleep, as the child lay in its cubicle hewn in the stone, the white fleeces heaped warmly round him. In the wild Amazon's soul, to her surprise, and at first against her will, the maternal sense had quickened from the moment of his conception, and (that burst of angry tears with which she had received him into the world once dried up), kindling more eagerly at every token of manly growth, had at length driven out every other feeling. And this animal sentiment, educating the human hand and heart in her, had become a moral one, when, King Theseus leaving her in anger, visibly unkind, the child had crept to her side, and tracing with small fingers the wrinkled lines of her woebegone brow, carved there as if by a thousand years of sorrow, had sown between himself and her the seed of an undying sympathy.

She was thus already on the watch for a host of minute recognitions on his part, of the self-sacrifice involved in her devotion to a career of which she must needs drain out the sorrow, careful that he might taste only the joy. So far, amid their spare living, the child, as if looking up to the warm broad wing of her love above him, seemed replete with comfort. Yet in his moments of childish sickness, the first passing shadows upon the deep joy of her motherhood, she teaches him betimes to soothe

or cheat pain—little bodily pains only, hitherto. She ventures sadly to assure him of the harsh necessities of life : " Courage, child ! Every one must take his share of suffering. Shift not thy body so vehemently. Pain, taken quietly, is easier to bear."

Carefully inverting the habits of her own rude childhood, she learned to spin the wools, white and grey, to clothe and cover him pleasantly. The spectacle of his unsuspicious happiness, though at present a matter of purely physical conditions, awoke a strange sense of poetry, a kind of artistic sense in her, watching, as her own long-deferred recreation in life, his delight in the little delicacies she prepared to his liking—broiled kids' flesh, the red wine, the mushrooms sought through the early dew—his hunger and thirst so daintily satisfied, as he sat at table, like the first-born of King Theseus, with two wax-lights and a fire at dawn or nightfall dancing to the prattle and laughter, a bright child, never stupidly weary. At times his very happiness would seem to her like a menace of misfortune to come. Was there not with herself the curse of that unsisterly action ? and not far from him, the terrible danger of the father's, the step-mother's jealousy, the mockery of those half-brothers to come ? Ah ! how perilous for happiness the sensibilities which make him so exquisitely happy now ! Before they started on their dreadful visit to the Minotaur, says Plutarch, the women told their

sons many tales and other things to encourage
them ; and, even as she had furnished the child
betimes with rules for the solace of bodily pain,
so now she would have brought her own sad
experience into service in precepts for the ejection
of its festering power out of any other trouble
that might visit him. Already those little dis-
appointments which are as the shadow beside
all conscious enjoyment, were no petty things
to her, but had for her their pathos, as children's
troubles will have, in spite of the longer chance
before them. They were as the first steps in a
long story of deferred hopes, or anticipations of
death itself and the end of them.

The gift of Ares gone, the mystic girdle she
would fain have transferred to the child, that
bloody god of storm and battle, hereditary
patron of her house, faded from her thoughts
together with the memory of her past life—the
more completely, because another familiar though
somewhat forbidding deity, accepting certainly
a cruel and forbidding worship, was already in
possession, and reigning in the new home when
she came thither. Only, thanks to some kindly
local influence (by grace, say, of its delicate air),
Artemis, this other god she had known in the
Scythian wilds, had put aside her fierce ways,
as she paused awhile on her heavenly course
among these ancient abodes of men, gliding
softly, mainly through their dreams, with abun-
dance of salutary touches. Full, in truth, of

grateful memory of some timely service at human hands! In these highland villages the tradition of celestial visitants clung fondly, of god or hero, belated or misled on long journeys, yet pleased to be among the sons of men, as their way led them up the steep, narrow, crooked street, condescending to rest a little, as one, under some sudden stress not clearly ascertained, had done here, in this very house, thereafter for ever sacred. The place and its inhabitants, of course, had been something bigger in the days of those old mythic hospitalities, unless, indeed, divine persons took kindly the will for the deed—very different, surely, from the present condition of things, for there was little here to detain a delicate traveller, even in the abode of Antiope and her son, though it had been the residence of a king.

Hard by stood the chapel of the goddess, who had thus adorned the place with her memories. The priests, indeed, were already departed to Athens, carrying with them the ancient image, the vehicle of her actual presence, as the surest means of enriching the capital at the expense of the country, where she must now make poor shift of the occasional worshipper on his way through these mountain passes. But safely roofed beneath the sturdy tiles of grey Hymettus marble, upon the walls of the little square recess enclosing the deserted pedestal, a series of crowded imageries, in the devout spirit

of earlier days, were eloquent concerning her. Here from scene to scene, touched with silver among the wild and human creatures in dun bronze, with the moon's disk around her head, shrouded closely, the goddess of the chase still glided mystically through all the varied incidents of her story, in all the detail of a written book.

A book for the delighted reading of a scholar, willing to ponder at leisure, to make his way surely, and understand. Very different, certainly, from the cruel-featured little idol his mother had brought in her bundle—the old Scythian Artemis, hanging there on the wall, side by side with the forgotten Ares, blood-red,—the goddess reveals herself to the lad, poring through the dusk by taper-light, as at once a virgin, necessarily therefore the creature of solitude, yet also as the assiduous nurse of children, and patroness of the young. Her friendly intervention at the act of birth everywhere, her claim upon the nursling, among tame and wild creatures equally, among men as among gods, nay! among the stars (upon the very star of dawn), gave her a breadth of influence seemingly coextensive with the sum of things. Yes! his great mother was in touch with everything. Yet throughout he can but note her perpetual chastity, with pleasurable though half-suspicious wonder at the mystery, he knows not what, involved therein, as though he awoke suddenly in some distant, unexplored region of her person and activity.

HIPPOLYTUS VEILED

Why the lighted torch always, and that long straight vesture rolled round so formally ? Was it only against the cold of these northern heights ?

To her, nevertheless, her maternity, her solitude, to this virgin mother, who, with no husband, no lover, no fruit of her own, is so tender to the children of others, in a full heart he devotes himself—his immaculate body and soul. Dedicating himself thus, he has the sense also that he becomes more entirely than ever the chevalier of his mortal mother, of her sad cause. The devout, diligent hands clear away carefully the dust, the faded relics of her former worship ; a worship renewed once more as the sacred spring, set free from encumbrance, in answer to his willing ministries murmurs again under the dim vault in its marble basin, work of primitive Titanic fingers—flows out through its rocky channel, filling the whole township with chaste thoughts of her.

Through much labour at length he comes to the veritable story of her birth, like a gift direct from the goddess herself to this loyal soul. There were those in later times who, like Æschylus, knew Artemis as the daughter not of Leto but of Demeter, according to the version of her history now conveyed to the young Hippolytus, together with some deepened insight into her character. The goddess of Eleusis, on a journey, in the old days when, as Plato says,

men lived nearer the gods, finding herself with child by some starry inmate of those high places, had lain down in the rock-hewn cubicle of the inner chamber, and, certainly in sorrow, brought forth a daughter. Here was the secret at once of the genial, all-embracing maternity of this new strange Artemis, and of those more dubious tokens, the lighted torch, the winding-sheet, the arrow of death on the string—of sudden death, truly, which may be thought after all the kindest, as prevenient of all disgraceful sickness or waste in the unsullied limbs. For the late birth into the world of this so shadowy daughter was somehow identified with the sudden passing into Hades of her first-born, Persephone. As he scans those scenes anew, an awful surmise comes to him ; his divine patroness moves there as death, surely. Still, however, gratefully putting away suspicion, he seized even in these ambiguous imageries their happier suggestions, satisfied in thinking of his new mother as but the giver of sound sleep, of the benign night, whence—mystery of mysteries !—good things are born softly, from which he awakes betimes for his healthful service to her. Either way, sister of Apollo or sister of Persephone, to him she should be a power of sanity, sweet as the flowers he offered her gathered at dawn, setting daily their purple and white frost against her ancient marbles. There was more certainly than the first breath of day in them. Was there

here something of her person, her sensible
presence, by way of direct response to him in
his early devotion, astir for her sake before the
very birds, nesting here so freely, the quail
above all, in some privileged connexion with
her story still unfathomed by the learned youth?
Amid them he too found a voice, and sang
articulately the praises of the great goddess.

Those more dubious traits, nevertheless, so
lightly disposed of by Hippolytus (Hecate thus
counting for him as Artemis goddess of health),
became to his mother, in the light of her sad
experience, the sum of the whole matter. While
he drew only peaceful inducements to sleep
from that two-sided figure, she reads there a
volume of sinister intentions, and liked little this
seemingly dead goddess, who could but move
among the living banefully, stealing with her
night-shade into the day where she had no proper
right. The gods had ever had much to do with
the shaping of her fortunes and the fortunes of
her kindred ; and the mortal mother felt nothing
less than jealousy from the hour when the lad had
first delightedly called her to share his discoveries,
and learn the true story (if it were not rather the
malicious counterfeit) of the new divine mother
to whom he has thus absolutely entrusted him-
self. Was not this absolute chastity itself a kind
of death ? She, too, in secret makes her gruesome
midnight offering with averted eyes. She dreams
one night he is in danger ; creeps to his cubicle

to see ; the face is covered, as he lies, against the cold. She traces the motionless outline, raises the coverlet ; with the nice black head deep in the fleecy pillow he is sleeping quietly, he dreams of that other mother gliding in upon the moonbeam, and awaking turns sympathetically upon the living woman, is subdued in a moment to the expression of her troubled spirit, and understands.

And when the child departed from her for the first time, springing from his white bed before the dawn, to accompany the elders on their annual visit to the Eleusinian goddess, the after-sense of his wonderful happiness, tranquillising her in spite of herself by its genial power over the actual moment, stirred nevertheless a new sort of anxiety for the future. Her work in life henceforward was defined as a ministry to so precious a gift, in full consciousness of its risk ; it became her religion, the centre of her pieties. She missed painfully his continual singing hovering about the place, like the earth itself made audible in all its humanities. Half-selfish for a moment, she prays that he may remain for ever a child, to her solace ; welcomes now the promise of his chastity (though chastity were itself a kind of death) as the pledge of his abiding always with her. And these thoughts were but infixed more deeply by the sudden stroke of joy at his return home in ceremonial trim and grown more manly, with much increase of self-confidence in that brief absence among his fellows.

HIPPOLYTUS VEILED

For, from the first, the unwelcome child, the outcast, had been successful, with that special good fortune which sometimes attends the outcast. His happiness, his invincible happiness, had been found engaging, perhaps by the gods, certainly by men; and when King Theseus came to take note how things went in that rough life he had assigned them, he felt a half liking for the boy, and bade him come down to Athens and see the sights, partly by way of proof to his already somewhat exacting wife of the difference between the old love and the new as measured by the present condition of their respective offspring. The fine nature, fastidious by instinct, but bred with frugality enough to find the charm of continual surprise in that delicate new Athens, draws, as he goes, the full savour of its novelties; the marbles, the space and finish, the busy gaiety of its streets, the elegance of life there, contrasting with while it adds some mysterious endearment to the thought of his own rude home. Without envy, in hope only one day to share, to win them by kindness, he gazes on the motley garden-plots, the soft bedding, the showy toys, the delicate keep of the children of Phædra, who turn curiously to their half-brother, venture to touch his long strange gown of homespun grey, like the soft coat of some wild creature who might let one stroke it. Close to their dainty existence for a while, he regards it as from afar; looks forward all day to the lights, the prattle, the laughter, the white

bread, like sweet cake to him, of their ordinary evening meal ; returns again and again, in spite of himself, to watch, to admire, feeling a power within him to merit the like ; finds his way back at last, still light of heart, to his own poor fare, able to do without what he would enjoy so much. As, grateful for his scanty part in things—for the make-believe of a feast in the little white loaves she too has managed to come by, sipping the thin white wine, he touches her dearly, the mother is shocked with a sense of something unearthly in his contentment, while he comes and goes, singing now more abundantly than ever a new canticle to her divine rival. Were things, after all, to go grudgingly with him ? Sensible of that curse on herself, with her suspicions of his kinsfolk, of this dubious goddess to whom he has devoted himself, she anticipates with more foreboding than ever his path to be, with or without a wife—her own solitude, or his—the painful heats and cold. She fears even these late successes ; it were best to veil their heads. The strong as such had ever been against her and hers. The father came again ; noted the boy's growth. Manliest of men, like Hercules in his cloak of lion's skin, he has after all but scant liking, feels, through a certain meanness of soul, scorn for the finer likeness of himself. Might this creature of an already vanishing world, who for all his hard rearing had a manifest distinction of character, one day become his rival, full of

loyalty as he was already to the deserted mother?

To charming Athens, nevertheless, he crept back, as occasion served, to gaze peacefully on the delightful good fortune of others, waiting for the opportunity to take his own turn with the rest, driving down thither at last in a chariot gallantly, when all the town was assembled to celebrate the king's birthday. For the goddess, herself turning ever kinder, and figuring more and more exclusively as the tender nurse of all things, had transformed her young votary from a hunter into a charioteer, a rearer and driver of horses, after the fashion of his Amazon mothers before him. Thereupon, all the lad's wholesome vanity had centered on the fancy of the world-famous games then lately established, as, smiling down his mother's terrors, and grateful to his celestial mother for many a hair-breadth escape, he practised day by day, fed the animals, drove them out, amused though companionless, visited them affectionately in the deserted stone stables of the ancient king. A chariot and horses, as being the showiest outward thing the world afforded, was like the pawn he moved to represent the big demand he meant to make, honestly, generously, on the ample fortunes of life. There was something of his old miraculous kindred, alien from this busy new world he came to, about the boyish driver with the fame of a scholar, in his grey fleecy cloak and hood of soft

white woollen stuff, as he drove in that morning.
Men seemed to have seen a star flashing, and
crowded round to examine the little mountain-
bred beasts, in loud, friendly intercourse with the
hero of the hour—even those usually somewhat
unsympathetic half-brothers now full of enthusi-
asm for the outcast and his good fight for
prosperity. Instinctively people admired his
wonderful placidity, and would fain have shared
its secret, as it were the carelessness of some fair
flower upon his face. A victor in the day's race,
he carried home as his prize a glittering new
harness in place of the very old one he had come
with. "My chariot and horses!" he says now,
with his single touch of pride. Yet at home,
savouring to the full his old solitary happiness,
veiled again from time to time in that ancient
life, he is still the student, still ponders the old
writings which tell of his divine patroness. At
Athens strange stories are told in turn of him, his
nights upon the mountains, his dreamy sin, with
that hypocritical virgin goddess, stories which
set the jealous suspicions of Theseus at rest once
more. For so "dream" not those who have
the tangible, appraisable world in view. Even
Queen Phædra looks with pleasure, as he comes,
on the once despised illegitimate creature, at
home now here too, singing always audaciously,
so visibly happy, occupied, popular.

Encompassed by the luxuries of Athens, far
from those peaceful mountain places, among people

further still in spirit from their peaceful light
and shade, he did not forget the kindly goddess,
still sharing with his earthly mother the prizes,
or what they would buy, for the adornment of
their spare abode. The tombs of the fallen
Amazons, the spot where they had breathed
their last, he piously visited, informed himself
of every circumstance of the event with devout
care, and, thinking on them amid the dainties
of the royal table, boldly brought them too
their share of the offerings to the heroic dead.
Aphrodite, indeed—Aphrodite, of whom he had
scarcely so much as heard—was just then the
best-served deity in Athens, with all its new
wealth of colour and form, its gold and ivory,
the acting, the music, the fantastic women,
beneath the shadow of the great walls still rising
steadily. Hippolytus would have no part in her
worship ; instead did what was in him to revive
the neglected service of his own goddess, stirring
an old jealousy. For Aphrodite too had looked
with delight upon the youth, already the centre
of a hundred less dangerous human rivalries
among the maidens of Greece, and was by no
means indifferent to his indifference, his instinc-
tive distaste ; while the sterner, almost forgotten
Artemis found once more her great moon-shaped
cake, set about with starry tapers, at the appointed
seasons.

They know him now from afar, by his
emphatic, shooting, arrowy movements ; and on

the day of the great chariot races " he goes in
and wins." To the surprise of all he com-
pounded his handsome prize for the old wooden
image taken from the chapel at home, lurking
now in an obscure shrine in the meanest quarter
of the town. Sober amid the noisy feasting
which followed, unashamed, but travelling by
night to hide it from their mockery, warm at
his bosom, he reached the passes at twilight, and
through the deep peace of the glens bore it to
the old resting-place, now more worthy than
ever of the presence of its mistress, his mother
and all the people of the village coming forth
to salute her, all doors set mystically open, as
she advances.

Phædra too, his step-mother, a fiery soul with
wild strange blood in her veins, forgetting her
fears of this illegitimate rival of her children,
seemed now to have seen him for the first time,
loved at last the very touch of his fleecy cloak,
and would fain have had him of her own
religion. As though the once neglected child
had been another, she tries to win him as a
stranger in his manly perfection, growing more
than an affectionate mother to her husband's
son. But why thus intimate and congenial, she
asks, always in the wrong quarter? Why not
compass two ends at once? Why so squeamishly
neglect the powerful, any power at all, in a city
so full of religion? He might find the image
of her sprightly goddess everywhere, to his

liking, gold, silver, native or stranger, new or old, graceful, or indeed, if he preferred it so, in iron or stone. By the way, she explains the delights of love, of marriage, the husband once out of the way ; finds in him, with misgiving, a sort of forwardness, as she thinks, on this one matter, as if he understood her craft and despised it. He met her questions in truth with scarce so much as contempt, with laughing counter-queries, why people needed wedding at all ? They might have *found* the children in the temples, or bought them, as you could buy flowers in Athens.

Meantime Phædra's young children draw from the seemingly unconscious finger the marriage-ring, set it spinning on the floor at his feet, and the staid youth places it for a moment on his own finger for safety. As it settles there, his step-mother, aware all the while, suddenly presses his hand over it. He found the ring there that night as he lay ; left his bed in the darkness, and again, for safety, put it on the finger of the image, wedding once for all that so kindly mystical mother. And still, even amid his earthly mother's terrible misgivings, he seems to foresee a charming career marked out before him in friendly Athens, to the height of his desire. Grateful that he is here at all, sharing at last so freely life's banquet, he puts himself for a moment in his old place, recalling his old enjoyment of the pleasure of others ;

feels, just then, no different. Yet never had
life seemed so sufficing as at this moment—the
meat, the drink, the drives, the popularity as he
comes and goes, even his step-mother's false,
selfish, ostentatious gifts. But she, too, begins
to feel something of the jealousy of that other
divine, would-be mistress, and by way of a last
effort to bring him to a better mind in regard to
them both, conducts him (immeasurable privi-
lege!) to her own private chapel.

You could hardly tell where the apartments
of the adulteress ended and that of the divine
courtesan began. Haunts of her long, indolent,
self-pleasing nights and days, they presented
everywhere the impress of Phædra's luxurious
humour. A peculiar glow, such as he had never
before seen, like heady lamplight, or sunshine to
some sleeper in a delirious dream, hung upon,
clung to, the bold, naked, shameful imageries,
as his step-mother trimmed the lamps, drew
forth her sickly perfumes, clad afresh in piquant
change of raiment the almost formless goddess
crouching there in her unclean shrine or stye,
set at last her foolish wheel in motion to a low
chant, holding him by the wrist, keeping close
all the while, as if to catch some germ of consent
in his indifferent words.

And little by little he perceives that all this
is for him—the incense, the dizzy wheel, the
shreds of stuff cut secretly from his sleeve, the
sweetened cup he drank at her offer, unavail-

ingly; and yes! his own features surely, in
pallid wax. With a gasp of flighty laughter she
ventures to point the thing out to him, full as
he is at last of visible, irrepressible dislike. Ah!
it was that very reluctance that chiefly stirred
her. Healthily white and red, he had a marvel-
lous air of discretion about him, as of one never
to be caught unaware, as if he never could be
anything but like water from the rock, or the
wild flowers of the morning, or the beams of
the morning star turned to human flesh. It was
the self-possession of this happy mind, the purity
of this virgin body, she would fain have per-
turbed, as a pledge to herself of her own gaudy
claim to supremacy. King Theseus, as she
knew, had had at least two earlier loves; for
once she would be a first love; felt at moments
that with this one passion once indulged, it
might be happiness thereafter to remain chaste
for ever. And then, by accident, yet surely
reading indifference in his manner of accepting
her gifts, she is ready again for contemptuous,
open battle. Is he indeed but a child still, this
nursling of the forbidding Amazon, of that
Amazonian goddess—to be a child always? or a
wily priest rather, skilfully circumventing her
sorceries, with mystic precautions of his own?
In truth, there is something of the priestly
character in this impassible discretion, remind-
ing her of his alleged intimacy with the rival
goddess, and redoubling her curiosity, her fond-

ness. Phædra, love-sick, feverish, in bodily sickness at last, raves of the cool woods, the chase, the steeds of Hippolytus, her thoughts running madly on what she fancies to be his secret business; with a storm of abject tears, foreseeing in one moment of recoil the weary tale of years to come, star-stricken as she declares, she dared at last to confess her longing to already half-suspicious attendants; and, awake one morning to find Hippolytus there kindly at her bidding, drove him openly forth in a tempest of insulting speech. There was a mordant there, like the menace of misfortune to come, in which the injured goddess also was invited to concur. What words! what terrible words! following, clinging to him, like acrid fire upon his bare flesh, as he hasted from Phædra's house, thrust out at last, his vesture remaining in her hands. The husband returning suddenly, she tells him a false story of violence to her bed, and is believed.

King Theseus, all his accumulated store of suspicion and dislike turning now to active hatred, flung away readily upon him, bewildered, unheard, one of three precious curses (some mystery of wasting sickness therein) with which Poseidon had indulged him. It seemed sad that one so young must call for justice, precariously, upon the gods, the dead, the very walls! Admiring youth dared hardly bid farewell to their late comrade; are generous, at most, in

stolen, sympathetic glances towards the fallen
star. At home, veiled once again in that
ancient twilight world, his mother, fearing
solely for what he may suffer by the departure
of that so brief prosperity, enlarged as it had
been, even so, by his grateful taking of it, is
reassured, delighted, happy once more at the
visible proof of his happiness, his invincible
happiness. Duly he returned to Athens, early
astir, for the last time, to restore the forfeited
gifts, drove back his gaily painted chariot to
leave there behind him, actually enjoying the
drive, going home on foot poorer than ever.
He takes again to his former modes of life, a
little less to the horses, a little more to the old
studies, the strange, secret history of his favourite
goddess,—wronged surely ! somehow, she too,
as powerless to help him ; till he lay sick at
last, battling one morning, unaware of his
mother's presence, with the feverish creations of
the brain ; the giddy, foolish wheel, the foolish
song, of Phædra's chapel, spinning there with
his heart bound thereto. "The curses of my
progenitors are come upon me !" he cries.
"And yet, why so ? guiltless as I am of evil."
His wholesome religion seeming to turn against
him now, the trees, the streams, the very rocks,
swoon into living creatures, swarming around
the goddess who has lost her grave quietness.
He finds solicitation, and recoils, in the wind, in
the sounds of the rain ; till at length delirium

itself finds a note of returning health. The feverish wood-ways of his fancy open unexpectedly upon wide currents of air, lulling him to sleep ; and the conflict ending suddenly altogether at its sharpest, he lay in the early light motionless among the pillows, his mother standing by, as she thought, to see him die. As if for the last time, she presses on him the things he had liked best in that eating and drinking she had found so beautiful. The eyes, the eyelids are big with sorrow ; and, as he understands again, making an effort for her sake, the healthy light returns into his ; a hand seizes hers gratefully, and a slow convalescence begins, the happiest period in the wild mother's life. When he longed for flowers for the goddess, she went a toilsome journey to seek them, growing close, after long neglect, wholesome and firm on their tall stalks. The singing she had longed for so despairingly hovers gaily once more within the chapel and around the house.

At the crisis of that strange illness she had supposed her long forebodings about to be realised at last ; but upon his recovery feared no more, assured herself that the curses of the father, the step-mother, the concurrent ill-will of that angry goddess, have done their utmost ; he will outlive her ; a few years hence put her to a rest surely welcome. Her misgivings, arising always out of the actual spectacle of his profound happiness, seemed at an end in this meek bliss, the more as

she observed that it was a shade less unconscious than of old. And almost suddenly he found the strength, the heart, in him, to try his fortune again with the old chariot ; and those still unsatisfied curses, in truth, going on either side of him like living creatures unseen, legend tells briefly how, a competitor for pity with Adonis, and Icarus, and Hyacinth, and other doomed creatures of immature radiance in all story to come, he set forth joyously for the chariot-races, not of Athens, but of Trœzen, her rival. Once more he wins the prize ; he says good-bye to admiring friends anxious to entertain him, and by night starts off homewards, as of old, like a child, returning quickly through the solitude in which he had never lacked company, and was now to die. Through all the perils of darkness he had guided the chariot safely along the curved shore ; the dawn was come, and a little breeze astir, as the grey level spaces parted delicately into white and blue, when in a moment an earthquake, or Poseidon the earth-shaker himself, or angry Aphrodite awake from the deep betimes, rent the tranquil surface ; a great wave leapt suddenly into the placid distance of the Attic shore, and was surging here to the very necks of the plunging horses, a moment since enjoying so pleasantly with him the caress of the morning air, but now, wholly forgetful of their old affectionate habit of obedience, dragging their leader headlong over the rough pavements.

Evening and the dawn might seem to have met on that hapless day through which they drew him home entangled in the trappings of the chariot that had been his ruin, till he lay at length, grey and haggard, at the rest he had longed for dimly amid the buffeting of those murderous stones, his mother watching impassibly, sunk at once into the condition she had so long anticipated.

Later legend breaks a supernatural light over that great desolation, and would fain relieve the reader by introducing the kindly Asclepius, who presently restores the youth to life, not, however, in the old form or under familiar conditions. To her, surely, counting the wounds, the disfigurements, telling over the pains which had shot through that dear head now insensible to her touch among the pillows under the harsh broad daylight, that would have been no more of a solace than if, according to the fancy of Ovid, he flourished still, a little deity, but under a new name and veiled now in old age, in the haunted grove of Aricia, far from his old Attic home, in a land which had never seen him as he was.

THE BEGINNINGS OF GREEK
SCULPTURE

I

THE HEROIC AGE OF GREEK ART

THE extant remains of Greek sculpture, though but a fragment of what the Greek sculptors produced, are, both in number and in excellence, in their fitness, therefore, to represent the whole of which they were a part, quite out of proportion to what has come down to us of Greek painting, and all those minor crafts which, in the Greek workshop, as at all periods when the arts have been really vigorous, were closely connected with the highest imaginative work. Greek painting is represented to us only by its distant reflexion on the walls of the buried houses of Pompeii, and the designs of subordinate though exquisite craftsmen on the vases. Of wrought metal, partly through the inherent usefulness of its material, tempting ignorant persons into whose hands it may fall to re-fashion it, we have comparatively little ; while, in consequence of the perishableness of their material, nothing

remains of the curious wood-work, the carved
ivory, the embroidery and coloured stuffs, on
which the Greeks set much store—of that whole
system of refined artisanship, diffused, like a
general atmosphere of beauty and richness, around
the more exalted creations of Greek sculpture.
What we possess, then, of that highest Greek
sculpture is presented to us in a sort of threefold
isolation; isolation, first of all, from the concomi-
tant arts—the frieze of the Parthenon without
the metal bridles on the horses, for which the
holes in the marble remain; isolation, secondly,
from the architectural group of which, with
most careful estimate of distance and point of
observation, that frieze, for instance, was designed
to be a part; isolation, thirdly, from the clear
Greek skies, the poetical Greek life, in our
modern galleries. And if one here or there, in
looking at these things, bethinks himself of the
required substitution; if he endeavours mentally
to throw them back into that proper atmosphere,
through which alone they can exercise over us
all the magic by which they charmed their
original spectators, the effort is not always a
successful one, within the grey walls of the
Louvre or the British Museum.

And the circumstance that Greek sculpture is
presented to us in such falsifying isolation from
the work of the weaver, the carpenter, and the
goldsmith, has encouraged a manner of regarding
it too little sensuous. Approaching it with full

information concerning what may be called the inner life of the Greeks, their modes of thought and sentiment amply recorded in the writings of the Greek poets and philosophers, but with no lively impressions of that mere craftsman's world of which so little has remained, students of antiquity have for the most part interpreted the creations of Greek sculpture, rather as elements in a sequence of abstract ideas, as embodiments, in a sort of petrified language, of pure thoughts, and as interesting mainly in connexion with the development of Greek intellect, than as elements of a sequence in the material order, as results of a designed and skilful dealing of accomplished fingers with precious forms of matter for the delight of the eyes. Greek sculpture has come to be regarded as the product of a peculiarly limited art, dealing with a specially abstracted range of subjects ; and the Greek sculptor as a workman almost exclusively intellectual, having only a sort of accidental connexion with the material in which his thought was expressed. He is fancied to have been disdainful of such matters as the mere tone, the fibre or texture, of his marble or cedar-wood, of that just perceptible yellowness, for instance, in the ivory-like surface of the Venus of Melos ; as being occupied only with forms as abstract almost as the conceptions of philosophy, and translateable it might be supposed into any material—a habit of regarding him still further encouraged by the modern

sculptor's usage of employing merely mechanical labour in the actual working of the stone.

The works of the highest Greek sculpture are indeed *intellectualised*, if we may say so, to the utmost degree ; the human figures which they present to us seem actually to conceive thoughts ; in them, that profoundly reasonable spirit of design which is traceable in Greek art, continuously and increasingly, upwards from its simplest products, the oil-vessel or the urn, reaches its perfection. Yet, though the most abstract and intellectualised of sensuous objects, they are still sensuous and material, addressing themselves, in the first instance, not to the purely reflective faculty, but to the eye ; and a complete criticism must have approached them from both sides— from the side of the intelligence indeed, towards which they rank as great thoughts come down into the stone ; but from the sensuous side also, towards which they rank as the most perfect results of that pure skill of hand, of which the Venus of Melos, we may say, is the highest example, and the little polished pitcher or lamp, also perfect in its way, perhaps the lowest.

To pass by the purely visible side of these things, then, is not only to miss a refining pleasure, but to mistake altogether the medium in which the most intellectual of the creations of Greek art, the Æginetan or the Elgin marbles, for instance, were actually produced ; even these having, in their origin, depended for much of

their charm on the mere material in which they were executed ; and the whole black and grey world of extant antique sculpture needing to be translated back into ivory and gold, if we would feel the excitement which the Greek seems to have felt in the presence of these objects. To have this really Greek sense of Greek sculpture, it is necessary to connect it, indeed, with the inner life of the Greek world, its thought and sentiment, on the one hand ; but on the other hand to connect it, also, with the minor works of price, *intaglios*, coins, vases ; with that whole system of material refinement and beauty in the outer Greek life, which these minor works represent to us ; and it is with these, as far as possible, that we must seek to relieve the air of our galleries and museums of their too intellectual greyness. Greek sculpture could not have been precisely a *cold* thing ; and, whatever a colour-blind school may say, pure thoughts have their coldness, a coldness which has sometimes repelled from Greek sculpture, with its unsuspected fund of passion and energy in material form, those who cared much, and with much insight, for a similar passion and energy in the coloured world of Italian painting.

Theoretically, then, we need that world of the minor arts as a complementary background for the higher and more austere Greek sculpture ; and, as matter of fact, it is just with such a world—with a period of refined and exquisite

tectonics (as the Greeks called all crafts strictly subordinate to architecture), that Greek art actually begins, in what is called the Heroic Age, that earliest, undefined period of Greek civilisation, the beginning of which cannot be dated, and which reaches down to the first Olympiad, about the year 776 B.C. Of this period we possess, indeed, no direct history, and but few actual monuments, great or small ; but as to its whole character and outward local colouring, for its art, as for its politics and religion, Homer may be regarded as an authority. The Iliad and the Odyssey, the earliest pictures of that heroic life, represent it as already delighting itself in the application of precious material and skilful handiwork to personal and domestic adornment, to the refining and beautifying of the entire outward aspect of life ; above all, in the lavish application of very graceful metal-work to such purposes. And this representation is borne out by what little we possess of its actual remains, and by all we can infer. Mixed, of course, with mere fable, as a description of the heroic age, the picture which Homer presents to us, deprived of its supernatural adjuncts, becomes continuously more and more realisable as the actual condition of early art, when we emerge gradually into historical time, and find ourselves at last among dateable works and real schools or masters.

The history of Greek art, then, begins, as some have fancied general history to begin, in a

golden age, but in an age, so to speak, of real gold, the period of those first twisters and hammerers of the precious metals—men who had already discovered the flexibility of silver and the ductility of gold, the capacity of both for infinite delicacy of handling, and who enjoyed, with complete freshness, a sense of beauty and fitness in their work—a period of which that flower of gold on a silver stalk, picked up lately in one of the graves at Mycenæ, or the legendary golden honeycomb of Dædalus, might serve as the symbol. The heroic age of Greek art is the age of the hero as smith.

There are in Homer two famous descriptive passages in which this delight in curious metalwork is very prominent; the description in the Iliad of the shield of Achilles,[1] and the description of the house of Alcinous in the Odyssey.[2] The shield of Achilles is part of the suit of armour which Hephæstus makes for him at the request of Thetis; and it is wrought of variously coloured metals, woven into a great circular composition in relief, representing the world and the life in it. The various activities of man are recorded in this description in a series of idyllic incidents with such complete freshness, liveliness, and variety, that the reader from time to time may well forget himself, and fancy he is reading a mere description of the incidents of actual life.

[1] *Il.* xviii. 468-608. [2] *Od.* vii. 37-132.

We peep into a little Greek town, and see in dainty miniature the bride coming from her chamber with torch-bearers and dancers, the people gazing from their doors, a quarrel between two persons in the market-place, the assembly of the elders to decide upon it. In another quartering is the spectacle of a city besieged, the walls defended by the old men, while the soldiers have stolen out and are lying in ambush. There is a fight on the river-bank; Ares and Athene, conspicuous in gold, and marked as divine persons by a scale larger than that of their followers, lead the host. The strange, mythical images of Kêr, Eris, and Kudoimos mingle in the crowd. A third space upon the shield depicts the incidents of peaceful labour—the ploughshare passing through the field, of enamelled black metal behind it, and golden before; the cup of mead held out to the plough-man when he reaches the end of the furrow; the reapers with their sheaves; the king standing in silent pleasure among them, intent upon his staff. There are the labourers in the vine-yard in minutest detail; stakes of silver on which the vines hang; the dark trench about it, and one pathway through the midst; the whole complete and distinct, in variously coloured metal. All things and living creatures are in their places—the cattle coming to water to the sound of the herdsman's pipe, various music, the rushes by the water-side, a lion-hunt with dogs,

the pastures among the hills, a dance, the fair dresses of the male and female dancers, the former adorned with swords, the latter with crowns. It is an image of ancient life, its pleasure and business. For the centre, as in some quaint chart of the heavens, are the earth and the sun, the moon and constellations; and to close in all, right round, like a frame to the picture, the great river Oceanus, forming the rim of the shield, in some metal of dark blue.

Still more fascinating, perhaps, because more completely realisable by the fancy as an actual thing—realisable as a delightful place to pass time in—is the description of the palace of Alcinous in the little island town of the Phæacians, to which we are introduced in all the liveliness and sparkle of the morning, as real as something seen last summer on the sea-coast; although, appropriately, Ulysses meets a goddess, like a young girl carrying a pitcher, on his way up from the sea. Below the steep walls of the town, two projecting jetties allow a narrow passage into a haven of stone for the ships, into which the passer-by may look down, as they lie moored below the roadway. In the midst is the king's house, all glittering, again, with curiously wrought metal; its brightness is " as the brightness of the sun or of the moon." The heart of Ulysses beats quickly when he sees it standing amid plantations ingeniously watered, its floor and walls of brass throughout, with continuous

195

cornice of dark iron ; the doors are of gold, the door-posts and lintels of silver, the handles, again, of gold—

> The walls were massy brass ; the cornice high
> Blue metals crowned in colours of the sky ;
> Rich plates of gold the folding-doors incase ;
> The pillars silver on a brazen base ;
> Silver the lintels deep-projecting o'er ;
> And gold the ringlets that command the door.

Dogs of the same precious metals keep watch on either side, like the lions over the old gateway of Mycenæ, or the gigantic, human-headed bulls at the entrance of an Assyrian palace. Within doors the burning lights at supper-time are supported in the hands of golden images of boys, while the guests recline on a couch running all along the wall, covered with peculiarly sumptuous women's work.

From these two glittering descriptions manifestly something must be deducted ; we are in wonder-land, and among supernatural or magical conditions. But the forging of the shield and the wonderful house of Alcinous are no merely incongruous episodes in Homer, but the consummation of what is always characteristic of him, a constant preoccupation, namely, with every form of lovely craftsmanship, resting on all things, as he says, like the shining of the sun. We seem to pass, in reading him, through the treasures of some royal collection ; in him the presentation of almost every aspect of life is

beautified by the work of cunning hands. The thrones, coffers, couches of curious carpentry, are studded with bossy ornaments of precious metal effectively disposed, or inlaid with stained ivory, or blue *cyanus*, or amber, or pale amber-like gold ; the surfaces of the stone conduits, the sea-walls, the public washing-troughs, the ramparts on which the weary soldiers rest themselves when returned to Troy, are fair and smooth ; all the fine qualities, in colour and texture, of woven stuff are carefully noted—the fineness, closeness, softness, pliancy, gloss, the whiteness or nectar-like tints in which the weaver delights to work ; to weave the sea-purple threads is the appropriate function of queens and noble women. All the Homeric shields are more or less ornamented with variously coloured metal, terrible sometimes, like Leonardo's, with some monster or grotesque. The numerous sorts of cups are bossed with golden studs, or have handles wrought with figures, of doves, for instance. The great brazen cauldrons bear an epithet which means *flowery*. The trappings of the horses, the various parts of the chariots, are formed of various metals. The women's ornaments and the instruments of their toilet are described—

πόρπας τε γναμπτάς θ᾽ ἕλικας, κάλυκάς τε καὶ ὅρμους

—the golden vials for unguents. Use and beauty are still undivided ; all that men's hands are set to make has still a fascination alike for workmen

and spectators. For such dainty splendour Troy, indeed, is especially conspicuous. But then Homer's Trojans are essentially Greeks—Greeks of Asia ; and Troy, though more advanced in all elements of civilisation, is no real contrast to the western shore of the Ægean. It is no *barbaric* world that we see, but the sort of world, we may think, that would have charmed also our comparatively jaded sensibilities, with just that quaint simplicity which we too enjoy in its productions ; above all, in its wrought metal, which loses perhaps more than any other sort of work by becoming mechanical. The metalwork which Homer describes in such variety is all *hammer*-work, all the joinings being effected by pins or riveting. That is just the sort of metal-work which, in a certain *naïveté* and vigour, is still of all work the most expressive of actual contact with dexterous fingers ; one seems to trace in it, on every particle of the partially resisting material, the touch and play of the shaping instruments, in highly trained hands, under the guidance of exquisitely disciplined senses—that *cachet*, or seal of nearness to the workman's hand, which is the special charm of all good metal-work, of early metal-work in particular.

Such descriptions, however, it may be said, are mere poetical ornament, of no value in helping us to define the character of an age. But what is peculiar in these Homeric descrip-

tions, what distinguishes them from others at first sight similar, is a sort of internal evidence they present of a certain degree of reality, signs in them of an imagination stirred by surprise at the spectacle of real works of art. Such minute, delighted, loving description of details of ornament, such following out of the ways in which brass, gold, silver, or paler gold, go into the chariots and armour and women's dress, or cling to the walls—the enthusiasm of the *manner*—is the warrant of a certain amount of truth in all that. The Greek poet describes these things with the same vividness and freshness, the same kind of fondness, with which other poets speak of flowers ; speaking of them poetically, indeed, but with that higher sort of poetry which seems full of the lively impression of delightful things recently seen. Genuine poetry, it is true, is always naturally sympathetic with all beautiful sensible things and qualities. But with how many poets would not this constant intrusion of material ornament have produced a tawdry effect ! The metal would all be tarnished and the edges blurred. And this is because it is not always that the products of even exquisite tectonics can excite or refine the æsthetic sense. Now it is probable that the objects of oriental art, the imitations of it at home, in which for Homer this actual world of art must have consisted, reached him in a quantity, and with a novelty, just sufficient to warm and stimulate without

surfeiting the imagination ; it is an exotic thing
of which he sees just enough and not too much.
The shield of Achilles, the house of Alcinous,
are like dreams indeed, but this sort of dreaming
winds continuously through the entire Iliad and
Odyssey—a child's dream after a day of real,
fresh impressions from things themselves, in
which all those floating impressions re-set them-
selves. He is as pleased in touching and looking
at those objects as his own heroes ; their gleam-
ing aspect brightens all he says, and has taken
hold, one might think, of his language, his very
vocabulary becoming *chryselephantine*. Homer's
artistic descriptions, though enlarged by fancy,
are not wholly imaginary, and the extant remains
of monuments of the earliest historical age are
like lingering relics of that dream in a tamer but
real world.

The art of the heroic age, then, as represented
in Homer, connects itself, on the one side, with
those fabulous jewels so prominent in mytho-
logical story, and entwined sometimes so oddly
in its representation of human fortunes—the
necklace of Eriphyle, the necklace of Helen,
which Menelaus, it was said, offered at Delphi
to Athene Pronœa on the eve of his expedition
against Troy—mythical objects, indeed, but
which yet bear witness even thus early to the
æsthetic susceptibility of the Greek temper.
But, on the other hand, the art of the heroic age
connects itself also with the actual early begin-

nings of artistic production. There are touches
of reality, for instance, in Homer's incidental
notices of its instruments and processes; especi-
ally as regards the working of metal. He goes
already to the potter's wheel for familiar, life-like
illustration. In describing artistic wood-work
he distinguishes various stages of work; we see
clearly the instruments for turning and boring,
such as the old-fashioned drill-borer, whirled
round with a string; he mentions the names of
two artists, the one of an actual workman, the
other of a craft turned into a proper name—stray
relics, accidentally preserved, of a world, as we
may believe, of such wide and varied activity.
The forge of Hephæstus is a true forge; the
magic tripods on which he is at work are really
put together by conceivable processes, known in
early times. Compositions in relief similar to
those which he describes were actually made out
of thin metal plates cut into a convenient shape,
and then beaten into the designed form by the
hammer over a wooden model. These reliefs
were then fastened to a differently coloured
metal background or base, with nails or rivets,
for there is no soldering of metals as yet. To
this process the ancients gave the name of
empæstik, such embossing being still, in our own
time, a beautiful form of metal-work.

Even in the marvellous shield there are other
and indirect notes of reality. In speaking of the
shield of Achilles, I departed intentionally from

the order in which the subjects of the relief are
actually introduced in the Iliad, because, just
then, I wished the reader to receive the full effect
of the variety and elaborateness of the composi-
tion, as a representation or picture of the whole
of ancient life embraced within the circumference
of a shield. But in the order in which Homer
actually describes those episodes he is following
the method of a very practicable form of com-
position, and is throughout much closer than
we might at first sight suppose to the ancient
armourer's proceedings. The shield is formed
of five superimposed plates of different metals,
each plate of smaller diameter than the one
immediately below it, their flat margins showing
thus as four concentric stripes or rings of metal,
around a sort of boss in the centre, five metals
thick, and the outermost circle or ring being the
thinnest. To this arrangement the order of
Homer's description corresponds. The earth
and the heavenly bodies are upon this boss in the
centre, like a little distant heaven hung above
the broad world, and from this Homer works
out, round and round, to the river Oceanus,
which forms the border of the whole; the
subjects answering to, or supporting each other,
in a sort of heraldic order—the city at peace set
over against the city besieged—spring, summer,
and autumn balancing each other—quite con-
gruously with a certain heraldic turn common
in contemporary Assyrian art, which delights in

this sort of conventional spacing out of its various subjects, and especially with some extant metal chargers of Assyrian work, which, like some of the earliest Greek vases with their painted plants and flowers conventionally arranged, illustrate in their humble measure such heraldic grouping.

The description of the shield of Hercules, attributed to Hesiod, is probably an imitation of Homer, and, notwithstanding some fine mythological impersonations which it contains, an imitation less admirable than the original. Of painting there are in Homer no certain indications, and it is consistent with the later date of the imitator that we may perhaps discern in his composition a sign that what he had actually seen was a painted shield, in the predominance in it, as compared with the Homeric description, of effects of colour over effects of form ; Homer delighting in ingenious devices for *fastening* the metal, and the supposed Hesiod rather in what seem like triumphs of heraldic *colouring ;* though the latter also delights in effects of mingled metals, of mingled gold and silver especially—silver figures with dresses of gold, silver centaurs with pine-trees of gold for staves in their hands. Still, like the shield of Achilles, this too we must conceive as formed of concentric plates of metal ; and here again that spacing is still more elaborately carried out, narrower intermediate rings being apparently

introduced between the broader ones, with
figures in rapid, horizontal, unbroken motion,
carrying the eye right round the shield, in
contrast with the repose of the downward or
inward movement of the subjects which divide
the larger spaces ; here too with certain analogies
in the rows of animals to the designs on the
earliest vases.

In Hesiod then, as in Homer, there are
undesigned notes of correspondence between
the partly mythical ornaments imaginatively
enlarged of the heroic age, and a world of actual
handicrafts. In the shield of Hercules another
marvellous detail is added in the image of
Perseus, very daintily described as hovering in
some wonderful way, as if really borne up by
wings, above the surface. And that curious,
haunting sense of magic in art, which comes
out over and over again in Homer—in the
golden maids, for instance, who assist Hephæstus
in his work, and similar details which seem at
first sight to destroy the credibility of the whole
picture, and make of it a mere wonder-land—is
itself also, rightly understood, a testimony to a
real excellence in the art of Homer's time. It
is sometimes said that works of art held to be
miraculous are always of an inferior kind ; but
at least it was not among those who thought
them inferior that the belief in their miraculous
power began. If the golden images move like
living creatures, and the armour of Achilles, so

wonderfully made, lifts him like wings, this again is because the imagination of Homer is really under the stimulus of delightful artistic objects actually seen. Only those to whom such artistic objects manifest themselves through real and powerful impressions of their wonderful qualities, can invest them with properties magical or miraculous.

I said that the inherent usefulness of the material of metal-work makes the destruction of its acquired form almost certain, if it comes into the possession of people either barbarous or careless of the work of a past time. Greek art is for us, in all its stages, a fragment only ; in each of them it is necessary, in a somewhat visionary manner, to fill up empty spaces, and more or less make substitution ; and of the finer work of the heroic age, thus dimly discerned as an actual thing, we had at least till recently almost nothing. Two plates of bronze, a few rusty nails, and certain rows of holes in the inner surface of the walls of the " treasury " of Mycenæ, were the sole representatives of that favourite device of primitive Greek art, the lining of stone walls with burnished metal, of which the house of Alcinous in the Odyssey is the ideal picture, and the temple of Pallas *of the Brazen House* at Sparta, adorned in the interior with a coating of reliefs in metal, a later, historical example. Of the heroic or so-called Cyclopean architecture, that " treasury,"

a building so imposing that Pausanias thought it worthy to rank with the Pyramids, is a sufficient illustration. Treasury, or tomb, or both (the selfish dead, perhaps, being supposed still to find enjoyment in the costly armour, goblets, and mirrors laid up there), this dome-shaped building, formed of concentric rings of stones gradually diminishing to a coping-stone at the top, may stand as the representative of some similar buildings in other parts of Greece, and of many others in a similar kind of architecture elsewhere, constructed of large many-sided blocks of stone, fitted carefully together without the aid of cement, and remaining in their places by reciprocal resistance. Characteristic of it is the general tendency to use vast blocks of stone for the jambs and lintels of doors, for instance, and in the construction of gable-shaped passages; two rows of such stones being made to rest against each other at an acute angle, within the thickness of the walls.

So vast and rude, fretted by the action of nearly three thousand years, the fragments of this architecture may often seem, at first sight, like works of nature. At Argos, Tiryns, Mycenæ, the skeleton of the old architecture is more complete. At Mycenæ the gateway of the *acropolis* is still standing with its two well-known sculptured lions—immemorial and almost unique monument of primitive Greek sculpture—supporting, herald-wise, a symbolical pillar on the

vast, triangular, pedimental stone above. The heads are gone, having been fashioned possibly in metal by workmen from the East. On what may be called the *façade*, remains are still discernible of inlaid work in coloured stone, and within the gateway, on the smooth slabs of the pavement, the wheel-ruts are still visible. Connect them with those metal war-chariots in Homer, and you may see in fancy the whole grandiose character of the place, as it may really have been. Shut within the narrow enclosure of these shadowy citadels were the palaces of the kings, with all that intimacy which we may sometimes suppose to have been alien from the open-air Greek life, admitting, doubtless, below the cover of their rough walls, many of those refinements of princely life which the Middle Age found possible in such places, and of which the impression is so fascinating in Homer's description, for instance, of the house of Ulysses, or of Menelaus at Sparta. Rough and frowning without, these old *châteaux* of the Argive kings were delicate within with a decoration almost as dainty and fine as the network of weed and flower that now covers their ruins, and of the delicacy of which, as I said, that golden flower on its silver stalk, or the golden honeycomb of Dædalus, might be taken as representative. In these metal-like structures of self-supporting polygons, locked so firmly and impenetrably together, with the whole mystery of the reason-

ableness of the arch implicitly within them, there is evidence of a complete artistic command over weight in stone, and an understanding of the "law of weight." But over weight only; the ornament still seems to be not strictly architectural, but, according to the notices of Homer, tectonic, borrowed from the sister arts, above all from the art of the metal-workers, to whom those spaces of the building are left which a later age fills with painting, or relief in stone. The skill of the Asiatic comes to adorn this rough native building; and it is a late, elaborate, somewhat voluptuous skill, we may understand, illustrated by the luxury of that Asiatic chamber of Paris, less like that of a warrior than of one going to the dance. Coupled with the vastness of the architectural works which actually remain, such descriptions as that in Homer of the chamber of Paris and the house of Alcinous furnish forth a picture of that early period—the tyrants' age, the age of the *acropoleis*, the period of great dynasties with claims to "divine right," and in many instances at least with all the culture of their time. The vast buildings make us sigh at the thought of wasted human labour, though there is a public usefulness too in some of these designs, such as the draining of the Copaic lake, to which the backs of the people are bent whether they will or not. For the princes there is much of that selfish personal luxury which is a constant trait of feudalism in

all ages. For the people, scattered over the country, at their agricultural labour, or gathered in small hamlets, there is some enjoyment, perhaps, of the aspect of that splendour, of the bright warriors on the heights—a certain share of the nobler pride of the tyrants themselves in those tombs and dwellings. Some surmise, also, there seems to have been, of the " curse " of gold, with a dim, lurking suspicion of curious facilities for cruelty in the command over those skilful artificers in metal—some ingenious rack or bull " to pinch and peel "—the tradition of which, not unlike the modern Jacques Bonhomme's shudder at the old ruined French donjon or bastille, haunts, generations afterwards, the ruins of those " labyrinths " of stone, where the old tyrants had their pleasures. For it is a mistake to suppose that that wistful sense of eeriness in ruined buildings, to which most of us are susceptible, is an exclusively modern feeling. The name *Cyclopean*, attached to those desolate remains of buildings which were older than Greek history itself, attests their romantic influence over the fancy of the people who thus attributed them to a superhuman strength and skill. And the Cyclopes, like all the early mythical names of artists, have this note of reality, that they are names not of individuals but of classes, the guilds or companies of workmen in which a certain craft was imparted and transmitted. The Dactyli, the *Fingers*, are the

first workers in iron ; the savage Chalybes in
Scythia the first smelters ; actual names are
given to the old, fabled Telchines—Chalkon,
Argyron, Chryson—workers in brass, silver, and
gold, respectively. The tradition of their activity
haunts the several regions where those metals
were found. They make the trident of Poseidon ;
but then Poseidon's trident is a real fisherman's
instrument, the tunny-fork. They are credited,
notwithstanding, with an evil sorcery, unfriendly
to men, as poor humanity remembered the
makers of chains, locks, Procrustean beds ; and,
as becomes this dark, recondite mine and metal
work, the traditions about them are gloomy
and grotesque, confusing mortal workmen with
demon guilds.

To this view of the heroic age of Greek art as
being, so to speak, an age of real gold, an age de-
lighting itself in precious material and exquisite
handiwork in all tectonic crafts, the recent
extraordinary discoveries at Troy and Mycenæ
are, on any plausible theory of their date and
origin, a witness. The æsthetic critic needs
always to be on his guard against the confusion
of mere curiosity or antiquity with beauty in art.
Among the objects discovered at Troy — mere
curiosities, some of them, however interesting
and instructive — the so-called royal cup of
Priam, in solid gold, two-handled and double-
lipped, (the smaller lip designed for the host and
his libation, the larger for the guest,) has, in the

very simplicity of its design, the grace of the economy with which it exactly fulfils its purpose, a positive beauty, an absolute value for the æsthetic sense, while strange and new enough, if it really settles at last a much-debated expression of Homer ; while the " diadem," with its twisted chains and flowers of pale gold, shows that those profuse golden fringes, waving so comely as he moved, which Hephæstus wrought for the helmet of Achilles, were really within the compass of early Greek art.

And the story of the excavations at Mycenæ reads more like some well-devised chapter of fiction than a record of sober facts. Here, those sanguine, half-childish dreams of buried treasure discovered in dead men's graves, which seem to have a charm for every one, are more than fulfilled in the spectacle of those antique kings, lying in the splendour of their crowns and breastplates of embossed plate of gold ; their swords, studded with golden imagery, at their sides, as in some feudal monument ; their very faces covered up most strangely in golden masks. The very floor of one tomb, we read, was thick with gold-dust—the heavy gilding fallen from some perished kingly vestment ; in another was a downfall of golden leaves and flowers ; and, amid this profusion of thin fine fragments, were rings, bracelets, smaller crowns as if for children, dainty butterflies for ornaments of dresses, and that golden flower on a silver stalk—all of pure,

soft gold, unhardened by alloy, the delicate films of which one must touch but lightly, yet twisted and beaten, by hand and hammer, into wavy, spiral relief, the cuttle-fish with its long undulating arms appearing frequently.

It is the very image of the old luxurious life of the princes of the heroic age, as Homer describes it, with the arts in service to its kingly pride. Among the other costly objects was one representing the head of a cow, grandly designed in gold with horns of silver, like the horns of the moon, supposed to be symbolical of Here, the great object of worship at Argos. One of the interests of the study of mythology is that it reflects the ways of life and thought of the people who conceived it ; and this religion of Here, the special religion of Argos, is congruous with what has been here said as to the place of art in the civilisation of the Argives ; it is a reflexion of that splendid and wanton old feudal life. For Here is, in her original essence and meaning, equivalent to Demeter—the one living spirit of the earth, divined behind the veil of all its manifold visible energies. But in the development of a common mythological motive the various peoples are subject to the general limitations of their life and thought ; they can but work outward what is within them ; and the religious conceptions and usages, ultimately derivable from one and the same rudimentary instinct, are sometimes most diverse. Out of

the visible, physical energies of the earth and its system of annual change, the old Pelasgian mind developed the person of Demeter, mystical and profoundly aweful, yet profoundly pathetic, also, in her appeal to human sympathies. Out of the same original elements, the civilisation of Argos, on the other hand, developes the religion of Queen Here, a mere Demeter, at best, of gaudy flower-beds, whose toilet Homer describes with all its delicate fineries; though, characteristically, he may still allow us to detect, perhaps, some traces of the mystical person of the earth, in the all-pervading scent of the ambrosial unguent with which she anoints herself, in the abundant tresses of her hair, and in the curious variegation of her ornaments. She has become, though with some reminiscence of the mystical earth, a very limited human person, wicked, angry, jealous—the lady of Zeus in her castle-sanctuary at Mycenæ, in wanton dalliance with the king, coaxing him for cruel purposes in sweet sleep, adding artificial charms to her beauty.

Such are some of the characteristics with which Greek art is discernible in that earliest age. Of themselves, they almost answer the question which next arises—Whence did art come to Greece? or was it a thing of absolutely native growth there? So some have decidedly maintained. Others, who lived in an age possessing little or no knowledge of Greek monuments anterior to the full development of art under

Pheidias, and who, in regard to the Greek sculpture
of the age of Pheidias, were like people criticising
Michelangelo, without knowledge of the earlier
Tuscan school—of the works of Donatello and
Mino da Fiesole — easily satisfied themselves
with theories of its importation ready-made
from other countries. Critics in the last century,
especially, noticing some characteristics which
early Greek work has in common, indeed, with
Egyptian art, but which are common also
to all such early work everywhere, supposed, as
a matter of course, that it came, as the Greek
religion also, from Egypt—that old, immemorial
half-known birthplace of all wonderful things.
There are, it is true, authorities for this deriva-
tion among the Greeks themselves, dazzled as
they were by the marvels of the ancient civili-
sation of Egypt, a civilisation so different from
their own, on the first opening of Egypt to
Greek visitors. But, in fact, that opening did not
take place till the reign of Psammetichus, about
the middle of the seventh century B.C., a relatively
late date. Psammetichus introduced and settled
Greek mercenaries in Egypt, and, for a time,
the Greeks came very close to Egyptian life.
They can hardly fail to have been stimulated by
that display of every kind of artistic workmanship
gleaming over the whole of life ; they may in
turn have freshened it with new motives. And
we may remark, that but for the peculiar usage
of Egypt concerning the tombs of the dead, but

for their habit of investing the last abodes of the dead with all the appurtenances of active life, out of that whole world of art, so various and elaborate, nothing but the great, monumental works in stone would have remained to ourselves. We should have experienced in regard to it, what we actually experience too much in our knowledge of Greek art—the lack of a fitting background, in the smaller tectonic work, for its great works in architecture, and the bolder sort of sculpture.

But, one by one, at last, as in the medieval parallel, monuments illustrative of the earlier growth of Greek art before the time of Pheidias have come to light, and to a just appreciation. They show that the development of Greek art had already proceeded some way before the opening of Egypt to the Greeks, and point, if to a foreign source at all, to oriental rather than Egyptian influences ; and the theory which de-rived Greek art, with many other Greek things, from Egypt, now hardly finds supporters. In Greece all things are at once old and new. As, in physical organisms, the actual particles of matter have existed long before in other com-binations ; and what is really new in a new organism is the new cohering force—the *mode* of life,—so, in the products of Greek civilisation, the actual elements are traceable elsewhere by antiquarians who care to trace them ; the elements, for instance, of its peculiar national

architecture. Yet all is also emphatically *autochthonous*, as the Greeks said, new-born at home, by right of a new, informing, combining spirit playing over those mere elements, and touching them, above all, with a wonderful sense of the nature and destiny of man—the dignity of his soul and of his body—so that in all things the Greeks are as discoverers. Still, the original and primary motive seems, in matters of art, to have come from without; and the view to which actual discovery and all true analogies more and more point is that of a connexion of the origin of Greek art, ultimately with Assyria, proximately with Phœnicia, partly through Asia Minor, and chiefly through Cyprus —an original connexion again and again re-asserted, like a surviving trick of inheritance, as in later times it came in contact with the civil-isation of Caria and Lycia, old affinities being here linked anew ; and with a certain Asiatic tradition, of which one representative is the Ionic style of architecture, traceable all through Greek art—an Asiatic curiousness, or ποικιλία, strongest in that heroic age of which I have been speaking, and distinguishing some schools and masters in Greece more than others ; and always in appreciable distinction from the more clearly defined and self-asserted Hellenic influ-ence. Homer himself witnesses to the inter-course, through early, adventurous commerce, as in the bright and animated picture with which

the history of Herodotus begins, between the Greeks and Eastern countries. We may, perhaps, forget sometimes, thinking over the greatness of its place in the history of civilisation, how small a country Greece really was; how short the distances onwards, from island to island, to the coast of Asia, so that we can hardly make a sharp separation between Asia and Greece, nor deny, besides great and palpable acts of importation, all sorts of impalpable Asiatic influences, by way alike of attraction and repulsion, upon Greek manners and taste. Homer, as we saw, was right in making Troy essentially a Greek city, with inhabitants superior in all culture to their kinsmen on the Western shore, and perhaps proportionally weaker on the practical or moral side, and with an element of languid Ionian voluptuousness in them, typified by the cedar and gold of the chamber of Paris—an element which the austere, more strictly European influence of the Dorian Apollo will one day correct in all genuine Greeks. The Ægean, with its islands, is, then, a bond of union, not a barrier; and we must think of Greece, as has been rightly said, as its whole continuous shore.

The characteristics of Greek art, indeed, in the heroic age, so far as we can discern them, are those also of Phœnician art, its delight in metal among the rest, of metal especially as an element in architecture, the covering of everything with plates of metal. It was from

Phœnicia that the costly material in which
early Greek art delighted actually came—ivory,
amber, much of the precious metals. These
the adventurous Phœnician traders brought in
return for the mussel which contained the
famous purple, in quest of which they penetrated
far into all the Greek havens. Recent dis-
coveries present the island of Cyprus, the great
source of copper and copper-work in ancient
times, as the special mediator between the art
of Phœnicia and Greece; and in some archaic
figures of Aphrodite with her dove, brought
from Cyprus and now in the British Museum—
objects you might think, at first sight, taken
from the niches of a French Gothic cathedral—
are some of the beginnings, at least, of Greek
sculpture manifestly under the influence of
Phœnician masters. And, again, mythology
is the reflex of characteristic facts. It is
through Cyprus that the religion of Aphrodite
comes from Phœnicia to Greece. Here, in
Cyprus, she is connected with some other
kindred elements of mythological tradition,
above all with the beautiful old story of
Pygmalion, in which the thoughts of art and
love are connected so closely together. First
of all, on the prows of the Phœnician ships,
the tutelary image of Aphrodite *Euplœa*, the
protectress of sailors, comes to Cyprus—to
Cythera; it is in this simplest sense that she
is, primarily, *Anadyomene*. And her connexion

with the arts is always an intimate one. In Cyprus her worship is connected with an architecture, not colossal, but full of dainty splendour—the art of the shrine-maker, the maker of reliquaries ; the art of the toilet, the toilet of Aphrodite ; the Homeric hymn to Aphrodite is full of all that ; delight in which we have seen to be characteristic of the true Homer.

And now we see why Hephæstus, that crook-backed and uncomely god, is the husband of Aphrodite. Hephæstus is the god of fire, indeed ; as fire he is flung from heaven by Zeus ; and in the marvellous contest between Achilles and the river Xanthus in the twenty-first book of the Iliad, he intervenes in favour of the hero, as mere fire against water. But he soon ceases to be thus generally representative of the functions of fire, and becomes almost exclusively representative of one only of its aspects, its function, namely, in regard to early art ; he becomes the patron of smiths, bent with his labour at the forge, as people had seen such real workers ; he is the most perfectly developed of all the Dædali, Mulcibers, or Cabeiri. That the god of fire becomes the god of all art, architecture included, so that he makes the houses of the gods, and is also the husband of Aphrodite, marks a threefold group of facts ; the prominence, first, of a peculiar kind of art in early Greece, that beautiful metal-work, with

which he is bound and bent ; secondly, the connexion of this, through Aphrodite, with an almost wanton personal splendour; the connexion, thirdly, of all this with Cyprus and Phœnicia, whence, literally, Aphrodite comes. Hephæstus is the " spiritual form " of the Asiatic element in Greek art.

This, then, is the situation which the first period of Greek art comprehends ; a people whose civilisation is still young, delighting, as the young do, in ornament, in the sensuous beauty of ivory and gold, in all the lovely productions of skilled fingers. They receive all this, together with the worship of Aphrodite, by way of Cyprus, from Phœnicia, from the older, decrepit Eastern civilisation, itself long since surfeited with that splendour ; and they receive it in frugal quantity, so frugal that their thoughts always go back to the East, where there is the fulness of it, as to a wonder-land of art. Received thus in frugal quantity, through many generations, that world of Asiatic tectonics stimulates the sensuous capacity in them, accustoms the hand to produce and the eye to appreciate the more delicately enjoyable qualities of material things. But nowhere in all this various and exquisite world of design is there as yet any adequate sense of man himself, nowhere is there an insight into or power over human form as the expression of human soul. Yet those arts of design in which that younger people delights

have in them already, as *designed* work, that spirit of reasonable order, that expressive congruity in the adaptation of means to ends, of which the fully developed admirableness of human form is but the consummation—a consummation already anticipated in the grand and animated figures of epic poetry, their power of thought, their laughter and tears. Under the hands of that younger people, as they imitate and pass largely and freely beyond those older craftsmen, the fire of the reasonable soul will kindle, little by little, up to the Theseus of the Parthenon and the Venus of Melos.

The ideal aim of Greek sculpture, as of all other art, is to deal, indeed, with the deepest elements of man's nature and destiny, to command and express these, but to deal with them in a manner, and with a kind of expression, as clear and graceful and simple, if it may be, as that of the Japanese flower-painter. And what the student of Greek sculpture has to cultivate generally in himself is the capacity for appreciating the expression of thought in outward form, the constant habit of associating sense with soul, of tracing what we call expression to its sources. But, concurrently with this, he must also cultivate, all along, a not less equally constant appreciation of intelligent *workmanship* in work, and of *design* in things designed, of the rational control of matter everywhere. From many sources he may feed this sense of intelligence

and design in the productions of the minor crafts, above all in the various and exquisite art of Japan. Carrying a delicacy like that of nature itself into every form of imitation, reproduction, and combination—leaf and flower, fish and bird, reed and water—and failing only when it touches the sacred human form, that art of Japan is not so unlike the earliest stages of Greek art as might at first sight be supposed. We have here, and in no mere fragments, the spectacle of a universal application to the instruments of daily life of fitness and beauty, in a temper still unsophisticated, as also unelevated, by the divination of the spirit of man. And at least the student must always remember that Greek art was throughout a much richer and warmer thing, at once with more shadows, and more of a dim magnificence in its surroundings, than the illustrations of a classical dictionary might induce him to think. Some of the ancient temples of Greece were as rich in æsthetic curiosities as a famous modern museum. That Asiatic ποικιλία, that spirit of minute and curious loveliness, follows the bolder imaginative efforts of Greek art all through its history, and one can hardly be too careful in keeping up the sense of this daintiness of execution through the entire course of its development. It is not only that the minute object of art, the tiny vase-painting, *intaglio*, coin, or cameo, often reduces into the palm of the hand lines grander than those of

many a life-sized or colossal figure ; but there is also a sense in which it may be said that the Venus of Melos, for instance, is but a supremely well-executed object of *vertu,* in the most limited sense of the term. Those solemn images of the temple of Theseus are a perfect embodiment of the human ideal, of the reasonable soul and of a spiritual world ; they are also the best *made* things of their kind, as an urn or a cup is well made.

A perfect, many-sided development of tectonic crafts, a state such as the art of some nations has ended in, becomes for the Greeks a mere opportunity, a mere starting-ground for their imaginative presentment of man, moral and inspired. A world of material splendour, moulded clay, beaten gold, polished stone ;—the informing, reasonable soul entering into that, reclaiming the metal and stone and clay, till they are as full of living breath as the real warm body itself ; the presence of those two elements is continuous throughout the fortunes of Greek art after the heroic age, and the constant right estimate of their action and reaction, from period to period, its true philosophy.

II

CRITICS of Greek sculpture have often spoken of it as if it had been always work in colourless stone, against an almost colourless background. Its real background, as I have tried to show, was a world of exquisite craftsmanship, touching the minutest details of daily life with splendour and skill, in close correspondence with a peculiarly animated development of human existence—the energetic movement and stir of typically noble human forms, quite worthily clothed—amid scenery as poetic as Titian's. If shapes of colourless stone did come into that background, it was as the undraped human form comes into some of Titian's pictures, only to cool and solemnise its splendour ; the work of the Greek sculptor being seldom in quite colourless stone, nor always or chiefly in fastidiously selected marble even, but often in richly toned metal (this or that sculptor preferring some special variety of the bronze he worked in, such as the

hepatizón or liver-coloured bronze, or the bright golden alloy of Corinth), and in its consummate products chryselephantine,—work in gold and ivory, on a core of cedar. Pheidias, in the Olympian Zeus, in the Athene of the Parthenon, fulfils what that primitive, heroic goldsmiths' age, dimly discerned in Homer, already delighted in ; and the celebrated work of which I have first to speak now, and with which Greek sculpture emerges from that half-mythical age and becomes in a certain sense historical, is a link in that goldsmiths' or chryselephantine tradition, carrying us forwards to the work of Pheidias, backwards to the elaborate Asiatic furniture of the chamber of Paris.

When Pausanias visited Olympia, towards the end of the second century after Christ, he beheld, among other precious objects in the temple of Here, a splendidly wrought treasure-chest of cedar-wood, in which, according to a legend, quick as usual with the true human colouring, the mother of Cypselus had hidden him, when a child, from the enmity of her family, the *Bacchiadæ*, then the nobility of Corinth. The child, named Cypselus after this incident (*Cypsele* being a Corinthian word for *chest*), became tyrant of Corinth, and his grateful descendants, as it was said, offered the beautiful old chest to the temple of Here, as a memorial of his preservation. That would have been not long after the year 625 B.C. So much for the

story which Pausanias heard—but inherent probability, and some points of detail in his description, tend to fix the origin of the chest at a date at least somewhat later ; and as Herodotus, telling the story of the concealment of Cypselus, does not mention the dedication of the chest at Olympia at all, it may perhaps have been only one of many later imitations of antique art. But, whatever its date, Pausanias certainly saw the thing, and has left a long description of it, and we may trust his judgment at least as to its archaic style. We have here, then, something plainly visible at a comparatively recent date, something quite different from those perhaps wholly mythical objects described in Homer,—an object which seemed to so experienced an observer as Pausanias an actual work of earliest Greek art. Relatively to later *Greek* art, it may have seemed to him, what the ancient bronze doors with their Scripture histories, which we may still see in the south transept of the cathedral of Pisa, are to later *Italian* art.

Pausanias tells us nothing as to its size, nor directly as to its shape. It may, for anything he says, have been oval, but it was probably rectangular, with a broad front and two narrow sides, standing, as the maker of it had designed, against the wall ; for, in enumerating the various subjects wrought upon it, in five rows one above another, he seems to proceed, beginning at the bottom on the right-hand side, along the front

from right to left, and then back again, through
the second row from left to right, and, alternating
thus, upwards to the last subject, at the top, on
the left-hand side.

The subjects represented, most of which had
their legends attached in difficult archaic writing,
were taken freely, though probably with a lead-
ing idea, out of various poetic cycles, as treated
in the works of those so-called *cyclic* poets, who
continued the Homeric tradition. Pausanias
speaks, as Homer does in his description of
the shield of Achilles, of a kind and amount
of expression in feature and gesture certainly
beyond the compass of any early art, and we
may believe we have in these touches only what
the visitor heard from enthusiastic *exegetæ*, the
interpreters or sacristans ; though any one who
has seen the Bayeux tapestry, for instance, must
recognise the pathos and energy of which, when
really prompted by genius, even the earliest
hand is capable. Some ingenious attempts have
been made to restore the grouping of the scenes,
with a certain formal expansion or balancing of
subjects, their figures and dimensions, in true
Assyrian manner, on the front and sides. We
notice some fine emblematic figures, the germs
of great artistic motives in after times, already
playing their parts there,—*Death,* and *Sleep,* and
Night. " There was a woman supporting on
her right arm a white child sleeping ; and on
the other arm she held a dark child, as if asleep ;

and they lay with their feet crossed. And the inscription shows, what might be understood without it, that they are Death and Sleep, and Night, the nurse of both of them."

But what is most noticeable is, as I have already said, that this work, like the chamber of Paris, like the Zeus of Pheidias, is chryselephantine, its main fabric cedar, and the figures upon it partly of ivory, partly of gold,[1] but (and this is the most peculiar characteristic of its style) partly wrought out of the wood of the chest itself. And, as we read the description, we can hardly help distributing in fancy gold and ivory, respectively, to their appropriate functions in the representation. The cup of Dionysus, and the wings of certain horses there, Pausanias himself tells us were golden. Were not the apples of the Hesperides, the necklace of Eriphyle, the bridles, the armour, the unsheathed sword in the hand of Amphiaraus, also of gold? Were not the other children, like the white image of Sleep, especially the naked child Alcmæon, of ivory? with Alcestis and Helen, and that one of the Dioscuri whose beard was still ungrown? Were not ivory and gold, again, combined in the throne of Hercules, and in the three goddesses conducted before Paris?

The "chest of Cypselus" fitly introduces the first historical period of Greek art, a period

[1] Χρυσοῦν is the word Pausanias uses, of the cup in the hand of Dionysus—the wood was *plated* with gold.

coming down to about the year 560 B.C., and the government of Pisistratus at Athens; a period of tyrants like Cypselus and Pisistratus himself, men of strong, sometimes unscrupulous individuality, but often also acute and cultivated patrons of the arts. It begins with a series of inventions, one here and another there,—inventions still for the most part technical, but which are attached to single names; for, with the growth of art, the influence of individuals, gifted for the opening of new ways, more and more defines itself; and the school, open to all comers, from which in turn the disciples may pass to all parts of Greece, takes the place of the family, in which the knowledge of art descends as a tradition from father to son, or of the mere trade-guild. Of these early industries we know little but the stray notices of Pausanias, often ambiguous, always of doubtful credibility. What we do see, through these imperfect notices, is a real period of animated artistic activity, richly rewarded. Byzes of Naxos, for instance, is recorded as having first adopted the plan of sawing marble into thin plates for use on the roofs of temples instead of tiles; and that his name has come down to us at all, testifies to the impression this fair white surface made on its first spectators. Various islands of the Ægean become each the source of some new artistic device. It is a period still under the reign of Hephæstus, delighting, above all, in magnificent

metal-work. "The Samians," says Herodotus, "out of a tenth part of their profits—a sum of six talents—caused a mixing vessel of bronze to be made, after the Argolic fashion ; around it are projections of griffins' heads ; and they dedicated it in the temple of Here, placing beneath it three colossal figures of bronze, seven cubits in height, leaning upon their knees." That was in the thirty-seventh Olympiad, and may be regarded as characteristic of the age. For the popular imagination, a kind of glamour, some mysterious connexion of the thing with human fortunes, still attaches to the curious product of artistic hands, to the ring of Polycrates, for instance, with its early specimen of engraved *smaragdus*, as to the mythical necklace of Harmonia. Pheidon of Argos first makes coined money, and the *obelisci*—the old nail-shaped iron money, now disused—are hung up in the temple of Here ; for, even thus early, the temples are in the way of becoming museums. Names like those of Eucheir and Eugrammus, who were said to have taken the art of baking clay vases from Samos to Etruria, have still a legendary air, yet may be real surnames ; as in the case of Smilis, whose name is derived from a graver's tool, and who made the ancient image of Here at Samos. Corinth — *mater statuariæ* — becomes a great nursery of art at an early time. Some time before the twenty-ninth Olympiad, Butades of Sicyon, the potter, settled there. The record of

early inventions in Greece is sometimes fondly
coloured with human sentiment or incident. It
is on the butterfly wing of such an incident—the
love-sick daughter of the artist, who outlines on
the wall the profile of her lover as he sleeps in
the lamplight, to keep by her in absence—
that the name of Butades the potter has come
down to us. The father fills up the outline, long
preserved, it was believed, in the *Nymphæum* at
Corinth, and hence the art of modelling from
the life in clay. He learns, further, a way of
colouring his clay red, and fixes his masks along
the temple eaves.

The temple of Athene Chalciœcus—*Athene
of the brazen house* — at Sparta, the work of
Gitiades, celebrated about this time as archi-
tect, statuary, and poet ; who made, besides the
image in her shrine, and besides other Dorian
songs, a hymn to the goddess—was so called from
its crust or lining of bronze plates, setting forth,
in richly embossed imagery, various subjects of
ancient legend. What Pausanias, who saw it,
describes, is like an elaborate development of
that method of covering the interiors of stone
buildings with metal plates, of which the
" Treasury " at Mycenæ is the earliest historical,
and the house of Alcinous the heroic, type. In
the pages of Pausanias, that glitter, " as of the
moon or the sun," which Ulysses stood still to
wonder at, may still be felt. And on the right
hand of this " brazen house," he tells us, stood an

image of Zeus, also of bronze, the most ancient of
all images of bronze. This had not been cast, nor
wrought out of a single mass of metal, but, the
various parts having been finished separately
(probably beaten to shape with the hammer over
a wooden mould), had been fitted together with
nails or rivets. That was the earliest method of
uniting the various parts of a work in metal
— image, or vessel, or breastplate — a method
allowing of much dainty handling of the cunning
pins and rivets, and one which has its place
still, in perfectly accomplished metal-work, as in
the equestrian statue of Bartolomeo Coleoni, by
Andrea Verrocchio, in the *piazza* of St. John
and St. Paul at Venice. In the British Museum
there is a very early specimen of it,—a large
egg-shaped vessel, fitted together of several
pieces, the projecting pins or rivets, forming a
sort of diadem round the middle, being still
sharp in form and heavily gilt. That method
gave place in time to a defter means of joining
the parts together, with more perfect unity and
smoothness of surface, the art of soldering;
and the invention of this art—of soldering iron,
in the first instance—is coupled with the name
of Glaucus of Chios, a name which, in connexion
with this and other devices for facilitating the
mechanical processes of art, — for perfecting
artistic effect with economy of labour,—became
proverbial, the " art of Glaucus " being attributed
to those who work well with rapidity and ease.

BEGINNINGS OF GREEK SCULPTURE

Far more fruitful still was the invention of casting, of casting hollow figures especially, attributed to Rhœcus and Theodorus, architects of the great temple at Samos. Such hollow figures, able, in consequence of their lightness, to rest, almost like an inflated bladder, on a single point—the entire bulk of a heroic rider, for instance, on the point of his horse's tail—admit of a much freer distribution of the whole weight or mass required, than is possible in any other mode of statuary ; and the invention of the art of casting is really the discovery of liberty in composition.[1]

And, at last, about the year 576 B.C., we come to the first true school of sculptors, the first clear example, as we seem to discern, of a communicable style, reflecting and interpreting some real individuality (the double personality, in this case, of two brothers) in the masters who evolved it, conveyed to disciples who came to acquire it from distant places, and taking root through them at various centres, where the names of the

[1] Pausanias, in recording the invention of casting, uses the word ἐχωνεύσαντο, but does not tell us whether the model was of wax, as in the later process ; which, however, is believed to have been the case. For an animated account of the modern process :—the core of plaister roughly presenting the designed form; the modelling of the waxen surface thereon, like the skin upon the muscles, with all its delicate touches — vein and eyebrow; the hardening of the plaister envelope, layer over layer, upon this delicately finished model ; the melting of the wax by heat, leaving behind it in its place the finished design *in vacuo*, which the molten stream of metal subsequently fills ; released finally, after cooling, from core and envelope—see Fortnum's Handbook of *Bronzes*, Chapter II.

masters became attached, of course, to many
fair works really by the hands of the pupils.
Dipœnus and Scyllis, these first true *masters*,
were born in Crete ; but their work is connected
mainly with Sicyon, at that time the chief seat
of Greek art. " In consequence of some injury
done them," it is said, "while employed there
upon certain sacred images, they departed to
another place, leaving their work unfinished ;
and, not long afterwards, a grievous famine fell
upon Sicyon. Thereupon, the people of Sicyon,
inquiring of the Pythian Apollo how they might
be relieved, it was answered them, ' if Dipœnus
and Scyllis should finish those images of the
gods ' ; which thing the Sicyonians obtained
from them, humbly, at a great price." That
story too, as we shall see, illustrates the spirit of
the age. For their sculpture they used the
white marble of Paros, being workers in marble
especially, though they worked also in ebony
and in ivory, and made use of gilding. " Figures
of cedar-wood, partly incrusted with gold "—
κέδρου ζῴδια χρυσῷ διηνθισμένα — Pausanias says
exquisitely, describing a certain work of their
pupil, Dontas of Lacedæmon. It is to that that
we have definitely come at last, in the school of
Dipœnus and Scyllis.

Dry and brief as these details may seem, they
are the witness to an active, eager, animated
period of inventions and beginnings, in which
the Greek workman triumphs over the first

rough mechanical difficulties which beset him in the endeavour to record what his soul conceived of the form of priest or athlete then alive upon the earth, or of the ever-living gods, then already more seldom seen upon it. Our own fancy must fill up the story of the unrecorded patience of the workshop, into which we seem to peep through these scanty notices—the fatigue, the disappointments, the steps repeated, ending at last in that moment of success, which is all Pausanias records, somewhat uncertainly.

And as this period begins with the chest of Cypselus, so it ends with a work in some respects similar, also seen and described by Pausanias—the throne, as he calls it, of the *Amyclæan Apollo.* It was the work of a well-known artist, Bathycles of Magnesia, who, probably about the year 550 B.C., with a company of workmen, came to the little ancient town of Amyclæ, near Sparta, a place full of traditions of the heroic age. He had been invited thither to perform a peculiar task—the construction of a throne; not like the throne of the Olympian Zeus, and others numerous in after times, for a seated figure, but for the image of the local Apollo; no other than a rude and very ancient pillar of bronze, thirty cubits high, to which, Hermes-wise, head, arms, and feet were attached. The thing stood upright, as on a base, upon a kind of tomb or reliquary, in which, according to tradition, lay the remains of the young prince

Hyacinth, son of the founder of that place,
beloved by Apollo for his beauty, and accident-
ally struck dead by him in play, with a quoit.
From the drops of the lad's blood had sprung up
the purple flower of his name, which bears on
its petals the letters of the ejaculation of woe ;
and in his memory the famous games of Amyclæ
were celebrated, beginning about the time of
the longest day, when the flowers are stricken
by the sun and begin to fade—a festival marked,
amid all its splendour, with some real melancholy,
and serious thought of the dead. In the midst
of the "throne" of Bathycles, this sacred
receptacle, with the strange, half-humanised
pillar above it, was to stand, probably in the
open air, within a consecrated enclosure. Like
the chest of Cypselus, the throne was decorated
with reliefs of subjects taken from epic poetry,
and it had supporting figures. Unfortunately,
what Pausanias tells us of this monument hardly
enables one to present it to the imagination with
any completeness or certainty ; its dimensions
he himself was unable exactly to ascertain, and
he does not tell us its material. There are
reasons, however, for supposing that it was of
metal ; and amid these ambiguities, the decora-
tions of its base, the grave or altar-tomb of
Hyacinth, shine out clearly, and are also, for
the most part, clear in their significance.

"There are wrought upon the altar figures,
on the one side of Biris, on the other of

Amphitrite and Poseidon. Near Zeus and Hermes, in speech with each other, stand Dionysus and Semele, and, beside her, Ino. Demeter, Kore, and Pluto are also wrought upon it, the Fates and the Seasons above them, and with them Aphrodite, Athene, and Artemis. They are conducting Hyacinthus to heaven, with Polybœa, the sister of Hyacinthus, who died, as is told, while yet a virgin. . . . Hercules also is figured on the tomb ; he too carried to heaven by Athene and the other gods. The daughters of Thestius also are upon the altar, and the Seasons again, and the Muses."

It was as if many lines of solemn thought had been meant to unite, about the resting-place of this local Adonis, in imageries full of some dim promise of immortal life.

But it was not so much in care for old idols as in the making of new ones that Greek art was at this time engaged. This whole first period of Greek art might, indeed, be called *the period of graven images*, and all its workmen sons of Dædalus ; for Dædalus is the mythical, or all but mythical, representative of all those arts which are combined in the making of lovelier idols than had heretofore been seen. The old Greek word which is at the root of the name Dædalus, the name of a craft rather than a proper name, probably means to work curiously—all curiously beautiful wood-work is Dædal work ; the main point about the curiously beautiful

chamber in which Nausicaa sleeps, in the Odyssey, being that, like some exquisite Swiss *châlet*, it is wrought in wood. But it came about that those workers in wood, whom Dædalus represents, the early craftsmen of Crete especially, were chiefly concerned with the making of religious images, like the carvers of Berchtesgaden and Oberammergau, the sort of daintily finished images of the objects of public or private devotion which such workmen would turn out. Wherever there was a wooden idol in any way fairer than others, finished, perhaps, sometimes, with colour and gilding, and appropriate real dress, there the hand of Dædalus had been. That such images were quite detached from pillar or wall, that they stood free, and were statues in the proper sense, showed that Greek art was already liberated from its earlier Eastern associations; such free-standing being apparently unknown in Assyrian art. And then, the effect of this Dædal skill in them was, that they came nearer to the proper form of humanity. It is the wonderful life-likeness of these early images which tradition celebrates in many anecdotes, showing a very early instinctive turn for, and delight in naturalism, in the Greek temper. As Cimabue, in his day, was able to charm men, almost as with illusion, by the simple device of half-closing the eyelids of his personages, and giving them, instead of round eyes, eyes that seemed to be in some degree sentient, and to feel

the light ; so the marvellous progress in those Dædal wooden images was, that the eyes were open, so that they seemed to look,—the feet separated, so that they seemed to walk. Greek art is thus, almost from the first, essentially distinguished from the art of Egypt, by an energetic striving after truth in organic form. In representing the human figure, Egyptian art had held by mathematical or mechanical proportions exclusively. The Greek apprehends of it, as the main truth, that it is a living organism, with freedom of movement, and hence the infinite possibilities of motion, and of expression by motion, with which the imagination credits the higher sort of Greek sculpture ; while the figures of Egyptian art, graceful as they often are, seem absolutely incapable of any motion or gesture, other than the one actually designed. The work of the Greek sculptor, together with its more real anatomy, becomes full also of human soul.

That old, primitive, mystical, first period of Greek religion, with its profound, though half-conscious, intuitions of spiritual powers in the natural world, attaching itself not to the worship of visible human forms, but to relics, to natural or half-natural objects—the roughly hewn tree, the unwrought stone, the pillar, the holy cone of Aphrodite in her dimly-lighted cell at Paphos —had passed away. The second stage in the development of Greek religion had come ; a

period in which poet and artist were busily engaged in the work of incorporating all that might be retained of the vague divinations of that earlier visionary time, in definite and intelligible human image and human story. The vague belief, the mysterious custom and tradition, develope themselves into an elaborately ordered ritual—into personal gods, imaged in ivory and gold, sitting on beautiful thrones. Always, wherever a shrine or temple, great or small, is mentioned, there, we may conclude, was a visible idol, there was conceived to be the actual dwelling-place of a god. And this understanding became not less but more definite, as the temple became larger and more splendid, full of ceremony and servants, like the abode of an earthly king, and as the sacred presence itself assumed, little by little, the last beauties and refinements of the visible human form and expression.

In what we have seen of this first period of Greek art, in all its curious essays and inventions, we may observe this demand for beautiful idols increasing in Greece—for sacred images, at first still rude, and in some degree the holier for their rudeness, but which yet constitute the beginnings of the religious style, consummate in the work of Pheidias, uniting the veritable image of man in the full possession of his reasonable soul, with the true religious mysticity, the signature there of something from afar. One by one these

new gods of bronze, or marble, or flesh-like
ivory, take their thrones, at this or that famous
shrine, like the images of this period which
Pausanias saw in the temple of Here at Olympia
—the throned *Seasons*, with Themis as the mother
of the *Seasons* (divine rectitude being still blended,
in men's fancies, with the unchanging physical
order of things) and *Fortune*, and *Victory* "having
wings," and Kore and Demeter and Dionysus,
already visibly there, around the image of Here
herself, seated on a throne; and all chrysele-
phantine, all in gold and ivory. Novel as these
things are, they still undergo consecration at
their first erecting. The figure of Athene, in
her brazen temple at Sparta, the work of Gitiades,
who makes also the image and the hymn, in
triple service to the goddess; and again, that
curious story of Dipœnus and Scyllis, brought
back with so much awe to remove the public
curse by completing their sacred task upon the
images, show how simply religious the age still
was—that this widespread artistic activity was
a religious enthusiasm also; those early sculptors
have still, for their contemporaries, a divine
mission, with some kind of hieratic or sacred
quality in their gift, distinctly felt.

The development of the artist, in the proper
sense, out of the mere craftsman, effected in
the first division of this period, is now complete;
and, in close connexion with that busy graving
of religious images, which occupies its second

division, we come to something like real person-
alities, to men with individual characteristics—
such men as Ageladas of Argos, Callon and
Onatas of Ægina, and Canachus of Sicyon.
Mere fragment as our information concerning
these early masters is at the best, it is at least
unmistakeably information about men with per-
sonal differences of temper and talent, of their
motives, of what we call *style*. We have come
to a sort of art which is no longer broadly
characteristic of a general period, one whose
products we might have looked at without its
occurring to us to ask concerning the artist, his
antecedents, and his school. We have to do
now with types of art, fully impressed with the
subjectivity, the intimacies of the artist.

Among these freer and stronger personalities
emerging thus about the beginning of the fifth
century before Christ—about the period of the
Persian war—the name to which most of this
sort of personal quality attaches, and which is
therefore very interesting, is the name of Canachus
of Sicyon, who seems to have comprehended in
himself all the various attainments in art which
had been gradually developed in the schools of
his native city—carver in wood, sculptor, brass-
cutter, and *toreutes*; by *toreuticè* being meant the
whole art of statuary in metals, and in their
combination with other materials. At last we
seem to see an actual person at work, and to
some degree can follow, with natural curiosity,

the motions of his spirit and his hand. We seem to discern in all we know of his productions the results of individual apprehension—the results, as well as the limitations, of an individual talent.

It is impossible to date exactly the chief period of the activity of Canachus. That the great image of Apollo, which he made for the Milesians, was carried away to Ecbatana by the Persian army, is stated by Pausanias; but there is a doubt whether this was under Xerxes, as Pausanias says, in the year 479 B.C., or twenty years earlier, under Darius. So important a work as this colossal image of Apollo, for so great a shrine as the *Didymæum*, was probably the task of his maturity; and his career may, therefore, be regarded as having begun, at any rate, prior to the year 479 B.C., and the end of the Persian invasion the event which may be said to close this period of art. On the whole, the chief period of his activity is thought to have fallen earlier, and to have occupied the last forty years of the previous century; and he would thus have flourished, as we say, about fifty years before the manhood of Pheidias, as Mino of Fiesole fifty years before the manhood of Michelangelo.

His chief works were an Aphrodite, wrought for the Sicyonians in ivory and gold; that Apollo of bronze carried away by the Persians, and restored to its place about the year B.C. 350; and a reproduction of the same work in cedar-

wood, for the sanctuary of *Apollo of the Ismenus*, at Thebes. The primitive Greek worship, as we may trace it in Homer, presents already, on a minor scale, all the essential characteristics of the most elaborate Greek worship of after times—the sacred enclosure, the incense and other offerings, the prayer of the priest, the shrine itself—a small one, roofed in by the priest with green boughs, not unlike a wayside chapel in modern times, and understood to be the dwelling-place of the divine person—within, almost certainly, an idol, with its own sacred apparel, a visible form, little more than symbolical perhaps, like the sacred pillar for which Bathycles made his throne at Amyclæ, but, if an actual image, certainly a rude one.

That primitive worship, traceable in almost all these particulars, even in the first book of the Iliad, had given place, before the time of Canachus at Sicyon, to a more elaborate ritual and a more completely designed image-work ; and a little bronze statue, discovered on the site of Tenea, where Apollo was the chief object of worship,[1] the best representative of many similar marble figures—those of Thera and Orchomenus, for instance—is supposed to represent Apollo as this still early age conceived him—youthful, naked, muscular, and with the germ of the Greek profile, but formally smiling, and with a formal diadem or fillet, over the long hair which

[1] Now preserved at Munich.

shows him to be no mortal athlete. The hands, like the feet, excellently modelled, are here extended downwards at the sides ; but in some similar figures the hands are lifted, and held straight outwards, with the palms upturned. The Apollo of Canachus also had the hands thus raised, and on the open palm of the right hand was placed a stag, while with the left he grasped the bow. Pliny says that the stag was an *automaton*, with a mechanical device for setting it in motion, a detail which hints, at least, at the subtlety of workmanship with which those ancient critics, who had opportunity of knowing, credited this early artist. Of this work itself nothing remains, but we possess perhaps some imitations of it. It is probably this most sacred possession of the place which the coins of Miletus display from various points of view, though, of course, only on the smallest scale. But a little bronze figure in the British Museum, with the stag in the right hand, and in the closed left hand the hollow where the bow has passed, is thought to have been derived from it ; and its points of style are still further illustrated by a marble head of similar character, also preserved in the British Museum, which has many marks of having been copied in marble from an original in bronze. A really ancient work, or only archaic, it certainly expresses, together with all that careful patience and hardness of workmanship which is characteristic of an early age, a certain Apolline

strength—a pride and dignity in the features, so steadily composed, below the stiff, archaic arrangement of the long, fillet-bound locks. It is the exact expression of that midway position, between an involved, archaic stiffness and the free play of individual talent, which is attributed to Canachus by the ancients.

His Apollo of cedar-wood, which inhabited a temple near the gates of Thebes, on a rising ground, below which flowed the river Ismenus, had, according to Pausanias, so close a resemblance to that at Miletus that it required little skill in one who had seen either of them to tell what master had designed the other. Still, though of the same dimensions, while one was of cedar the other was of bronze—a reproduction one of the other we may believe, but with the modifications, according to the use of good workmen even so early as Canachus, due to the difference of the material. For the likeness between the two statues, it is to be observed, is not the mechanical likeness of those earlier images represented by the statuette of Tenea, which spoke, not of the style of one master, but only of the manufacture of one workshop. In those two images of Canachus — the Milesian Apollo and the Apollo of the Ismenus—there were resemblances amid differences; resemblances, as we may understand, in what was nevertheless peculiar, novel, and even innovating in the precise conception of the god therein set forth;

resemblances which spoke directly of a single workman, though working freely, of one hand and one fancy, a likeness in that which could by no means be truly copied by another ; it was the beginning of what we mean by the style of a master. Together with all the novelty, the innovating and improving skill, which has made Canachus remembered, an attractive, old-world, deeply-felt mysticity seems still to cling about what we read of these early works. That piety, that religiousness of temper, of which the people of Sicyon had given proof so oddly in their dealings with those old carvers, Scyllis and Dipœnus, still survives in the master who was chosen to embody his own novelty of idea and execution in so sacred a place as the shrine of Apollo at Miletus. Something still conventional, combined, in these images, with the effect of great artistic skill, with a palpable beauty and power, seems to have given them a really imposing religious character. Escaping from the rigid uniformities of the stricter archaic style, he is still obedient to certain hieratic influences and traditions ; he is still reserved, self-controlled, composed or even mannered a little, as in some sacred presence, with the severity and strength of the early style.

But there are certain notices which seem to show that he had his purely poetical motives also, as befitted his age ; motives which prompted works of mere fancy, like his *Muse*

with the Lyre, symbolising the chromatic style
of music ; Aristocles his brother, and Ageladas
of Argos executing each another statue to
symbolise the two other orders of music. The
Riding Boys, of which Pliny speaks, like the
mechanical stag on the hand of Apollo, which
he also describes, were perhaps mechanical toys,
as Benvenuto Cellini made toys. In the *Beard-
less Æsculapius*, again—the image of the god of
healing, not merely as the son of Apollo, but
as one ever young—it is the *poetry* of sculpture
that we see.

This poetic feeling, and the piety of temper
so deeply impressed upon his images of Apollo,
seem to have been combined in his chrys-
elephantine Aphrodite, as we see it very dis-
tinctly in Pausanias, enthroned with an apple in
one hand and a poppy in the other, and with the
sphere, or *polos*, about the head, in its quaint
little temple or chapel at Sicyon, with the
hieroképis, or holy garden, about it. This is
what Canachus has to give us instead of the
strange, symbolical cone, with the lights burning
around it, in its dark cell—the form under
which Aphrodite was worshipped at her famous
shrine of Paphos.

"A woman to keep it fair," Pausanias tells
us, "who may go in to no man, and a virgin
called the *water-bearer*, who holds her priesthood
for a year, are alone permitted to enter the
sacred place. All others may gaze upon the

goddess and offer their prayers from the door-way. The seated image is the work of Cana-chus of Sicyon. It is wrought in ivory and gold, bearing a sphere on the head, and having in the one hand a poppy and in the other an apple. They offer to her the thighs of all victims excepting swine, burning them upon sticks of juniper, together with leaves of lad's-love, a herb found in the enclosure without, and nowhere else in the world. Its leaves are smaller than those of the beech and larger than the ilex ; in form they are like an oak-leaf, and in colour resemble most the leaves of the poplar, one side dusky, the other white."

That is a place one would certainly have liked to see. So real it seems !—the seated image, the people gazing through the doorway, the fragrant odour. Must it not still be in secret keeping somewhere ? — we are almost tempted to ask ; maintained by some few solitary worshippers, surviving from age to age, among the villagers of Achaia.

In spite of many obscurities, it may be said that what we know, and what we do not know, of Canachus illustrates the amount and sort of knowledge we possess about the artists of the period which he best represents. A *naïveté*—a freshness, an early-aged simplicity and sincerity —that, we may believe, had we their works before us, would be for us their chief æsthetic charm. Cicero remarked that, in contrast with

the works of the next generation of sculptors, there was a stiffness in the statues of Canachus which made them seem untrue to nature— "Canachi signa rigidiora esse quam ut imitentur veritatem." But Cicero belongs to an age surfeited with artistic licence, and likely enough to undervalue the severity of the early masters, the great motive struggling still with the minute and rigid hand. So the critics of the last century ignored, or underrated, the works of the earlier Tuscan sculptors. In what Cicero calls "rigidity" of Canachus, combined with what we seem to see of his poetry of conception, his freshness, his solemnity, we may understand no really repellent hardness, but only that earnest patience of labour, the expression of which is constant in all the best work of an early time, in the *David* of Verrocchio, for instance, and in the early Flemish painters, as it is natural and becoming in youth itself. The very touch of the struggling hand was upon the work ; but with the interest, the half-repressed animation of a great promise, fulfilled, as we now see, in the magnificent growth of Greek sculpture in the succeeding age ; which, however, for those earlier workmen, meant the loins girt and the half-folded wings not yet quite at home in the air, with a gravity, a discretion and reserve, the charm of which, if felt in quiet, is hardly less than that of the wealth and fulness of final mastery.

THE MARBLES OF ÆGINA

I HAVE dwelt the more emphatically upon the purely sensuous aspects of early Greek art, on the beauty and charm of its mere material and workmanship, the grace of hand in it, its chryselephantine character, because the direction of all the more general criticism since Lessing has been, somewhat one-sidedly, towards the ideal or abstract element in Greek art, towards what we may call its philosophical aspect. And, indeed, this philosophical element, a tendency to the realisation of a certain inward, abstract, intellectual ideal, is also at work in Greek art—a tendency which, if that chryselephantine influence is called Ionian, may rightly be called the Dorian, or, in reference to its broader scope, the European influence ; and this European influence or tendency is really towards the impression of an order, a sanity, a proportion in all work, which shall reflect the inward order of human reason, now fully conscious of itself,—towards a sort of art in which the record and delineation of humanity, as active in the wide, inward world of

its passion and thought, has become more or less definitely the aim of all artistic handicraft.

In undergoing the action of these two opposing influences, and by harmonising in itself their antagonism, Greek sculpture does but reflect the larger movements of more general Greek history. All through Greek history we may trace, in every sphere of the activity of the Greek mind, the action of these two opposing tendencies,—the centrifugal and centripetal tendencies, as we may perhaps not too fancifully call them. There is the centrifugal, the Ionian, the Asiatic tendency, flying from the centre, working with little forethought straight before it, in the development of every thought and fancy; throwing itself forth in endless play of undirected imagination; delighting in brightness and colour, in beautiful material, in changeful form everywhere, in poetry, in philosophy, even in architecture and its subordinate crafts. In the social and political order it rejoices in the freest action of local and personal influences; its restless versatility drives it towards the assertion of the principles of separatism, of individualism,—the separation of state from state, the maintenance of local religions, the development of the individual in that which is most peculiar and individual in him. Its claim is in its grace, its freedom and happiness, its lively interest, the variety of its gifts to civilisation; its weakness is self-evident, and was what made the unity of Greece impossible.

THE MARBLES OF ÆGINA

It is this centrifugal tendency which Plato is desirous to cure, by maintaining, over against it, the Dorian influence of a severe simplification everywhere, in society, in culture, in the very physical nature of man. An enemy everywhere to *variegation*, to what is cunning or " myriad-minded," he sets himself, in mythology, in music, in poetry, in every kind of art, to enforce the ideal of a sort of Parmenidean abstractness and calm.

This exaggerated ideal of Plato's is, however, only the exaggeration of that salutary European tendency, which, finding human mind the most absolutely real and precious thing in the world, enforces everywhere the impress of its sanity, its profound reflexions upon things as they really are, its sense of proportion. It is the centripetal tendency, which links individuals to each other, states to states, one period of organic growth to another, under the reign of a composed, rational, self-conscious order, in the universal light of the understanding.

Whether or not this temper, so clearly trace-able as a distinct influence in the course of Greek development, was indeed the peculiar gift of the Dorian race, certainly that race is the best illustration of it, in its love of order, of that severe *composition* everywhere, of which the Dorian style of architecture is, as it were, a material symbol—in its constant aspiration after what is earnest and dignified, as exemplified most evidently in the religion of its predilection, the religion of Apollo.

253

For as that Ionian influence, the chryselephantine influence, had its patron in Hephæstus, belonged to the religion of Hephæstus, husband of Aphrodite, the representation of exquisite workmanship, of fine art in metal, coming from the East in close connexion with the artificial furtherance, through dress and personal ornament, of the beauty of the body ; so that Dorian or European influence embodied itself in the religion of Apollo. For the development of this or that mythological conception, from its root in fact or law of the physical world, is very various in its course. Thus, Demeter, the spirit of life in grass,—and Dionysus, the "spiritual form" of life in the green sap,— remain, to the end of men's thoughts and fancies about them, almost wholly physical. But Apollo, the "spiritual form" of sunbeams, early becomes (the merely physical element in his constitution being almost wholly suppressed) exclusively ethical, — the "spiritual form" of inward or intellectual light, in all its manifestations. He represents all those specially European ideas, of a reasonable, personal freedom, as understood in Greece ; of a reasonable polity ; of the sanity of soul and body, through the cure of disease and of the sense of sin ; of the perfecting of both by reasonable exercise or *ascésis*; his religion is a sort of embodied equity, its aim the realisation of fair reason and just consideration of the truth of things everywhere.

THE MARBLES OF ÆGINA

I cannot dwell on the general aspects of this subject further, but I would remark that in art also the religion of Apollo was a sanction of, and an encouragement towards the true valuation of humanity, in its sanity, its proportion, its knowledge of itself. Following after this, Greek art attained, in its reproductions of human form, not merely to the profound expression of the highest indwelling spirit of human intelligence, but to the expression also of the great human passions, of the powerful movements as well as of the calm and peaceful order of the soul, as finding in the affections of the body a language, the elements of which the artist might analyse, and then combine, order, and recompose. In relation to music, to art, to all those matters over which the Muses preside, Apollo, as distinct from Hermes, seems to be the representative and patron of what I may call *reasonable* music, of a great intelligence at work in art, of beauty attained through the conscious realisation of ideas. They were the cities of the Dorian affinity which early brought to perfection that most characteristic of Greek institutions, the sacred dance, with the whole gymnastic system which was its natural accompaniment. And it was the familiar spectacle of that living sculpture which developed, perhaps, beyond everything else in the Greek mind, at its best, a sense of the beauty and significance of the human form.

Into that bewildered, dazzling world of minute

and dainty handicraft—the chamber of Paris, the house of Alcinous—in which the form of man alone had no adequate place, and as yet, properly, was not, this Dorian, European, Apolline influence introduced the intelligent and spiritual human presence, and gave it its true value, a value consistently maintained to the end of Greek art, by a steady hold upon and preoccupation with the inward harmony and system of human personality.

In the works of the Asiatic tradition—the marbles of Nineveh, for instance—and, so far as we can see, in the early Greek art, which derives from it, as, for example, in the archaic remains from Cyprus, the form of man is inadequate, and below the measure of perfection attained there in the representation of the lower forms of life ; just as in the little reflective art of Japan, so lovely in its reproduction of flower or bird, the human form alone comes almost as a caricature, or is at least untouched by any higher ideal. To that Asiatic tradition, then, with its perfect craftsmanship, its consummate skill in design, its power of hand, the Dorian, the European, the true Hellenic influence brought a revelation of the soul and body of man.

And we come at last in the marbles of Ægina to a monument, which bears upon it the full expression of this humanism,—to a work, in which the presence of man, realised with complete mastery of hand, and with clear apprehension of how he actually is and moves and looks,

is touched with the freshest sense of that new-found, inward value ; the energy of worthy passions purifying, the light of his reason shining through, bodily forms and motions, solemnised, attractive, pathetic. We have reached an extant work, real and visible, of an importance out of all proportion to anything actually remaining of earlier art, and justifying, by its direct interest and charm, our long prelude on the beginnings of Greek sculpture, while there was still almost nothing actually to see.

These fifteen figures of Parian marble, of about two-thirds the size of life, forming, with some deficiencies, the east and west gables of a temple of Athene, the ruins of which still stand on a hill-side by the sea-shore, in a remote part of the island of Ægina, were discovered in the year 1811, and having been purchased by the Crown Prince, afterwards King Louis I., of Bavaria, are now the great ornament of the *Glyptothek*, or Museum of Sculpture, at Munich. The group in each gable consisted of eleven figures ; and of the fifteen larger figures dis-covered, five belong to the eastern, ten to the western gable, so that the western gable is complete with the exception of one figure, which should stand in the place to which, as the groups are arranged at Munich, the beautiful figure, bending down towards the fallen leader, has been actually transferred from the eastern gable ; certain fragments showing that the lost figure

corresponded essentially to this, which has there-
fore been removed hither from its place in the
less complete group to which it properly belongs.
For there are two legitimate views or motives in
the restoration of ancient sculpture, the anti-
quarian and the æsthetic, as they may be termed
respectively ; the former limiting itself to the
bare presentation of what actually remains of the
ancient work, braving all shock to living eyes
from the mutilated nose or chin ; while the
latter, the æsthetic method, requires that, with
the least possible addition or interference, by the
most skilful living hand procurable, the object
shall be made to please, or at least content the
living eye seeking enjoyment and not a bare fact
of science, in the spectacle of ancient art. This
latter way of restoration,—the æsthetic way,—
followed by the famous connoisseurs of the
Renaissance, has been followed here ; and the
visitor to Munich actually sees the marbles of
Ægina, as restored after a model by the tasteful
hand of Thorwaldsen.

Different views have, however, been main-
tained as to the right grouping of the figures ;
but the composition of the two groups was
apparently similar, not only in general character
but in a certain degree of correspondence of all the
figures, each to each. And in both the subject
is a combat,—a combat between Greeks and
Asiatics concerning the body of a Greek hero,
fallen among the foemen,—an incident so char-

acteristic of the poetry of the heroic wars. In both cases, Athene, whose temple this sculpture was designed to decorate, intervenes, her image being complete in the western gable, the head and some other fragments remaining of that in the eastern. The incidents represented were probably chosen with reference to the traditions of Ægina in connexion with the Trojan war. Greek legend is ever deeply coloured by local interest and sentiment, and this monument probably celebrates Telamon, and Ajax his son, the heroes who established the fame of Ægina, and whom the united Greeks, on the morning of the battle of Salamis, in which the Æginetans were distinguished above all other Greeks in bravery, invited as their peculiar, spiritual allies from that island.

Accordingly, antiquarians are, for the most part, of opinion that the eastern gable represents the combat of Hercules (Hercules being the only figure among the warriors certainly to be identified), and of his comrade Telamon, against Laomedon of Troy, in which, properly, Hercules was leader, but here, as squire and archer, is made to give the first place to Telamon, as the titular hero of the place. Opinion is not so definite regarding the subject of the western gable, which, however, probably represents the combat between the Greeks and Trojans over the body of Patroclus. In both cases an Æginetan hero, in the eastern gable Telamon, in the western

his son Ajax, is represented in the extreme crisis of battle, such a crisis as, according to the deep religiousness of the Greeks of that age, was a motive for the visible intervention of the goddess in favour of her chosen people.

Opinion as to the date of the work, based mainly on the characteristics of the work itself, has varied within a period ranging from the middle of the sixtieth to the middle of the seventieth Olympiad, inclining on the whole to the later date, in the period of the Ionian revolt against Persia, and a few years earlier than the battle of Marathon.

In this monument, then, we have a revelation in the sphere of art, of the temper which made the victories of Marathon and Salamis possible, of the true spirit of Greek chivalry as displayed in the Persian war, and in the highly ideal conception of its events, expressed in Herodotus and approving itself minutely to the minds of the Greeks, as a series of affairs in which the gods and heroes of old time personally intervened, and that not as mere shadows. It was natural that the high-pitched temper, the stress of thought and feeling, which ended in the final conflict of Greek liberty with Asiatic barbarism, should stimulate quite a new interest in the poetic legends of the earlier conflict between them in the heroic age. As the events of the Crusades and the chivalrous spirit of that period, leading men's minds back to ponder over the deeds of

Charlemagne and his paladins, gave birth to the composition of the *Song of Roland*, just so this Æginetan sculpture displays the Greeks of a later age feeding their enthusiasm on the legend of a distant past, and is a link between Herodotus and Homer. In those ideal figures, pensive a little from the first, we may suppose, with the shadowiness of a past age, we may yet see how Greeks of the time of Themistocles really conceived of Homeric knight and squire.

Some other fragments of art, also discovered in Ægina, and supposed to be contemporary with the temple of Athene, tend, by their roughness and immaturity, to show that this small building, so united in its effect, so complete in its simplicity, in the symmetry of its two main groups of sculpture, was the perfect artistic flower of its time and place. Yet within the limits of this simple unity, so important an element in the charm and impressiveness of the place, a certain inequality of design and execution may be detected; the hand of a slightly earlier master, probably, having worked in the western gable, while the master of the eastern gable has gone some steps farther than he in fineness and power of expression; the stooping figure of the supposed Ajax,—belonging to the western group in the present arrangement, but really borrowed, as I said, from the eastern,—which has in it something above the type of the figures grouped round it, being this later sculptor's work. Yet Over-

beck, who has elaborated the points of this distinction of styles, commends without reserve the technical excellence of the whole work, executed, as he says, "with an application of all known instruments of sculpture; the delicate calculation of weight in the composition of the several parts, allowing the artist to dispense with all artificial supports, and to set his figures, with all their complex motions, and yet with *plinths* only three inches thick, into the basis of the gable; the bold use of the chisel, which wrought the shield, on the freely-held arm, down to a thickness of scarcely three inches; the fineness of the execution, even in parts of the work invisible to an ordinary spectator, in the diligent finishing of which the only motive of the artist was to satisfy his own conviction as to the nature of good sculpture."

It was the Dorian cities, Plato tells us, which first shook off the false Asiatic shame, and stripped off their clothing for purposes of exercise and training in the *gymnasium ;* and it was part of the Dorian or European influence to assert the value in art of the unveiled and healthy human form. And here the artists of Ægina, notwithstanding Homer's description of Greek armour, glowing like the sun itself, have displayed the Greek warriors—Greek and Trojan alike—not in the equipments they would really have worn, but naked,—flesh fairer than that golden armour, though more subdued and tran-

quil in effect on the spectator, the undraped form of man coming like an embodiment of the Hellenic spirit, and as an element of *temperance*, into the somewhat gaudy spectacle of Asiatic, or archaic art. Paris alone bears his dainty trappings, characteristically,—a coat of golden scale-work, the scales set on a lining of canvas or leather, shifting deftly over the delicate body beneath, and represented on the gable by the gilding, or perhaps by real gilt metal.

It was characteristic also of that more truly Hellenic art—another element of its temperance —to adopt the use of marble in its works ; and the material of these figures is the white marble of Paros. Traces of colour have, however, been found on certain parts of them. The outer surfaces of the shields and helmets have been blue ; their inner parts and the crests of the helmets, red ; the hem of the drapery of Athene, the edges of her sandals, the plinths on which the figures stand, also red ; one quiver red, another blue ; the eyes and lips, too, coloured ; perhaps, the hair. There was just a limited and conventionalised use of colour, in effect, upon the marble.

And although the actual material of these figures is marble, its coolness and massiveness suiting the growing severity of Greek thought, yet they have their reminiscences of work in bronze, in a certain slimness and tenuity, a certain dainty lightness of poise in their grouping, which

remains in the memory as a peculiar note of their style ; the possibility of such easy and graceful balancing being one of the privileges or opportunities of statuary in cast metal, of that hollow casting in which the whole weight of the work is so much less than that of a work of equal size in marble, and which permits so much wider and freer a disposition of the parts about its centre of gravity. In Ægina the tradition of metal-work seems to have been strong, and Onatas, whose name is closely connected with Ægina, and who is contemporary with the presumably later portion of this monument, was above all a worker in bronze. Here again, in this lurking spirit of metal-work, we have a new element of complexity in the character of these precious remains. And then, to compass the whole work in our imagination, we must conceive yet another element in the conjoint effect ; metal being actually mingled with the marble, brought thus to its daintiest point of refinement, as the little holes indicate, bored into the marble figures for the attachment of certain accessories in bronze, —lances, swords, bows, the *Medusa's* head on the *ægis* of Athene, and its fringe of little snakes.

And as there was no adequate consciousness and recognition of the essentials of man's nature in the older, oriental art, so there is no pathos, no *humanity* in the more special sense, but a kind of hardness and cruelty rather, in those oft-repeated, long, matter-of-fact processions, on the

marbles of Nineveh, of slave-like soldiers on their way to battle mechanically, or of captives on their way to slavery or death, for the satisfaction of the Great King. These Greek marbles, on the contrary, with that figure yearning forward so graciously to the fallen leader, are deeply impressed with a natural pathetic effect—the true reflexion again of the temper of Homer in speaking of war. Ares, the god of war himself, we must remember, is, according to his original import, the god of storms, of winter raging among the forests of the Thracian mountains, a brother of the north wind. It is only afterwards that, surviving many minor gods of war, he becomes a leader of hosts, a sort of divine knight and patron of knighthood ; and, through the old intricate connexion of love and war, and that amorousness which is the universally conceded privilege of the soldier's life, he comes to be very near Aphrodite,—the paramour of the goddess of physical beauty. So that the idea of a sort of soft dalliance mingles, in his character, so unlike that of the Christian leader, Saint George, with the idea of savage, warlike impulses ; the fair, soft creature suddenly raging like a storm, to which, in its various wild incidents, war is constantly likened in Homer ; the effects of delicate youth and of tempest blending, in Ares, into one expression, not without that cruelty which mingles also, like the influence of some malign fate upon him, with the finer

characteristics of Achilles, who is a kind of merely human double of Ares. And in Homer's impressions of war the same elements are blent, —the delicacy, the beauty of youth, especially, which makes it so fit for purposes of love, spoiled and wasted by the random flood and fire of a violent tempest; the glittering beauty of the Greek "war-men," expressed in so many brilliant figures, and the splendour of their equipments, in collision with the miserable accidents of battle, and the grotesque indignities of death in it, brought home to our fancy by a hundred pathetic incidents,—the sword hot with slaughter, the stifling blood in the throat, the spoiling of the body in every member severally. He thinks of, and records, at his early ending, the distant home from which the boy came, who goes stumbling now, just stricken so wretchedly, his bowels in his hands. He pushes the expression of this contrast to the *macabre* even, suggesting the approach of those lower forms of life which await to-morrow the fair bodies of the heroes, who strive and fall to-day like these in the Æginetan gables. For it is just that twofold sentiment which this sculpture has embodied. The seemingly stronger hand which wrought the eastern gable has shown itself strongest in the rigid expression of the truth of pain, in the mouth of the famous recumbent figure on the extreme left, the lips just open at the corner, and in the hard-shut lips of Hercules. Otherwise,

these figures all smile faintly, almost like the monumental effigies of the Middle Age, with a smile which, even if it be but a result of the mere conventionality of an art still somewhat immature, has just the pathetic effect of Homer's conventional epithet "tender," when he speaks of the flesh of his heroes.

And together with this touching power there is also in this work the effect of an early simplicity, the charm of its limitations. For as art which has passed its prime has sometimes the charm of an absolute refinement in taste and workmanship, so immature art also, as we now see, has its own attractiveness in the *naïveté*, the freshness of spirit, which finds power and interest in simple motives of feeling, and in the freshness of hand, which has a sense of enjoyment in mechanical processes still performed unmechanically, in the spending of care and intelligence on every touch. As regards Italian art, the sculpture and paintings of the earlier Renaissance, the æsthetic value of this *naïveté* is now well understood ; but it has its value in Greek sculpture also. There, too, is a succession of phases through which the artistic power and purpose grew to maturity, with the enduring charm of an unconventional, unsophisticated freshness, in that very early stage of it illustrated by these marbles of Ægina, not less than in the work of Verrocchio and Mino of Fiesole. Effects of this we may note in that sculpture

of Ægina, not merely in the simplicity, or monotony even, of the whole composition, and in the exact and formal correspondence of one gable to the other, but in the simple readiness with which the designer makes the two second spearmen kneel, against the probability of the thing, so as just to fill the space he has to compose in. The profiles are still not yet of the fully developed Greek type, but have a somewhat sharp prominence of nose and chin, as in Etrurian design, in the early sculpture of Cyprus, and in the earlier Greek vases; and the general proportions of the body in relation to the shoulders are still somewhat archaically slim. But then the workman is at work in dry earnestness, with a sort of hard strength in detail, a scrupulousness verging on stiffness, like that of an early Flemish painter; he communicates to us his still youthful sense of pleasure in the experience of the first rudimentary difficulties of his art overcome. And withal, these figures have in them a true expression of life, of animation. In this monument of Greek chivalry, pensive and visionary as it may seem, those old Greek knights live with a truth like that of Homer or Chaucer. In a sort of stiff grace, combined with a sense of things bright or sorrowful directly felt, the Æginetan workman is as it were the Chaucer of Greek sculpture.

THE AGE OF ATHLETIC PRIZEMEN

A CHAPTER IN GREEK ART

It is pleasant when, looking at medieval sculpture, we are reminded of that of Greece ; pleasant likewise, conversely, in the study of Greek work to be put on thoughts of the Middle Age. To the refined intelligence, it would seem, there is something attractive in complex expression as such. The *Marbles of Ægina*, then, may remind us of the Middle Age where it passes into the early Renaissance, of its most tenderly finished warrior-tombs at Westminster or in Florence. A less mature phase of medieval art is recalled to our fancy by a primitive Greek work in the Museum of Athens, Hermes, bearing a ram, a little one, upon his shoulders. He bears it thus, had borne it round the walls of Tanagra, as its citizens told, by way of purifying that place from the plague, and brings to mind, of course, later images of the " Good Shepherd." It is not the subject of the work, however, but its style, that sets us down in thought before some gothic

cathedral front. Suppose the *Hermes Kriophorus* lifted into one of those empty niches, and the archæologist will inform you rightly, as at Auxerre or Wells, of Italian influence, perhaps of Italian workmen, and along with them indirect old Greek influence coming northwards ; while the connoisseur assures us that all good art, at its respective stages of development, is in essential qualities everywhere alike. It is observed, as a note of imperfect skill, that in that carved block of stone the animal is insufficiently detached from the shoulders of its bearer. Again, how precisely gothic is the effect ! Its very limitation as sculpture emphasises the function of the thing as an architectural ornament. And the student of the Middle Age, if it came within his range, would be right in so esteeming it. Hieratic, stiff and formal, if you will, there is a knowledge of the human body in it nevertheless, of the body, and of the purely animal soul therein, full of the promise of what is coming in that chapter of Greek art which may properly be entitled, "The Age of Athletic Prizemen."

That rude image, a work perhaps of Calamis of shadowy fame, belongs to a phase of art still in grave-clothes or swaddling-bands, still strictly surbordinate to religious or other purposes not immediately its own. It had scarcely to wait for the next generation to be superseded, and we need not wonder that but little of it remains. But that it was a widely active phase of art, with

all the vigour of local varieties, is attested by another famous archaic monument, too full of a kind of sacred poetry to be passed by. The reader does not need to be reminded that the Greeks, vivid as was their consciousness of this life, cared much always for the graves of the dead ; that to be cared for, to be honoured, in one's grave, to have τύμβος ἀμφίπολος, a *frequented* tomb, as Pindar says, was a considerable motive with them, even among the young. In the study of its funeral monuments we might indeed follow closely enough the general development of art in Greece from beginning to end. The carved slab of the ancient shepherd of Orcho-menus, with his dog and rustic staff, the *stélé* of the ancient man-at-arms signed " Aristocles," rich originally with colour and gold and fittings of bronze, are among the few still visible pictures, or portraits, it may be, of the earliest Greek life. Compare them, compare their expression, for a moment, with the deeply incised tombstones of the Brethren of St. Francis and their clients, which still roughen the pavement of Santa Croce at Florence, and recal the varnished poly-chrome decoration of those Greek monuments in connexion with the worn-out blazonry of the funeral brasses of England and Flanders. The Shepherd, the Hoplite, begin a series continuous to the era of full Attic mastery in its gentlest mood, with a large and varied store of memorials of the dead, which, not so strangely as it may

seem at first sight, are like selected pages from
daily domestic life. See, for instance, at the
British Museum, Trypho, "the son of Eutychus,"
one of the very pleasantest human likenesses
there, though it came from a cemetery—a son
it was hard to leave in it at nineteen or twenty.
With all the suppleness, the delicate muscu-
larity, of the flower of his youth, his handsome
face sweetened by a kind and simple heart, in
motion, surely, he steps forth from some shadowy
chamber, *strigil* in hand, as of old, and with his
coarse towel or cloak of monumental drapery
over one shoulder. But whither precisely, you
may ask, and as what, is he moving there in the
doorway ? Well ! in effect, certainly, it is the
memory of the dead lad, emerging thus from
his tomb,—the still active soul, or permanent
thought, of him, as he most liked to be.

The *Harpy Tomb*, so called from its mysterious
winged creatures with human faces, carrying the
little shrouded souls of the dead, is a work many
generations earlier than that graceful monument
of Trypho. It was from an ancient cemetery
at Xanthus in Lycia that it came to the British
Museum. The Lycians were not a Greek
people ; but, as happened even with "barbarians"
dwelling on the coast of Asia Minor, they
became lovers of the Hellenic culture, and Xan-
thus, their capital, as may be judged from the
beauty of its ruins, managed to have a consider-
able portion in Greek art, though infusing it

with a certain Asiatic colour. The frugally designed frieze of the Harpy Tomb, in the lowest possible relief, might fairly be placed between the monuments of Assyria and those primitive Greek works among which it now actually stands. The stiffly ranged figures in any other than strictly archaic work would seem affected. But what an undercurrent of refined sentiment, presumably not Asiatic, not "barbaric," lifting those who felt thus about death so early into the main stream of Greek humanity, and to a level of visible refinement in execution duly expressive of it !

In that old burial-place of Xanthus, then, a now nameless family, or a single bereaved member of it, represented there as a diminutive figure crouching on the earth in sorrow, erected this monument, so full of family sentiment, and of so much value as illustrating what is for us a somewhat empty period in the history of Greek art, strictly so called. Like the less conspicuously adorned tombs around it, like the tombs in Homer, it had the form of a tower—a square tower about twenty-four feet high, hollowed at the top into a small chamber, for the reception, through a little doorway, of the urned ashes of the dead. Four sculptured slabs were placed at this level on the four sides of the tower in the manner of a frieze. I said that the winged creatures with human faces carry the little souls of the dead. The interpretation of these mystic

imageries is, in truth, debated. But in face of
them, and remembering how the sculptors and
glass-painters of the Middle Age constantly
represented the souls of the dead as tiny bodies,
one can hardly doubt as to the meaning of these
particular details which, repeated on every side,
seem to give the key-note of the whole composi-
tion.[1] Those infernal, or celestial, birds, indeed,
are not true to what is understood to be the
harpy form. Call them sirens, rather. People,
and not only old people, as you know, appear
sometimes to have been quite charmed away by
what dismays most of us. The tiny shrouded
figures which the sirens carry are carried very
tenderly, and seem to yearn in their turn towards
those kindly nurses as they pass on their way to
a new world. Their small stature, as I said,
does not prove them infants, but only new-born
into that other life, and contrasts their helpless-
ness with the powers, the great presences, now
around them. A cow, far enough from Myron's
famous illusive animal, suckles her calf. She is

[1] In some fine reliefs of the thirteenth century, Jesus himself
draws near to the deathbed of his Mother. The soul has already
quitted her body, and is seated, a tiny crowned figure, on his left
arm (as she had carried Him) to be taken to heaven. In the
beautiful early fourteenth century monument of Aymer de Valence
at Westminster, the soul of the deceased, "a small figure wrapped
in a mantle," is supported by two angels at the head of the tomb.
Among many similar instances may be mentioned the soul of the
beggar, Lazarus, on a carved capital at Vézélay; and the same
subject in a coloured window at Bourges. The clean, white little
creature seems glad to escape from the body, tattooed all over with
its sores in a regular pattern.

one of almost any number of artistic symbols of new-birth, of the renewal of life, drawn from a world which is, after all, so full of it. On one side sits enthroned, as some have thought, the Goddess of Death ; on the opposite side the Goddess of Life, with her flowers and fruit. Towards her three young maidens are advancing —were they still alive thus, graceful, virginal, with their long, plaited hair, and long, delicately-folded tunics, looking forward to carry on their race into the future ? Presented severally, on the other sides of the dark hollow within, three male persons—a young man, an old man, and a boy—seem to be bringing home, somewhat wearily, to their " long home," the young man, his armour, the boy, and the old man, like old Socrates, the mortuary cock, as they approach some shadowy, ancient deity of the tomb, or it may be the throned impersonation of their " fathers of old." The marble surface was coloured, at least in part, with fixtures of metal here and there. The designer, whoever he may have been, was possessed certainly of some tranquillising second thoughts concerning death, which may well have had their value for mourners ; and he has expressed those thoughts, if lispingly, yet with no faults of commission, with a befitting grace, and, in truth, at some points, with something already of a really Hellenic definition and vigour. He really speaks to us in his work, through his symbolic and

imitative figures, — speaks to our intelligence persuasively.

The surviving thought of the lad Trypho, returning from his tomb to the living, was of athletic character ; how he was and looked when in the flower of his strength. And it is not of the dead but of the living, who look and are as he, that the artistic genius of this period is full. It is a period, truly, not of battles, such as those commemorated in the *Marbles of Ægina*, but of more peaceful contests—at Olympia, at the Isthmus, at Delphi—the glories of which Pindar sang in language suggestive of a sort of metallic beauty, firmly cut and embossed, like crowns of wild olive, of parsley and bay, in crisp gold. First, however, it had been necessary that Greece should win its liberty, political standing-ground, and a really social air to breathe in, with development of the youthful limbs. Of this process Athens was the chief scene ; and the earliest notable presentment of humanity by Athenian art was in celebration of those who had vindicated liberty with their lives — two youths again, in a real incident, which had, however, the quality of a poetic invention, turning, as it did, on that ideal or romantic friendship which was characteristic of the Greeks.

With something, perhaps, of hieratic convention, yet presented as they really were, as friends and admirers loved to think of them,

THE AGE OF ATHLETIC PRIZEMEN

Harmodius and Aristogeiton stood, then, soon after their heroic death, side by side in bronze, the work of Antenor, in a way not to be forgotten, when, thirty years afterwards, a foreign tyrant, Xerxes, carried them away to Persia. Kritios and Nesistes were, therefore, employed for a reproduction of them, which would naturally be somewhat more advanced in style. In its turn this also disappeared. The more curious student, however, would still fancy he saw the trace of it—of that copy, or of the original, after-wards restored to Athens—here or there, on vase or coin. But in fact the very images of the heroic youths were become but ghosts, haunting the story of Greek art, till they found or seemed to find a body once more when, not many years since, an acute observer detected, as he thought, in a remarkable pair of statues in the Museum of Naples, if freed from incorrect restorations and rightly set together, a veritable descendant from the original work of Antenor. With all their truth to physical form and movement, with a conscious mastery of delineation, they were, nevertheless, in certain details, in the hair, for instance, archaic, or rather archaistic—designedly archaic, as from the hand of a workman, for whom, in this subject, archaism, the very touch of the ancient master, had a sentimental or even a religious value. And unmistakeably they were young assassins, moving, with more than fraternal unity, the younger in advance of and covering

the elder, according to the account given by
Herodotus, straight to their purpose ;—against
two wicked brothers, as you remember, two
good friends, on behalf of the dishonoured sister
of one of them.

Archæologists have loved to adjust them
tentatively, with various hypotheses as to the
precise manner in which they thus went together.
Meantime they have figured plausibly as repre-
sentative of Attic sculpture at the end of its
first period, still immature indeed, but with a
just claim to take breath, so to speak, having
now accomplished some stades of the journey.
Those young heroes of Athenian democracy,
then, indicate already what place Athens and
Attica will occupy in the supreme age of art
soon to come ; indicate also the subject from
which that age will draw the main stream of its
inspiration—living youth, "iconic" in its exact
portraiture, or "heroic" as idealised in various
degrees under the influence of great thoughts
about it—youth in its self-denying contention
towards great effects ; great intrinsically, as at
Marathon, or when Harmodius and Aristogeiton
fell, or magnified by the force and splendour of
Greek imagination with the stimulus of the
national games. For the most part, indeed,
it is not with youth taxed spasmodically, like
that of Harmodius and Aristogeiton, and the
"necessity" that was upon it, that the Athenian
mind and heart are now busied ; but with youth

in its voluntary labours, its habitual and measured discipline, labour for its own sake, or in wholly friendly contest for prizes which in reality borrow all their value from the quality of the receiver.

We are with Pindar, you see, in this athletic age of Greek sculpture. It is the period no longer of battle against a foreign foe, recalling the Homeric ideal, nor against the tyrant at home, fixing a dubious ideal for the future, but of peaceful combat as a fine art—*pulvis Olympicus*. Anticipating the arts, poetry, a generation before Myron and Polycleitus, had drawn already from the youthful combatants in the great national games the motives of those Odes, the bracing words of which, as I said, are like work in fine bronze, or, as Pindar himself suggests, in ivory and gold. Sung in the victor's supper-room, or at the door of his abode, or with the lyre and the pipe as they took him home in procession through the streets, or commemorated the happy day, or in a temple where he laid up his crown, Pindar's songs bear witness to the pride of family or township in the physical perfection of son or citizen, and his consequent success in the long or the short foot-race, or the foot-race in armour, or the *pentathlon*, or any part of it. "Now on one, now on another," as the poet tells, "doth the grace that quickeneth (quickeneth, literally, on the race-course) look favourably." Ἄριστον ὕδωρ he declares indeed, and the actual prize, as we know, was in itself of little or no worth—a

cloak, in the Athenian games, but at the greater games a mere handful of parsley, a few sprigs of pine or wild olive. The prize has, so to say, only an intellectual or moral value. Yet actually Pindar's own verse is all of gold and wine and flowers, is itself avowedly a flower, or "liquid nectar," or "the sweet fruit of his soul to men that are winners in the games." "As when from a wealthy hand one lifting a cup, made glad within with the dew of the vine, maketh gift thereof to a youth":—the keynote of Pindar's verse is there! This brilliant living youth of his day, of the actual time, for whom, as he says, he "awakes the clear-toned gale of song"—ἐπέων οἶμον λίγυν—that song mingles sometimes with the splendours of a recorded ancient lineage, or with the legendary greatness of a remoter past, its gods and heroes, patrons or ancestors, it might be, of the famous young man of the hour, or with the glory and solemnity of the immortals themselves taking a share in mortal contests. On such pretext he will tell a new story, or bring to its last perfection by his manner of telling it, his pregnancy and studied beauty of expression, an old one. The tale of Castor and Polydeukes, the appropriate patrons of virginal yet virile youth, starred and mounted, he tells in all its human interest.

"Ample is the glory stored up for Olympian winners." And what Pindar's contemporaries asked of him for the due appreciation, the

consciousness, of it, by way of song, that the next generation sought, by way of sculptural memorial in marble, and above all, as it seems, in bronze. The keen demand for athletic statuary, the honour attached to the artist employed to make his statue at Olympia, or at home, bear witness again to the pride with which a Greek town, the pathos, it might be, with which a family, looked back to the victory of one of its members. In the courts of Olympia a whole population in marble and bronze gathered quickly,—a world of portraits, out of which, as the purged and perfected essence, the ideal soul, of them, emerged the *Diadumenus*, for instance, the *Discobolus*, the so-called *Jason* of the Louvre. Olympia was in truth, as Pindar says again, a *mother* of gold-crowned contests, the mother of a large offspring. All over Greece the enthusiasm for gymnastic, for the life of the *gymnasia*, prevailed. It was a gymnastic which, under the happy conditions of that time, was already surely what Plato pleads for, already one half music, μουσική, a matter, partly, of character and of the soul, of the fair proportion between soul and body, of the soul with itself. Who can doubt it who sees and considers the still irresistible grace, the contagious pleasantness, of the *Discobolus*, the *Diadumenus*, and a few other precious survivals from the athletic age which immediately preceded the manhood of Pheidias, between the Persian and the Peloponnesian wars ?

Now, this predominance of youth, of the
youthful form, in art, of bodily gymnastic pro-
moting natural advantages to the utmost, of the
physical perfection developed thereby, is a sign
that essential mastery has been achieved by the
artist—the power, that is to say, of a full and
free realisation. For such youth, in its very
essence, is a matter properly within the limits of
the visible, the empirical, world ; and in the
presentment of it there will be no place for
symbolic hint, none of that reliance on the help-
ful imagination of the spectator, the legitimate
scope of which is a large one, when art is dealing
with religious objects, with what in the fulness
of its own nature is not really expressible at all.
In any passable representation of the Greek
discobolus, as in any passable representation of an
English cricketer, there can be no successful
evasion of the natural difficulties of the thing to
be done—the difficulties of competing with
nature itself, or its maker, in that marvellous
combination of motion and rest, of inward
mechanism with the so smoothly finished sur-
face and outline—finished *ad unguem*—which
enfold it.

Of the gradual development of such mastery
of natural detail, a veritable counterfeit of nature,
the veritable *rhythmus* of the runner, for example
—twinkling heel and ivory shoulder—we have
hints and traces in the historians of art. One
had attained the very turn and texture of the

crisp locks, another the very feel of the tense nerve and full-flushed vein, while with another you saw the bosom of Ladas expand, the lips part, as if for a last breath ere he reached the goal. It was like a child finding little by little the use of its limbs, the testimony of its senses, at a definite moment. With all its poetic impulse, it is an age clearly of faithful observation, of what we call realism, alike in its iconic and heroic work ; alike in portraiture, that is to say, and in the presentment of divine or abstract types. Its workmen are close students now of the living form as such ; aim with success at an ever larger and more various expression of its details ; or replace a conventional statement of them by a real and lively one. That it was thus is attested indirectly by the fact that they busied themselves, seemingly by way of a *tour de force*, and with no essential interest in such subject, alien as it was from the pride of health which is characteristic of the gymnastic life, with the expression of physical pain, in Philoctetes, for instance. The adroit, the swift, the strong, in full and free exercise of their gifts, to the delight of others and of themselves, though their sculptural record has for the most part perished, are specified in ancient literary notices as the sculptor's favourite subjects, repeated, remodelled, over and over again, for the adornment of the actual scene of athletic success, or the market-place at home of the distant Northern or Sicilian town

whence the prizeman had come.—A countless series of popular illustrations to Pindar's Odes! And if art was still to minister to the religious sense, it could only be by clothing celestial spirits also as nearly as possible in the bodily semblance of the various athletic combatants, whose patrons respectively they were supposed to be.

The age to which we are come in the story of Greek art presents to us indeed only a chapter of scattered fragments, of names that are little more, with but surmise of their original significance, and mere reasonings as to the sort of art that may have occupied what are really empty spaces. Two names, however, connect themselves gloriously with certain extant works of art ; copies, it is true, at various removes, yet copies of what is still found delightful through them, and by copyists who for the most part were themselves masters. Through the variations of the copyist, the restorer, the mere imitator, these works are reducible to two famous original types—the *Discobolus* or quoit-player, of Myron, the *beau idéal* (we may use that term for once justly) of athletic motion ; and the *Diadumenus* of Polycleitus, as, binding the fillet or crown of victory upon his head, he presents the *beau idéal* of athletic repose, and almost begins to think.

Myron was a native of Eleutheræ, and a pupil of Ageladas of Argos. There is nothing more to tell by way of positive detail of this so famous

artist, save that the main scene of his activity was Athens, now become the centre of the artistic as of all other modes of life in Greece. *Multiplicasse veritatem videtur,* says Pliny. He was in fact an earnest realist or naturalist, and rose to central perfection in the portraiture, the idealised portraiture, of athletic youth, from a mastery first of all in the delineation of inferior objects, of little lifeless or living things. Think, however, for a moment, how winning such objects are still, as presented on Greek coins ;— the ear of corn, for instance, on those of Metapontum ; the microscopic cockle - shell, the dolphins, on the coins of Syracuse. Myron, then, passes from pleasant truth of that kind to the delineation of the worthier sorts of animal life,—the ox, the dog—to nothing short of illusion in the treatment of them, as ancient connoisseurs would have you understand. It is said that there are thirty-six extant epigrams on his brazen cow. That animal has her gentle place in Greek art, from the Siren tomb, suckling her young there, as the type of eternal rejuvenescence, onwards to the procession of the Elgin frieze, where, still breathing deliciously of the distant pastures, she is led to the altar. We feel sorry for her, as we look, so lifelike is the carved marble. The sculptor who worked there, whoever he may have been, had profited doubtless by the study of Myron's famous work. For what purpose he made it, does not appear ;—as

an architectural ornament ; or a votive offering ;
perhaps only because he liked making it. In
hyperbolic epigram, at any rate, the animal
breathes, explaining sufficiently the point of
Pliny's phrase regarding Myron — *Corporum
curiosus.* And when he came to his main
business with the quoit-player, the wrestler, the
runner, he did not for a moment forget that they
too were animals, young animals, delighting in
natural motion, in free course through the
yielding air, over uninterrupted space, accord-
ing to Aristotle's definition of pleasure : " the
unhindered exercise of one's natural force."
Corporum tenus curiosus : — he was a " curious
workman" as far as the living body is concerned.
Pliny goes on to qualify that phrase by saying
that he did not express the sensations of the mind
—*animi sensus.* But just there, in fact, precisely
in such limitation, we find what authenticates
Myron's peculiar value in the evolution of Greek
art. It is of the essence of the athletic prizeman,
involved in the very ideal of the quoit-player,
the cricketer, not to give expression to mind, in
any antagonism to, or invasion of, the body ; to
mind as anything more than a function of the
body, whose healthful balance of functions it
may so easily perturb ;—to disavow that insidious
enemy of the fairness of the bodily soul as such.

Yet if the art of Myron was but little occupied
with the reasonable soul (*animus*), with those
mental situations the expression of which, though

it may have a pathos and a beauty of its own, is for the most part adverse to the proper expression of youth, to the beauty of youth, by causing it to be no longer youthful, he was certainly a master of the animal or physical soul there (*anima*) ; how it is, how it displays itself, as illustrated, for instance, in the *Discobolus*. Of voluntary animal motion the very soul is undoubtedly there. We have but translations into marble of the original in bronze. In that, it was as if a blast of cool wind had congealed the metal, or the living youth, fixed him imperishably in that moment of rest which lies between two opposed motions, the *backward* swing of the right arm, the movement *forwards* on which the left foot is in the very act of starting. The matter of the thing, the stately bronze or marble, thus rests indeed ; but the artistic form of it, in truth, scarcely more, even to the eye, than the rolling ball or disk, may be said to rest, at every moment of its course,—just metaphysically, you know.

This mystery of combined motion and rest, of rest in motion, had involved, of course, on the part of the sculptor who had mastered its secret, long and intricate consideration. Archaic as it is, primitive still in some respects, full of the primitive youth it celebrates, it is, in fact, a learned work, and suggested to a great analyst of literary style, singular as it may seem, the " elaborate " or " contorted " manner in literature

of the later Latin writers, which, however, he finds "laudable" for its purpose. Yet with all its learned involution, thus so oddly characterised by Quintilian, so entirely is this quality subordinated to the proper purpose of the *Discobolus* as a work of art, a thing to be looked at rather than to think about, that it makes one exclaim still, with the poet of athletes, "The natural is ever best!"—τὸ δὲ φυᾷ ἅπαν κράτιστον. Perhaps that triumphant, unimpeachable naturalness is after all the reason why, on seeing it for the first time, it suggests no new view of the beauty of human form, or point of view for the regarding of it; is acceptable rather as embodying (say, in one perfect flower) all one has ever fancied or seen, in old Greece or on Thames' side, of the unspoiled body of youth, thus delighting itself and others, at that perfect, because unconscious, point of good-fortune, as it moves or rests just there for a moment, between the animal and spiritual worlds. "Grant them," you pray in Pindar's own words, "grant them with feet so light to pass through life!"

The face of the young man, as you see him in the British Museum for instance, with fittingly inexpressive expression, (look into, look at the curves of, the blossomlike cavity of the opened mouth) is beautiful, but not altogether virile. The eyes, the facial lines which they gather into one, seem ready to follow the coming motion of the *discus* as those of an onlooker might be;

but that head does not really belong to the *discobolus*. To be assured of this you have but to compare with that version in the British Museum the most authentic of all derivations from the original, preserved till lately at the Palazzo Massimi in Rome. Here, the vigorous head also, with the face, smooth enough, but spare, and tightly drawn over muscle and bone, is sympathetic with, yields itself to, the concentration, in the most literal sense, of all beside ;— is itself, in very truth, the steady centre of the *discus*, which begins to spin ; as the source of will, the source of the motion with which the *discus* is already on the wing,—that, and the entire form. The *Discobolus* of the Massimi Palace presents, moreover, in the hair, for instance, those survivals of primitive manner which would mark legitimately Myron's actual pre-Pheidiac standpoint ; as they are congruous also with a certain archaic, a more than merely athletic, spareness of form generally—delightful touches of unreality in this realist of a great time, and of a sort of conventionalism that has an attraction in itself.

Was it a portrait ? That one can so much as ask the question is a proof how far the master, in spite of his lingering archaism, is come already from the antique marbles of Ægina. Was it the portrait of one much-admired youth, or rather the type, the rectified essence, of many such, at the most pregnant, the essential, moment, of the

exercise of their natural powers, of what they really were ? Have we here, in short, the sculptor Myron's reasoned memory of many a quoit-player, of a long flight of quoit-players ; as, were he here, he might have given us the cricketer, the passing generation of cricketers, *sub specie eternitatis*, under the eternal form of art ?

Was it in that case a commemorative or votive statue, such as Pausanias found scattered throughout Greece ? Was it, again, designed to be part only of some larger decorative scheme, as some have supposed of the Venus of Melos, or a work of *genre* as we say, a thing intended merely to interest, to gratify the taste, with no further purpose ? In either case it may have represented some legendary quoit-player—Perseus at play with Acrisius fatally, as one has suggested ; or Apollo with Hyacinthus, as Ovid describes him in a work of poetic *genre*.

And if the *Discobolus* is, after all, a work of *genre*—a work merely imitative of the detail of actual life—for the adornment of a room in a private house, it would be only one of many such produced in Myron's day. It would be, in fact, one of the *pristæ* directly attributed to him by Pliny, little congruous as they may seem with the grandiose motions of his more characteristic work. The *pristæ*, the sawyers,—a celebrated creation of the kind,—is supposed to have given its name to the whole class of like things. No

age, indeed, since the rudiments of art were mastered, can have been without such reproductions of the pedestrian incidents of every day, for the mere pleasant exercise at once of the curiosity of the spectator and the imitative instinct of the producer. The *Terra-Cotta* Rooms of the Louvre and the British Museum are a proof of it. One such work indeed there is, delightful in itself, technically exquisite, most interesting by its history, which properly finds its place beside the larger, the full-grown, physical perfection of the *Discobolus*, one of whose alert younger brethren he may be,—the *Spinario* namely, the boy drawing a thorn from his foot, preserved in the so rare, veritable antique bronze at Rome, in the Museum of the Capitol, and well known in a host of ancient and modern reproductions.

There, or elsewhere in Rome, tolerated in the general destruction of ancient sculpture—like the "Wolf of the Capitol," allowed by way of heraldic sign, as in modern Siena, or like the equestrian figure of Marcus Aurelius doing duty as Charlemagne,—like those, but like very few other works of the kind, the *Spinario* remained, well-known and in honour, throughout the Middle Age. Stories like that of Ladas the famous runner, who died as he reached the goal in a glorious foot-race of boys, the subject of a famous work by Myron himself, (the "last breath," as you saw, was on the boy's lips) were told of the half-grown bronze lad at the Capitol.

Of necessity, but fatally, he must pause for a few moments in his course; or the course is at length over, or the breathless journey with some all-important tidings; and now, not till now, he thinks of resting to draw from the sole of his foot the cruel thorn, driven into it as he ran. In any case, there he still sits for a moment, for ever, amid the smiling admiration of centuries, in the agility, in the perfect *naïveté* also as thus occupied, of his sixteenth year, to which the somewhat lengthy or attenuated structure of the limbs is conformable. And then, in this attenuation, in the almost Egyptian proportions, in the shallowness of the chest and shoulders especially, in the Phœnician or old Greek sharpness and length of profile, and the long, conventional, wire-drawn hair of the boy, arching formally over the forehead and round the neck, there is something of archaism, of that archaism which survives, truly, in Myron's own work, blending with the grace and power of well-nigh the maturity of Greek art. The blending of interests, of artistic alliances, is certainly delightful.

Polycleitus, the other famous name of this period, and with a fame justified by work we may still study, at least in its immediate derivatives, had also tried his hand with success in such subjects. In the *Astragalizontes*, for instance, well known to antiquity in countless reproductions, he had treated an incident of the every-day life of every age, which Plato sketches by the way.

THE AGE OF ATHLETIC PRIZEMEN

Myron, by patience of genius, had mastered the secret of the expression of movement, had plucked out the very heart of its mystery. Polycleitus, on the other hand, is above all the master of rest, of the expression of rest after toil, in the victorious and crowned athlete, *Diadumenus*. In many slightly varying forms, marble versions of the original in bronze of Delos, the *Diadumenus*, indifferently, mechanically, is binding round his head a ribbon or fillet. In the Vaison copy at the British Museum it was of silver. That simple fillet is, in fact, a *diadem*, a crown, and he assumes it as a victor ; but, as I said, mechanically, and, prize in hand, might be asking himself whether after all it had been worth while. For the active beauty of the *Agonistes* of which Myron's art is full, we have here, then, the passive beauty of the victor. But the later incident, the realisation of rest, is actually in affinity with a certain earliness, so to call it, in the temper and work of Polycleitus. He is already something of a reactionary ; or pauses, rather, to enjoy, to convey enjoyably to others, the full savour of a particular moment in the development of his craft, the moment of the perfecting of restful form, before the mere consciousness of technical mastery in delineation urges forward the art of sculpture to a bewildering infinitude of motion. In opposition to the ease, the freedom, of others, his aim is, by a voluntary restraint in the exercise of such technical mastery,

to achieve nothing less than the impeccable, within certain narrow limits. He still hesitates, is self-exacting, seems even to have checked a growing readiness of hand in the artists about him. He was renowned as a graver, found much to do with the chisel, introducing many a fine after-thought, when the rough-casting of his work was over. He studied human form under such conditions as would bring out its natural features, its static laws, in their entirety, their harmony ; and in an *academic* work, so to speak, no longer to be clearly identified in what may be derivations from it, he claimed to have fixed the *canon*, the common measure, of perfect man. Yet with Polycleitus certainly the measure of man was not yet " the measure of an angel," but still only that of mortal youth ; of youth, however, in that scrupulous and uncontaminate purity of form which recommended itself even to the Greeks as befitting messengers from the gods, if such messengers should come.

And yet a large part of Myron's contemporary fame depended on his religious work—on his statue of Here, for instance, in ivory and gold— that too, doubtless, expressive, as appropriately to its subject as to himself, of a passive beauty. We see it still, perhaps, in the coins of Argos. And has not the crowned victor, too, in that mechanic action, in his demure attitude, something which reminds us of the religious significance of the Greek athletic service ? It was a

sort of worship, you know—that department of public life ; such worship as Greece, still in its superficial youth, found itself best capable of. At least those solemn contests began and ended with prayer and sacrifice. Their most honoured prizes were a kind of religiously symbolical objects. The athletic life certainly breathes of abstinence, of rule and the keeping under of one's self. And here in the *Diadumenus* we have one of its priests, a priest of the religion whose central motive was what has been called " the worship of the body,"—its modest priest.

The so-called *Jason* at the Louvre, the *Apoxyo-menus*, and a certain number of others you will meet with from time to time—whatever be the age and derivation of the actual marble which reproduced for Rome, for Africa, or Gaul, types that can have had their first origin in one only time and place—belong, at least æsthetically, to this group, together with the *Adorante* of Berlin, Winckelmann's antique favourite, who with up-lifted face and hands seems to be indeed in prayer, looks immaculate enough to be interced-ing for others. As to the *Jason* of the Louvre, one asks at first sight of him, as he stoops to make fast the sandal on his foot, whether the young man can be already so marked a personage. Is he already the approved hero, bent on some great act of his famous *epopée;* or mere youth only, again, arraying itself mechanically, but alert in eye and soul, prompt to be roused to any

great action whatever? The vaguely opened lips certainly suggest the latter view; if indeed the body and the head (in a different sort of marble) really belong to one another. Ah! the more closely you consider the fragments of antiquity, those stray letters of the old Greek æsthetic alphabet, the less positive will your conclusions become, because less conclusive the data regarding artistic origin and purpose. Set here also, however, to the end that in a congruous atmosphere, in a real perspective, they may assume their full moral and æsthetic expression, whatever of like spirit you may come upon in Greek or any other work, remembering that in England also, in Oxford, we have still, for any master of such art that may be given us, subjects truly " made to his hand."

As with these, so with their prototypes at Olympia, or at the Isthmus, above all perhaps in the *Diadumenus* of Polycleitus, a certain melancholy (a *pagan* melancholy, it may be rightly called, even when we detect it in our English youth) is blent with the final impression we retain of them. They are at play indeed, in the sun; but a little cloud passes over it now and then; and just because of them, because they are there, the whole aspect of the place is chilled suddenly, beyond what one could have thought possible, into what seems, nevertheless, to be the proper and permanent light of day. For though they pass on from age to age the

type of what is pleasantest to look on, which, as type, is indeed eternal, it is, of course, but for an hour that it rests with any one of them individually. Assuredly they have no maladies of soul any more than of the body—*Animi sensus non expressit.* But if they are not yet thinking, there is the capacity of thought, of painful thought, in them, as they seem to be aware wistfully. In the *Diadumenus* of Polycleitus this expression allies itself to the long-drawn facial type of his preference, to be found also in another very different subject, the ideal of which he fixed in Greek sculpture—the would-be virile Amazon, in exquisite pain, alike of body and soul —the " Wounded Amazon." We may be reminded that in the first mention of athletic contests in Greek literature—in the twenty-third book of the *Iliad*—they form part of the funeral rites of the hero Patroclus.

It is thus, though but in the faintest degree, even with the veritable prince of that world of antique bronze and marble, the *Discobolus at Rest* of the Vatican, which might well be set where Winckelmann set the *Adorante*, representing as it probably does, the original of Alcamenes, in whom, a generation after Pheidias, an earlier and more earnest spirit still survived. Although the crisply trimmed head may seem a little too small to our, perhaps not quite rightful, eyes, we might accept him for that *canon*, or measure, of the perfect human form, which

Polycleitus had proposed. He is neither the victor at rest, as with Polycleitus, nor the combatant already in motion, as with Myron ; but, as if stepping backward from Myron's precise point of interest, and with the heavy *discus* still in the left hand, he is preparing for his venture, taking stand carefully on the right foot. Eye and mind concentre, loyally, entirely, upon the business in hand. The very finger is reckoning while he watches, intent upon the cast of another, as the metal glides to the goal. Take him, to lead you forth quite out of the narrow limits of the Greek world. You have pure humanity there, with a glowing, yet restrained joy and delight in itself, but without vanity ; and it *is* pure. There is nothing certainly supersensual in that fair, round head, any more than in the long, agile limbs ; but also no impediment, natural or acquired. To have achieved just that, was the Greek's truest claim for furtherance in the main line of human development. He had been faithful, we cannot help saying, as we pass from that youthful company, in what comparatively is perhaps little—in the culture, the administration, of the visible world ; and he merited, so we might go on to say—he merited Revelation, something which should solace his heart in the inevitable fading of that. We are reminded of those strange prophetic words of the Wisdom, the *Logos*, by whom God made the world, in one of

the *sapiential*, half-Platonic books of the Hebrew Scriptures :—" I was by him, as one brought up with him ; rejoicing in the habitable parts of the earth. My delights were with the sons of men."

THE END

Printed by R. & R. Clark, Limited, *Edinburgh.*

Made in the USA
Middletown, DE
04 August 2022

70592047R00184